FREEHAND DRAWING
SELF-TAUGHT

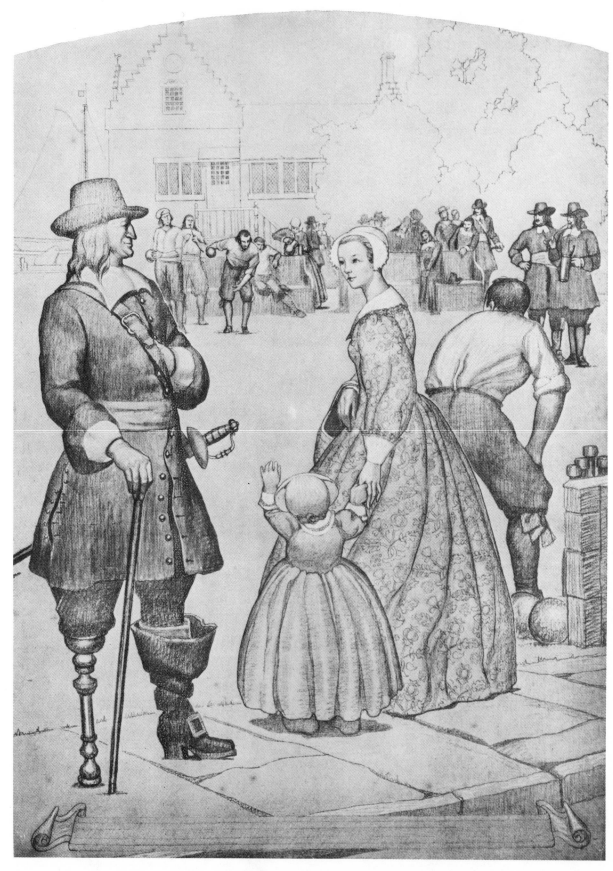

PENCIL CARTOON FOR A MURAL PANEL BY GRIFFITH BAILEY COALE

One of a series for the New York Athletic Club Building. See concluding paragraph of volume for comment

FREEHAND DRAWING SELF·TAUGHT

With Emphasis on the Techniques of Different Media

By

ARTHUR L. GUPTILL

WATSON GUPTILL PUBLICATIONS / NEW YORK

To My Mother

NELLIE STEWART GUPTILL

This Book is

Lovingly Dedicated

Paperback Edition
First Printing, 1980.
Second Printing, 1981
Third Printing, 1984

Paperback edition first published in the United States
by Watson-Guptill Publications
a division of Billboard Publications, Inc.,
1515 Broadway, New York, N.Y. 10036

Library of Congress Catalog Card Number: 80-5043
ISBN 0-8230-1920-9

PREFACE

During the twenty years and more that I have taught at Pratt Institute, Brooklyn, N. Y., the Brooklyn Institute of Arts and Sciences, and elsewhere, I have sought in vain for a single volume to use in my classes, containing a presentation of those basic and unchanging principles and sound practices which underlie all good drawing (regardless of subject and media), coupled with a discussion of the techniques of such varied media as pencil, charcoal, crayon, pen and ink, brush and ink, and wash.

That I have not been alone in feeling the need for such a treatise has been repeatedly evidenced by the fact that as the years have come and gone and I have brought out my books on pencil, pen, and color—each concentrating on a single medium—I have been importuned on numerous occasions, both by teachers and by students, to prepare, for sale at a modest figure, concise yet adequate instruction along exactly these lines.

The present volume is the direct result of these importunities; in it I have incorporated as many as possible of the suggestions which these kind friends have so generously offered.

For convenience, I have divided the entire subject-matter into two parts. Part 1 has a dual scope and aim. First, by means of a comprehensive text, fully illustrated, the reader is led, step by step, from elementary matters, including the selection of his materials and arrangement of his working space, through problems involving such fundamentals as the blocking out of proportions, the treatment of light, shade, and shadow, the use of outline, and the representation of values, color, textures, etc. In the early pages particular emphasis is placed on object-drawing; later many sorts of subjects are considered. Secondly, far more than customary attention is given to the techniques of the various media discussed. Not only are their common uses demonstrated, but the way is pointed to original investigation. A notable feature of Part 1 is the series of graded projects, adapted to the needs of both the novice and the more adept student. These projects, together with the suggested tests, make it possible for the

reader, regardless of his age or state of progress, to advance rapidly along lines which are sound, even if forced to work without a teacher.

Part 2, again, has a double purpose and value. Primarily it is a reference work, for whereas in Part 1 the drawings are from my own hand, offered to illustrate points brought out by the text, our second part is a veritable gallery of fine examples, representing the work of numerous artists the world over. All sorts of subjects, media, and methods are shown, with particular stress on such things as the student can well hope to master. Further than this, the accompanying text and captions contain pertinent pointers supplementing those of Part 1, arranged for easy perusal and assimilation. Not a few of these were offered by the artists themselves, which adds greatly to their value.

Wherever limited space has prevented the adequate treatment of some specific subject, references to other sources of information have been made. It is hoped that these, together with the complete index, will prove of value to the reader, and especially to the teacher, whose needs I have kept constantly in mind. Particularly have I sought to aid the teacher who is forced to give instruction in drawing yet is without the advantage of an art education. Hence, though no specific courses of study are offered, designed for individual grades, it should not be difficult to assign work adapted to students of any age, talent, or state of progress. The volume should prove extremely well suited to junior high schools, high schools, and the first year of art schools and colleges.

Let me take this occasion to extend my thanks, and those of my publishers, to the many individuals who have had a part in the making of this volume. Especially do we acknowledge our indebtedness to the artists of the supplementary drawings (who have shown, without exception, a splendid spirit of cooperation), and to *Pencil Points* magazine, in which many of these illustrations originally appeared.

A. L. G.

Westways, Gorham, Maine
August, 1933

CONTENTS

PART I

CONTENTS

PART 2

PART I

A BOOK OF INSTRUCTION

INCLUDING A SERIES OF
GRADED EXERCISES ADAPTED
TO BOTH THE BEGINNER AND
THE ADVANCED STUDENT

*With an Exhaustive Text and Ample Illustrations
by the Author*

CHAPTER I

SOME PRELIMINARY CONSIDERATIONS
Encouragement and Advice for the Beginner

IF WE were face to face, you and I, and you should ask, "Can I learn to draw?" my unhesitant reply would be, "Yes." For anyone with normal intelligence can. There is not the slightest doubt about it.

Drawing is, in our early youth—and should be throughout life—a far more natural means of expression than writing. For writing, like talking, must be learned. Drawing, of course, needs study, too, before one can go far with it. Yet what child does not draw well, relatively speaking, without the slightest tutoring? Give him chalk and a sidewalk, a stick and beach of sand, or pencil and paper, and he produces results which, all things considered, are little short of marvelous.

Rarely, however, does this instinct show later development consistent with its early promise. We need not go into the reasons for this; it is enough to point out that most children all too soon reach the age where they draw only occasionally, unless required, in which case their work is liable to show indirect, self-conscious effort instead of its former spontaneity.

Despite this, I am convinced that the desire to draw, plus a certain instinctive ability, is never wholly extinguished. It lies dormant in each of us, awaiting a reawakening. Let me tell you why I feel so positive.

From time to time I have had students "wished" on me because freehand drawing was a part of some prescribed course of study. In architectural classes, for instance, I have had men—many of them—who took my work only because there was no choice. Their leaning was in some different direction. Not a few openly scorned the esthetic in favor of the practical. Others believed freehand drawing beyond their capacity. But here is the encouraging point. Many of these very men, despite their seeming indifference, distaste, or lack of confidence, not only developed a real interest in drawing, but did creditable work. A few discovered unsuspected talent and later turned to art as a means of a liveli-

hood. Not one among those who made reasonable effort ever proved an absolute failure. So you see I *know* that you, too, can learn.

I cannot promise, of course, that you can become a leading artist; few in any generation do. Some individuals have far more innate ability than others and are able to attain correspondingly greater skill. What I can promise is that, even if forced to work without a teacher, you can soon develop at least a modicum of efficiency—enough so you can enjoy your drawing as a hobby. Farther than this, I can offer reasonable assurance that you can eventually become a professional artist if your wish is strong enough and backed by assiduous application. For the field of art is broad today, and there are many places, as in advertising art and industrial design, where one does not require the consummate skill expected of the portrait painter or mural artist. Best of all, you should be able to get as much fun from the process of learning as from the increased dexterity which it engenders.

If you hope to advance beyond rather amateurish beginnings, however, you must not go at the matter half-heartedly. One cannot gain proficiency through desultory or infrequent practice. You must accept drawing as a thing to challenge your best effort. Despite any claims to the contrary, it cannot be taught or learned in "ten easy lessons." This does not mean that in order to reach a reasonable degree of skill you must make yourself a slave to your subject, studying night and day. It does mean that you must take the trouble to learn a few basic principles well, and to perform diligently numerous exercises of various sorts designed to train the mind, the hand, and the eye. Especially do you need sufficient perseverance to carry you past the sometimes discouraging or tedious beginnings to the point where the satisfaction of accomplishment carries you along. Unfortunately, many a novice becomes discouraged all too soon, abandoning his attempts just as he is prepared to make real progress.

Of the major causes for discouragement three are outstanding—timidity, over-confidence, and impatience.

Timidity often prevents one, even after he has acquired the necessary foundation, from trying to do subjects or utilize media or methods which appeal to him. He mentally lists "hands," for instance, as "difficult"; he has heard that pen technique is hard, and so evades it. Whatever his inborn ability, such lack of confidence retards his development and makes it one-sided. Unless he can eventually muster up greater courage he is quite certain either to discontinue further serious effort, admitting defeat, or, as just mentioned, to limit himself needlessly as to media, methods, or subject-matter. If extremely timid, any work which he does will stand as a revelation of his state of mind.

Bad as timidity is, over-confidence, especially when ill-founded, is infinitely worse. The least said about it the better. The fellow who swell-headedly thinks he is the best "drawer" in the neighborhood, having been patted on the back by parents, teachers, and friends, will not only prove insufferable to his associates (almost every art class has at least one), but will hinder his own progress until such time as a little sense can somehow be injected into his system. Then there is danger of an unfortunate reaction; disillusioned, he may give up the whole thing in disgust, or, at best, pass through a trying period of readjustment before finding himself. How he eventually makes out will depend, of course, on his true ability and the completeness of his conversion to a sane point of view. It is worth pointing out in this connection that the student of average ability, but with the right attitude, often advances far more rapidly and to greater heights than does the man of superior talent who, through conceit or indolence, fails to make the most of his opportunities.

Even the student who follows the middle ground between timidity and over-confidence is so likely to try to rush ahead rapidly, particularly at first, that he neglects some of the essential fundamentals. In his haste, for instance, he may scorn object, and cast, drawing, with the valuable lessons they offer, in order to attempt at once to portray his favorite movie queen or football hero. This is a sore mistake. It is as unreasonable for a beginner in drawing, no matter how gifted, to expect to do "pretty girls and handsome men" well, as for the novice at the piano to hope to render a Bach fugue successfully. If only more students could be made to realize the truth of this! One who, because of undue haste, falls into this error of trying things beyond his capacity, usually becomes aware, sooner or later, of the superficial nature of his results, and so is utterly discouraged. It is certainly not a pleasant prospect to face the necessity of going back to the very thing one has so lightly held.

So, as a parting word of advice, trite but sound, I urge you, if a beginner, to curb your impetuosity for the present, and buckle down to attempting to do a few simple things well. Perform, in the proper order, such exercises as are prescribed in the coming pages, reading the text in full and carrying out the instructions to the best of your ability, and I promise you will build a foundation which will prove true and lasting, whatever line of drawing or painting you may later elect to follow. Not only will these exercises sufficiently tax your skill, but if you will view each as a definite part of a systematic, progressive course of study, rather than a thing by itself, they should stimulate your interest. No man-made game or puzzle can put one's ingenuity to a greater test than can the tasks which Nature sets before him when he seeks to record or interpret her forms and moods through pictorial delineation.

CHAPTER II

EQUIPMENT : WORKING SPACE
With a Description of a Home Studio

THOUGH the equipment needed for our problems is simple and relatively inexpensive, it should be selected and prepared with care. Our present concern is with the larger essentials required for practically all the suggested exercises. At the proper time I shall discuss many individual items.

Working Space. The student studying at home should first of all seek a suitable working space. It is hoped every reader can at least find some well-lighted room corner where he can draw unmolested. In Figure 1 is shown a home studio which in many respects is ideal. Study this and strive for an equally practical arrangement.

Illumination. A vital matter is illumination. If actual objects are to be drawn, a single window is considered best, for the more windows the greater the complexity in direction and character of light, shade, and shadow (see Chapter XIX). In Figure 1, the window faces the north, insuring steady, clear illumination. Dark window shades, top and bottom, together with draw curtains, permit excellent control of both its amount and direction. For night study an electric light is provided (of "daylight" type, if work in color is contemplated), arranged on an adjustable telescopic bracket—a swinging hook, like those used for bird-cages, can be substituted. Such a light is customarily located to take the place, as nearly as possible, of daylight, so if one is forced to turn it on, as during a winter afternoon, the change in illumination is minimized.

Object Stand. When objects are to be drawn, they should lie within the range of direct vision and be interestingly lighted. In Figure 1 the object stand is in a relatively bare portion of the room, away from distracting influences. The light falls at a pleasing angle from the left. The stand is merely an ordinary table with a plain cloth thrown over it for simplification. Its length and position against the wall permit placing the drawing beside the subject now and then for comparison (see Chapter IV).

Object Rest. The open, boxlike contrivance on this stand is what is known as an "object rest" or "shadow box." Its main purpose is to afford a simple background to throw the object or objects to be drawn into definite relief, permitting the eye to focus upon them easily. It is especially valuable when the stand cannot be placed against the wall, or when the surroundings would prove distracting without it.

Such a box is usually of cardboard or thin wood, white or neutral in tone. Often it is arranged to fold away when not in use. An end like that pictured at the left is sometimes added, designed to cast shadow on or behind the objects, if wanted. It also affords a corner if now and then one wishes to arrange his objects in such an angle. A rest of this type may be turned to any position, according to the lighting desired. Inverted, the closed end can be brought to the right. In color work (which is not within our scope), a cloth of selected hue is sometimes draped over the whole.

Drawing Table. The adjustable table pictured is of a very practical type, as it can be raised or lowered at will, and used either flat or tilted. The instrument-shelf at the top always remains horizontal. Any small table 30" or so in height may be substituted (see Figure 2).

Drawing Board. Note in Figure 1 the wooden drawing board. Unless one relies on paper in pad or block form, some such board is needed. For most of our work, paper approximately 11" × 15", or 9" × 12", is satisfactory. A board 16" × 22" or so accommodates this and affords ample rest for wrist and hand. For larger work such as charcoal drawing, a board about 23" × 31" is better.

Chair. A sturdy chair is necessary. Its placement obviously depends on the location of the table, which *must* be well lighted. In our sketch, table and chair, though properly related, are farther from both object stand and window than is customary.

Easel. For certain types of work, particularly when of large size, an easel is desirable, though scarcely essential. A few dollars will buy one. The adjustable table in Figure 1 can be raised stand would do nearly as well. Other conveniences are cases for supplies and reference materials, finished drawings, etc. Portfolios are popular.

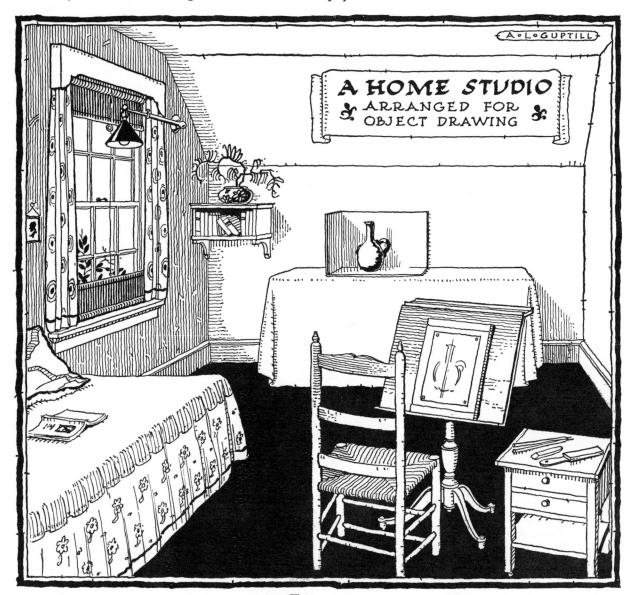

FIGURE 1

IT IS EXTREMELY IMPORTANT TO HAVE A SUITABLE WORKING SPACE
The chair and table should be a bit nearer the window

to use as a substitute. The student sometimes stands, or sits on a high stool.

Taboret. Some support for the smaller materials is of advantage. Our sketch shows an artists' taboret. An extra chair or a smoking For work from the photograph, memory, or the imagination, no object stand or rest is needed, and control of light is less essential. The chair, table, and taboret would doubtless be placed nearer the window than here illustrated.

CHAPTER III

NATURALISM VS. CONVENTIONALITY
Representative Drawing: Outline Drawing

THE layman sometimes imagines that the best drawing or painting is the one which pictures Nature with the greatest fidelity. Actually this is not true. On the contrary, many recognized masterpieces show only a vague resemblance to the natural motives which inspired them.

Even should the artist desire to make exceedingly realistic drawings, he knows he would fall far short of his aim. No matter how capable one is, he has but to attempt to paint a sunset, in its full brilliancy, to discover both his own limitations and those of his materials. If he turns to far less striking effects, he still finds it impossible to attain more than a suggestion or approximation of the thing he strives to represent. The brightness and scintillation of sunshine, the vividness and variety of Nature's colorings, the vibration of the atmosphere, the bewildering diversity and complexity of detail (think of representing, individually, the leaves of a single tree!), cannot be duplicated.

As a matter of fact, the artist usually has no wish to duplicate such appearances. He translates, indicates, and perhaps exaggerates. He goes to Nature for inspiration, but his work bears the stamp of his own personality. He is an interpreter rather than a copyist.

So, partly through choice and partly through necessity, artists proceed in their own way. Among other things, they employ many established conventions. Of these, one of the most common is the interpretation of color in nonchromatic terms—white, grays, and black. Just as the white marble of the sculptor (who often copies Nature's forms, but seldom her colorings) can be chiseled into something which satisfies our esthetic sensibilities, seeming neither incomplete nor incongruous, so drawings or paintings without color meet universal acceptance.

Another convention accepted without question is the employment of outline. Outline is so common in Art that we sometimes forget that Nature makes no use of it. Her forms are not bounded by distinct edges. We are able to distinguish one area from another only because of contrasts of color or light and dark. We frequently see what *appear* to be outlines, to be sure, but careful inspection always proves them to be nothing more than narrow bands of color, local tone, or light, shade, or shadow. Outline is a natural means of pictorial representation, however, as is proven by the fact that the child and the untutored savage employ it, seemingly by instinct. It is extremely easy for us all to think of form as bounded by line.

Representative Drawings. Let me digress for a moment to make clear that any drawings which aim to portray actual persons, places, or things go under the general title "representative drawings," even when, instead of being as literal as possible, they make use of such conventions as I have just mentioned. In other words, representative drawings exhibit a sort of conventionalized naturalism. When I use the word "drawings" in this book, I have in mind this type. All our illustrations would fall within my intended category, for they quite precisely picture the forms of the objects shown, though they sometimes make free with light and dark, and ignore color or translate it in terms of outline or white, gray, and black.

Outline Drawing. As the first thing which we customarily think of, when it comes to representative drawing, is the portrayal of form, and as form can so easily be interpreted in outline, our first studies will be in outline drawing (see Chapter IV).

Tracing on Glass. As an introduction to this, I heartily urge every reader to perform this set of experiments.

First, take an ordinary sheet of glass and hold it upright, as in Figure 2, looking through it at some object, one eye being closed to avoid a duplicated image. Now trace on this glass with a lithographic or china-marking pencil (which a damp cloth will instantly remove) an outline

of the object exactly as it appears. If careful to maintain your position, this tracing, when finished (but before you move from your seat), will seem to hide or coincide with the boundaries

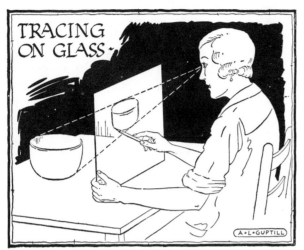

FIGURE 2

of the object depicted. So far as form is concerned, such a tracing stands as a correct representative drawing of the particular object shown, as seen from one specific point of view.

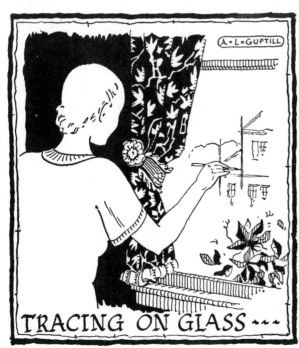

FIGURE 3

Next, by way of further emphasis, go to the window (Figure 3)—preferably one with large glass to permit freedom of vision—and, looking directly out (not slantwise), trace on the window pane, with one eye closed, some visible object. Anything will do which is at rest— a tree, a mountain, or a ship. A building is good because of its definite form. Again this tracing is a true representative drawing, in outline, of the object.

In like manner, place tracing paper over a photograph (Figure 4) and outline its main elements; once more, assuming the photograph is not distorted, you have a correct representative drawing.

The purpose of these exercises is not to teach you to draw (though such practice is sometimes of help), but only to make you realize that every drawing, so far as it indicates form, is, in a sense, a tracing of the object depicted. Lest you be confused over the relative sizes of the subjects shown in the various types of tracings just de-

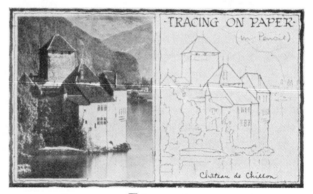

FIGURE 4

scribed, I hasten to explain that there need be no fixed relation between the size of a drawing and the subject drawn. Size has nothing to do with correctness; a drawing can be as large or as small as the artist chooses.

Incidental to all this, tracing on glass introduces another interesting thought; this is that as a representative drawing, to be correct, must be made from a single point of view, the slightest shift in position upsetting the proportions, when finished it should, strictly speaking, be observed from a corresponding point. This is a logical theory which, unfortunately, can seldom be put to practice. We cannot label a drawing "To be viewed by the spectator, with one eye closed, from a point two feet from the paper, six inches to the left of, and five inches above, the center"! The artist, therefore, tries, though

often subconsciously, to get effects which are pleasing from every angle, avoiding in particular the acute perspective which comes from standing too close to his subject. This relationship between station point and picture need not worry the beginner, and seldom is of any great concern to the artist. A unique exception is in the Wiertz museum at Brussels, where a number of paintings are arranged in individual booths; the spectator peeks at them through properly located apertures, the effects being surprisingly naturalistic.

So much by way of foundation for the work to follow.

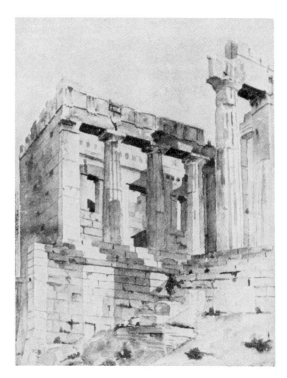

DRAWN BY SEWALL SMITH

CHAPTER IV

FORM REPRESENTATION : OBJECT DRAWING
"Blocking Out" Proportions: Errors: Tests

ALL representative drawing involves one or more of the following factors: 1, representation of form; 2, representation of tones of light and dark; 3, representation of color; and, 4, representation of texture.

Of these, our present interest is with the first, which is perhaps the most vital of all. Surely one can't go far as an artist until he can draw things in the right proportion. As form is so easily expressed in outline, our immediate exercises, as mentioned in the previous chapter, are to be in outline drawing. I shall describe thoroughly a single typical problem; the instruction is suited to general application.

Project and Aim. Our project is to draw, in outline, a simple object. The primary aim in this, and like problems of your own choosing, is to develop the power to see form correctly, as it appears to the eye, and to represent it on paper accurately, in outline alone.

Preparation: Materials. Though lighting is less important just now than in later problems, it is nevertheless advisable to arrange your room approximately as in Figure 1, with the object stand directly before you and the chair and table naturally disposed. Mark the placing of the chair legs with a bit of chalk, as it is essential to sit in one position.

For materials, you need only a drawing board, preferably not smaller than 16″ × 22″, several sheets of drawing paper (9″ × 12″ will do, though 11″ × 15″ or larger is better), thumbtacks, a medium pencil (HB, B, 2B or 3B), and a soft eraser (kneaded rubber is excellent). A block of paper may be substituted for the separate sheets, in which case the board and thumbtacks are of course superfluous. The kind of paper and exact degree of pencil matters little just now, as attention should be given to accuracy of proportion rather than excellence of line.

Selecting the Subject. Now choose an object to draw. Let it be simple. Would that every student could be brought to realize that a rea-sonable amount of practice in representing such elementary forms as cubes and spheres can qualify him in the easiest way to do far more difficult subjects!

For exemplification, if we think of buildings for a moment, we realize that the ordinary house is merely a rectangular prism, supporting a triangular prism. Most towers consist of upright square prisms or cylinders, bearing pyramids, cones, or like forms. A dome is customarily hemispherical; often it is raised on a cylindrical drum. Figure 5 is presented to demonstrate that even highly complex architectural masses can be resolved into comparatively simple elements, mainly geometric. Many other large objects—locomotives, trolley cars, balloons, etc.—are basically as simple.

Turning from large objects to small, we find this geometric relationship is common to innumerable things. A candy box is a rectangular prism, a bowl a hemisphere, a lampshade a truncated cone or pyramid, and a washing machine a cylinder. Even objects which at first glance do not seem particularly geometric, such as the jar at A or the jug at B, Figure 6, can often best be constructed in or about a cylinder, sphere, or something of the sort. This is likewise true of furniture. In diagraming the chair at C, I visualized it as frozen into a cubical block of ice. I drew the cube first and subdivided it. Such a method of construction is particularly advantageous when one works from memory or the imagination.

Nothing offers a more logical starting point, then, than simple geometric solids such as the blocks used in many schools. Every lesson learned from them will have a thousand applications. Equally good—better, in some respects, and far more interesting—are cracker boxes, flower pots, books and things of that general nature. Not only in form (which interests us just now), but also in light, shade, color, and texture, large objects and small follow the same

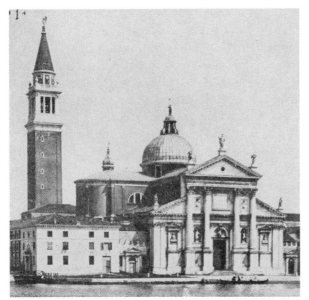

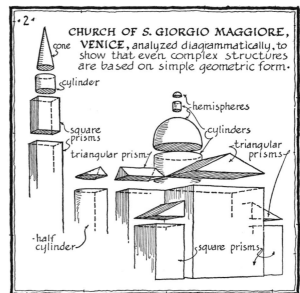

FIGURE 5

laws; the identical methods of technique also apply to both.

One should by no means confine his efforts to solids basically geometric; these should soon be supplanted by, or alternated with, old shoes, vegetables, flowers, or any of a hundred and one objects irregular in form. These have more individuality than the geometric ones, and individuality is a thing which the student must learn to recognize and portray.

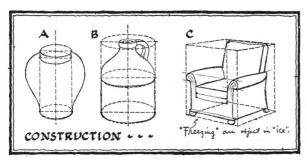

FIGURE 6

For my first demonstration, I have selected a typical cardboard carton (Plate 1), and suggest that you start with an equally simple object—one with no complex values or colors to confuse you.

Placing the Subject. It is something of an art to place or pose an object, or group of objects, to advantage. Just as the photographer spends some time posing a sitter, so the student should give some thought to the effective arrangement of the subject of every sketch. This is particularly true when it comes to later shaded work.

View-finder. As an aid in this direction, you should at once prepare a "view-finder." One of cardboard, post card size or so, with a rectangular opening near its center about 1½" × 2" in size, will do nicely. Some like an additional

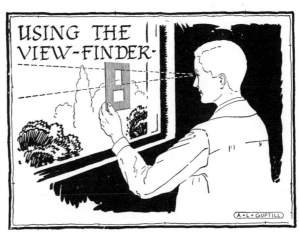

FIGURE 7

opening, giving a choice of vertical or horizontal selections without turning the card (see Figure 7). Its purpose and use is much like that of the camera finder. When you have taken your working position, hold the finder upright, as far from the eye as proves desirable, and study the subject through either aperture with one eye closed. The finder serves as a frame, detaching the subject from its surroundings, and so giving it much

the appearance of a picture. Every subject selected to sketch should be studied in this manner and rearranged, if necessary, until it seems to compose pleasingly. In the present example our carton has been posed after just such critical examination.

Analysis. With your subject properly placed, give a few minutes to its careful analysis in order to get in mind its distinguishing characteristics. Is it regular or irregular in mass? Is it short or tall? Light or dark? Rough or smooth? Hard or soft? Dull or polished? Are straight or curved lines needed for its delineation? Try to photograph its image on your mind, closing your eyes after a moment to test your ability to recall its appearance. Forget how you think such an object *should* appear; look and see how it *does* appear. Preconceived notions regarding appearances often prove a decided handicap.

Starting to Draw. Now, before drawing your first strokes, make sure you are comfortable,

with your materials well arranged. Especially should your paper be adjusted to your satisfaction, firmly supported at such an angle that it can be seen easily and at the same time permits a free, natural handling of the pencil. Some artists like it almost vertical; others rather flat. It is well to become accustomed to both positions. It should never be so foreshortened as to cause unsuspected distortion to develop—a thing which may happen if it is too flat or too far to one side.

If you use a drawing board, have several extra sheets of paper beneath your drawing. This affords a better surface, unaffected by any irregularities of the wood. To avoid unsightly thumbtack holes, place your tacks just outside the edges of the paper.

Concerning the position of your pencil, there are no rules. Usually it is held much as for writing, though often with the point farther extended. See Figure 8 for a number of typical

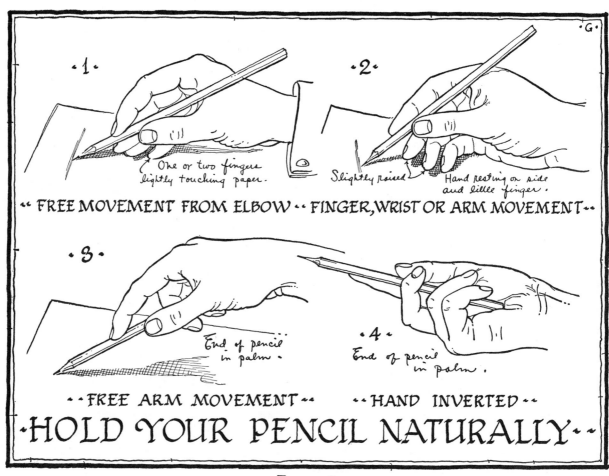

·1· One or two fingers lightly touching paper.
·· FREE MOVEMENT FROM ELBOW ··

·2· Slightly raised — Hand resting on side and little finger.
·· FINGER, WRIST OR ARM MOVEMENT ··

·3· End of pencil in palm.
·· FREE ARM MOVEMENT ··

·4· End of pencil in palm.
·· HAND INVERTED ··

·HOLD YOUR PENCIL NATURALLY··

FIGURE 8

PLATE 1 ·· FORM REPRESENTATION·

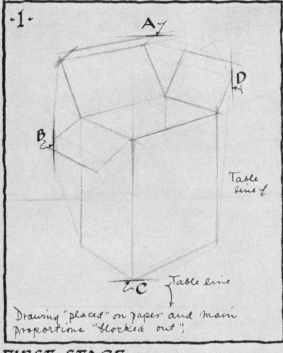

·1·

A
D
B

Table line ↓

C Table line

Drawing "placed" on paper and main
proportions "blocked out".

FIRST STAGE · · ·

·2·

C↑

Note "invisible"
lines

Subdivisions added.
Proportions corrected.

SECOND STAGE · · ·

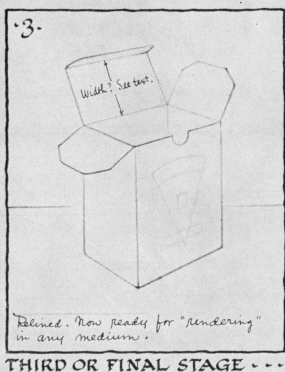

·3·

Width? See text.

Relined. Now ready for "rendering"
in any medium.

THIRD OR FINAL STAGE · · ·

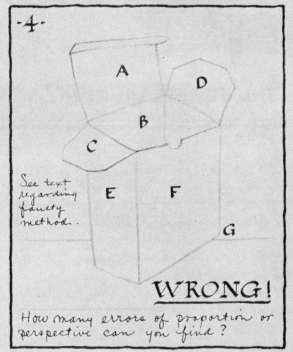

·4·

A
D
B
C
E F
G

See text
regarding
faulty
method.

WRONG!

How many errors of proportion or
perspective can you find?

WRONG METHOD · · ·

ABILITY TO DRAW IN CORRECT PROPORTION IS OF SUPERLATIVE IMPORTANCE
This can best be acquired through the drawing of objects

positions. Sometimes, especially when the paper is placed upright, the hand is inverted as at 4.

Sit straight, though not stiffly so, endeavoring to maintain your exact position at least until the larger proportions are well established. This is necessary. Remember an object changes in appearance for every new point of view; if you gradually slump you will keep seeing the thing differently.

Cleanliness. Soiled drawings are so unattractive as to be absolutely inexcusable. You must not allow yourself to fall into careless habits. Keep your hands immaculate; don't rub your sleeves through your drawings (have the arms

Table Line. It is advisable to sketch a "table" line, which customarily represents the intersection of the vertical and horizontal planes of the object rest. Sometimes a second table line is drawn to indicate the near edge of the horizontal plane. These lines, in the final drawing, keep the object from seeming to float in space. They should not be too black.

First Stage. With these salient points and foundation lines established, a few strokes to define the larger proportions of the subject are next swept in quickly with a free arm movement and a "feather touch" of the pencil. This brings the drawing to the point shown at 1,

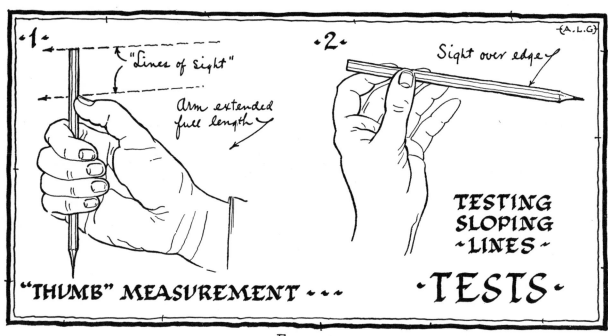

FIGURE 9

bare, if possible); don't use a softer pencil than necessary, and wipe it with a rag, whenever sharpened, for the removal of loose graphite. As you draw, brush your drawing delicately now and then with an extremely soft brush or cloth. Keep an extra sheet of paper always under the hand to protect your work.

"Placing" the Subject. Referring to Plate 1, you will see (1) that the first move in sketching any subject is to "place" it nicely on the paper by locating, by dots or fine lines, its outermost limits, as at A, B, C, and D. Make a horizontal or vertical picture as your subject suggests. Don't have the drawing too small; fill your paper reasonably well.

though here, to emphasize the method, these construction lines have been made more prominent than is customary. If too prominent, they may prove confusing rather than helpful. They must not be creased into the paper.

Testing. When your drawing reaches this point, try to make certain that your main proportions are right before proceeding to smaller subdivisions. Set the drawing back beside the object for direct comparison. In this position mistakes are often plainly evident. If there is no suitable accommodation on or near the object stand, an inexpensive music rack, of folding type, is convenient.

Thumb or Pencil Measurement. Though you

must rely largely on the eye for the detection of errors of proportion (and the eye becomes an extremely accurate aid when well trained), there is a simple test of considerable value. It is called "thumb" or "pencil" measurement (see 1, Figure 9). A pencil, point down, is held vertically at arm's length between one eye and the object to be measured, the other eye being closed. The top of the pencil is brought to coincide with some salient upper point of the object. Then, with the pencil kept steady in this position, the thumb, as shown in our illustration, is slid down until the nail marks some other vital point of the object—perhaps its lowest extremity. The pencil is now measuring an important vertical dimension. Next, the hand is rotated, with wrist and arm as a pivot, into a horizontal position, where the measure of height is brought into comparison with the object's length or some other horizontal dimension. The process can, of course, be reversed, or dimensions taken slantwise. Within reason it can be repeated for smaller subdivisions. The common practice is to measure the shorter of two questionable distances first, bringing this into comparison with the longer. The pencil should always be kept at a uniform distance from the body, and should be rotated in a plane which is vertical, or approximately so.

As the various proportions of the subject are compared in this manner, corresponding proportions in the drawing can be tested, either by eye or by laying the pencil upon them.

Testing Slants. Another use of the pencil is suggested at 2, Figure 9. It sometimes seems difficult for the beginner to judge the pitches of the various slanting lines of an object. By holding the pencil at arm's length, to hide or coincide with a given line, its true pitch can be estimated more easily. Or the pencil can be held horizontally or vertically and the slant compared with this. In sketching objects which are irregular in form the pencil is similarly used for ascertaining the slope from one salient point to another. Once determined, these slopes are often indicated on a sketch, while in its early stages, by light pencil lines. In Plate 2, at 3, both sketches show several objects reduced to lowest terms by means of these slants. Such groups can sometimes be bounded by lines approximat-

ing squares, circles, triangles, or other simple forms.

The view-finder can also be of great help in judging pitches, for, held upright, it reveals, through contrast, the comparative shape and direction of any questionable line.

As a further test of a drawing, customarily depending on the eye alone, the angles formed by intersecting lines in the subject can be compared with corresponding angles in the drawing.

Object Analysis. Figure 10 illustrates an interesting sidelight on this phase of form repre-

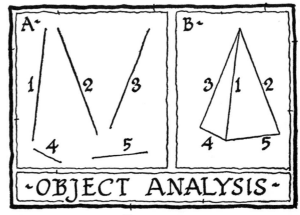

FIGURE 10

sentation. If one is asked to copy, as from a blackboard, a single straight line of some given slant, he seldom has much difficulty in doing so. With equal ease he can copy a group of lines like those at A, though of varying length and slant. Strange to say, however, he is far more liable to get into trouble if he tries to draw an object, such as the pyramid at B, made up of identically the same lines. This would be equally true were the lines curved instead of straight. This seems to indicate that the student, as he draws any object, should, in addition to thinking of it as a whole (which is recognized as wise), try to separate it mentally into its component parts, drawing each correct in itself. And it would pay him, in testing, to analyze and compare every line and space area with this thought in mind.

Second Stage. When you have tested your first stage drawing, and made any corrections which seem necessary, you are ready to advance it another step. Corrections, by the way, need

not in every case be made by erasure. If the first lines are light, and they should be, merely make your new strokes a bit heavier: they can be distinguished easily.

Your next move is to subdivide the subject (especially if complex) still further, or to perfect it, as at 2, Plate 1. It becomes, in this second stage, a rather complete construction diagram, ready for a last refinement. It often aids in getting the proper proportions if invisible lines and points are located as at C.

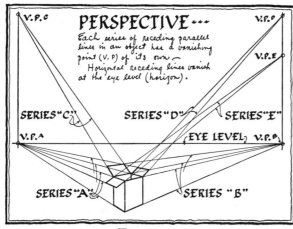

FIGURE 11

Perspective Laws. To do this sort of thing to best advantage a knowledge of linear perspective is necessary. You can scarcely afford not to learn, at your earliest opportunity, the basic laws and their application.

In the case of our present carton, for example, if one knows the fundamental rule that "objects appear smaller in proportion to their distance from the eye," he almost unconsciously represents the nearest upright corner the longest of the four, that at the left somewhat shorter and that at the right shorter still. The back corner, most of which is hidden, would be the shortest of all. This means that the horizontal lines which connect the extremities of these vertical corners, to bound the top and bottom of the main rectangular prism, would appear to converge. One set would go to the right and one to the left to meet at distant "vanishing points" at the level of the eye, for "horizontal parallel lines which recede from the eye appear to converge, and, if sufficiently extended, seem to meet at the eye level." Each series of slanting

parallel lines, as on cover and flaps, would also converge to a vanishing point. All this is shown in Figure 11, which illustrates a carton similar to that in Plate 1.

This drawing and brief explanation are not intended to make these points clear, but only to introduce the reader to this important science. Figure 12 helps to demonstrate that perspective principles apply to the representation of all sorts of subjects, large as well as small.

Though our limited space precludes a discussion of these principles, they are admirably set forth in Dora Miriam Norton's *Freehand Perspective and Sketching,* published by Bridgman Publishers, Pelham, N. Y. A brief book on instrumental perspective would be of help, too, such as *Perspective,* by Ben J. Lubschez (D. Van Nostrand Co., New York).

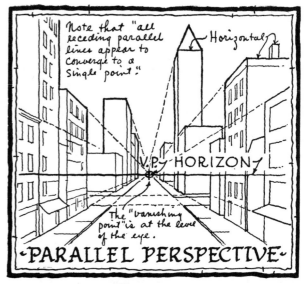

FIGURE 12

Third Stage: Rest Periods. If a drawing is to be shaded, as described in later chapters, it is customarily brought only to the second stage shown at 2, Plate 1. In no case should it be pushed farther until carefully tested and corrected. Let me reiterate that every few minutes you should set your drawing back for direct comparison with the object. You would also be wise to rest the eye for a moment now and then, by concentrating on something else. If you leave a drawing even for a short time you will often note, on return, errors so glaring that you will be amazed you ever made them. The pro-

fessional artist has learned the value of frequent rest periods.

After such a rest, assume *exactly* your previous position; a slight difference can be enough to cause a marked change in the appearance of the subject. Some teachers, in slipping into students' chairs for criticism, are not careful enough about this, particularly if shorter or taller, and so give faulty instruction.

Now, with the eye fresh, add the smaller subdivisions and make your final corrections; if you care about the appearance of your drawing, soften it with the eraser (at the same time cleaning the entire sheet) and reline (see Sketch 3, Plate 1).

It is not my thought that you reline your first drawings with particular attention to quality of stroke. Remember your principal aim just now is to interpret form correctly, and this one thing needs all your thought. Each sketch should be pushed far enough in this third stage, however, to suggest many of the smaller peculiarities of the subject, yet without losing all the virility and simplicity of the earlier stages.

Margin Line. Generally a freehand line, an inch or so from the edge of the paper all around, adds interest to a sketch (whether in outline or tone), framing it and so concentrating attention upon it. All sketches should be dated, too; it is helpful to look them over occasionally to note progress.

Final Analysis. When you think a drawing is absolutely completed, set it back once more for comparison with the subject. Better yet, lay it aside for several hours and then compare it. Does it seem a reasonably correct and complete interpretation of the masses drawn? Has it caught the peculiarities of the subject? You must learn to be a severe critic of your own work.

Final analysis of the sketch at 3, Plate 1, revealed one decided fault. What of the width of the cover? Does it seem too wide? Too narrow? It is too narrow.

Trial Sketches. The beginner customarily realizes, if fair with himself, that his first drawings have many weaknesses. It is by no means easy to do a correct outline drawing of even a simple object. Many times he finds it profitable to make, as a preliminary to his larger drawing,

a small trial sketch, perhaps on the margin of his paper. This forces him to gain acquaintance with at least the larger characteristics of his subject before starting the final work. Note the trial sketches on Plate 2.

A Universal Method. I am often asked whether it is customary to go through these several stages in making a drawing, and whether there are no short cuts. My answer is that though the number of stages can vary, the general system described is used by a majority of artists in drawing all sorts of subjects, even including portraits. One usually does develop short cuts, as hand and eye become better trained, perhaps substituting dots or light touches for the heavier construction lines of the beginner, drawing more with mind and eye and less with the pencil. A simple subject like our carton would perhaps be drawn at once in its final stage. Yet, fundamentally, the method is the same, the artist subconsciously thinking through some of the processes which the beginner is forced to carry out.

Wandering Method. One interesting variation of this procedure might be called the "free" or "wandering" method. I wish I could demonstrate this on paper for it's a hard thing to put in writing. The artist starts to draw by substituting for the direct touches or sweeping lines which most teachers recommend for first stage construction, a sort of scrawly prediction of a more precise framework which gradually evolves, almost by magic, as he "feels out" the wanted proportions. Customarily the pencil is scarcely taken from the paper, but is hastily pushed here and there, attention being fixed on the subject, with only an occasional glance at the drawing. As he locates each vital boundary or division line satisfactorily, he increases his pressure for sharper definition of form. Ultimately he passes the eraser over the whole, leaving, of all the apparent tangle of lines, a few faint but accurately placed indications to guide him in his final work. The thought behind this method is that the quicker one gets something on his paper more or less representative of his subject, the better able he is to make comparisons and so press his work to its termination. The success of the method depends on the man who uses it.

Space Cutting. Some subjects, particularly

landscapes, are quite like picture puzzles, so great is their complexity of form. Figure 13 serves well enough as an illustration. Artists, in blocking out such subjects, often "cut" the area of their paper or canvas into spaces, giving as much attention to the proportions of the areas between objects (as A, B, C, and D) as to the objects. Sometimes it is actually easier to draw the spaces and let the objects take care of themselves.

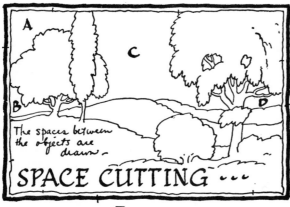

FIGURE 13

A Frequent Error. Such variations of the common method are acceptable. We might even say that any method which produces right results is right. Some methods, however, have proven so unsatisfactory that they must be frowned upon. The beginner all too often employs that illustrated at 4, Plate 1; this is decidedly faulty. Instead of making sure of the main proportions first, gradually subdividing them in logical order, he completes one portion (such as A), then another (B), and so on. He draws by addition rather than by division. The result is that no matter how accurate each detail may seem in itself at the moment he draws it, the completed whole is quite certain to be badly distorted. Hence this method cannot be too severely condemned for beginners' use.

Additional Projects. I have devoted considerable space to this entire matter, as the correct delineation of form is one of the few really vital processes which you need master. It requires a lot of practice. When you have sketched a variety of single objects, differing in size, shape, color, etc., try groupings of two or more.

The sketches in Plate 2 are largely self-ex-

planatory. Attention is called to the center lines in the bowl, vase, bottle, etc. If an object is symmetrical, such an axis makes it easier to draw both sides alike. Sketch 4 indicates that when one is qualified to do animals, people, and other living things, he continues to employ the identical methods used for the more humble inanimate objects. All the sketches in Plate 2 stand ready for shading or refinement of outline.

Memory Sketches. Whatever you draw, attempt to store a picture of it in your memory. Most of us have far less perfect mental impressions of things than we realize—even such common things as we see daily. Test yourself. Try to draw from memory, no matter how crudely, your church or school, a telephone, your dog, a watering pot, a steam roller, a bicycle, your mother. Can you bring really clear images of such things to mind? The artist, especially the illustrator, needs a large collection of accurate mental pictures. As an aid in attaining yours, sketch every object which you select for your present exercises in a number of positions. Then put it aside and try to do it from memory. A week or two later, repeat the attempt. Make memory sketching a regular part of your training.

Time Sketches: Quick Sketching. One seldom gets far as an artist, excepting in a few limited fields, unless he can draw people, animals, and living things generally. And such subjects seldom stand still, at least for long. This means one must learn to work rapidly. Even when drawing objects it is well to have this in mind. See how good a sketch you can make in ten minutes, five minutes, one minute. You thus develop decisiveness and speed.

Sketch Book. If you really wish to learn to draw, you must draw, draw, and draw. Start a sketch book and always have it with you. Any blank notebook will do. No instructions are necessary. Use it! Attempt everything, everywhere. Supplement our prescribed exercises by making numerous sketches along similar lines, covering every conceivable sort of subject. Don't worry about what these sketches look like to the other fellow. Simply make sure that you are honestly recording such attributes of each subject as interest you. Start now! And keep going!

PLATE 2 · FORM REPRESENTATION ··

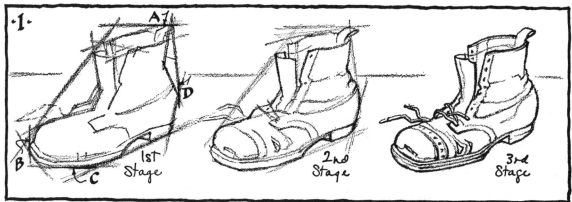

·1·

A
D
B
C
1st Stage
2nd Stage
3rd Stage

IRREGULAR OBJECTS ARE "LAID OUT" AS SIMPLE MASSES ···

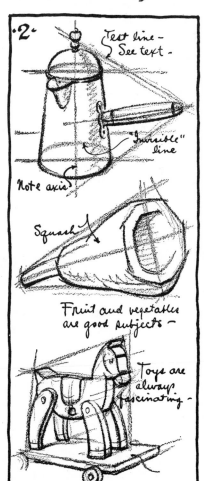

·2·

Test line – See text –

"Invisible" line

Note axis

Squash

Fruit and vegetables are good subjects –

Toys are always fascinating –

·3·

A

B

Curved line objects

Straight and curved lines

TRIAL STUDIES FOR COMPOSITION ···

·4·

A

B

Construction lines mainly straight.

Construction lines mainly curved –

TRIAL SKETCHES ··· LIVING SUBJECTS PERMIT SAME METHOD

THE PRINCIPLES GAINED FROM SIMPLE OBJECTS APPLY TO ALL SUBJECTS

One should seek things of wide diversity of form, tone, and texture

CHAPTER V

DRAWING AND TESTING ON GLASS
Faults of Perception and Their Cure

BY THE time you have made a dozen or so outline drawings of simple objects, following the suggestions so far offered, you will probably discover that you are developing increased confidence, and growing impatient for the next step.

On the contrary, if things do not go as well as expected—and art *is* long—you may find yourself in the dumps. Discouragement at this time is not uncommon, for the objects attempted look so easy it is hard to believe that, working in outline alone, you cannot quickly and accurately portray them. If satisfactory results fail to materialize, don't question your ultimate success; remember drawing is something of a knack, and progress often comes by fits and starts.

If your discouragement does not soon pass away (the making of a good drawing or two often effecting a cure), it is possible that your difficulty is more one of improper perception than of faulty delineation. You simply have not learned to see. We all think we can see, of course, yet it's only half seeing when we see with the eye and not with the mind. To draw a thing well you must comprehend its appearance, and comprehension is a mental, rather than a visual, process. We are often handicapped in developing our powers of comprehension as related to appearances because our minds are crowded with misconceptions of long standing.

This diagnosis of your trouble may be wrong, but suppose you test it by means of a drawing glass. For, so far as form is concerned, this can demonstrate how well or how poorly you see. Furthermore, if it proves your perception faulty, it stands as a corrective agent.

I mentioned in Chapter III that a drawing is much like a tracing on glass. This gives us the key to our present experiments. First, if you have not already done so, perform the exercise recommended on page 5 in describing Figure 2. Your aim is not to make a good drawing—the glass is too slippery for that—but to see how your subject really looks, represented on a plane surface. When your drawing is finished, study it with care, learning all you can from it. Then wipe it off with a damp rag and repeat the entire process with another subject.

Though this exercise, if sufficiently continued, should help to free your mind of erroneous impressions, it is only now that we come to the really important step. When tired of tracing—which, after all, has value only to a limited point, as it calls for no creative effort—lay the glass flat on your drawing board, just as you customarily would your paper, and slide a sheet of paper beneath it as a background. Place an object on your stand and attempt to draw its outline correctly on the glass. In doing this you will of course keep both eyes open. Make your drawing a little smaller than the object. When you have established the main proportions, raise the glass into an upright position and look through it, with one eye closed, to see if you can make the drawing on the glass and the object coincide. Shift the glass as necessary. If your drawing is of the right size (a little experience will teach you this) and proper proportion, you should have no difficulty in bringing it into almost exact coincidence with the object. If not correct, errors will show plainly, and you should remedy them. Persevere until you have mastered one subject; then try another and another. Keep at this practice for a while, for, in teaching you to see, it helps to develop your faculty for criticizing your own work—an extremely important matter if you are forced to study without a teacher.

Anson K. Cross, who has used much this same method for many years in art classes under his instruction (and reports astonishing results), has perfected a special glass, arranged, I believe, with a spirit level, as well as lenses to train one's color perception.

CHAPTER VI

LINE: MORE ABOUT OUTLINE DRAWING
Some First Comparisons of Standard Media

AS YOU sketch away at your objects, carry-ing out the instructions of Chapters IV and V, steal a few minutes now and then in order to gain at least a speaking acquaintance with some of the more common drawing media. Purchase a few sticks of charcoal, several types and grades of pencils and crayons, also a pen or two, a brush, some drawing ink, a tube of black water-color, and a number of kinds of paper. Our later pages, Chapters VIII to XIV, reveal more def-inite selections.

If you hesitate to tackle so many media at once, pick a single one—the pencil, perhaps—and for a time confine your efforts to that. Don't get the foolish notion, though, of at once specializing in one medium. Instead, ground yourself, without too much delay, in at least the four or five media which are in everyday use. If eventually you decide on specialization, that's another matter. It is perhaps wise to stay away from color at present, only because it involves many factors which might prove confusing along with all the rest.

With your selected materials at hand, see how many kinds of lines and tones you can produce.

Line. You will soon discover that some media, such as the pen, pointed pencil, and fine brush, are at their best for linear work; others, in-cluding charcoal, soft crayon, and the large brush, are better for producing larger areas of tone. We place our present emphasis on the former, as they are well suited to outline draw-ing, which is our next consideration. Any line practice which you get has a double value, for not only are many shapes bounded or subdi-vided by outline, but in some media, such as the pointed pencil and pen, a majority of tones are built up of individual strokes.

Be sure to draw many lines side by side for comparison, somewhat like those in Figure 14. These were done on illustration board; use sev-eral different papers. Note here that an attempt was made to smooch each stroke at its right ex-tremity. You, too, should try smooching, to see

how well each medium resists rubbing. Media with poor resistance require "fixing"; see page 28.

As a further similar exercise, it is extremely interesting and profitable to take one instrument at a time (such as the pen), and ascertain how many different kinds of lines you can make with it. When you have exhausted your ingenuity, examine reproductions of illustrations for fur-ther suggestions. You'll find an endless succes-sion of strokes, long and short, wide and narrow, straight and curved, solid and broken, firm and shaky, bold and timid. Copy some of them.

Outline Drawing. Now you are ready to at-tempt drawings of various subjects in carefully studied outline. You have doubtless discovered, if you have undertaken to draw objects, that a single kind of outline is not enough to express all types with satisfaction. A line which does for bounding a smooth, shiny surface, for instance, is far from ideal for one rough and dull. If the right type of line is used, outline drawing, which we have pointed to as affording a natural and easy way of representing form, becomes a most expressive way as well.

Reference Material. Incidentally it would be a fine thing for the student, perhaps at this time, to start an organized collection of all sorts of reproductions of drawings, searching from day to day for the types particularly applicable to his current work. Outline drawings offer a logi-cal beginning.

Plate 3. In view of the ready availability of much excellent material of this nature, I offer only this one page of examples—just enough to make clear a few pertinent points. Though my drawing is in ink (this lending itself so gra-ciously to the purpose), the same suggestions could be adapted to other media with little trou-ble. Pencil is perhaps even more sympathetic.

Most of these sketches need no text, though their notes should be carefully studied. Let me jump to Sketch 8, for this expresses a most im-portant point, which is that outline need by no

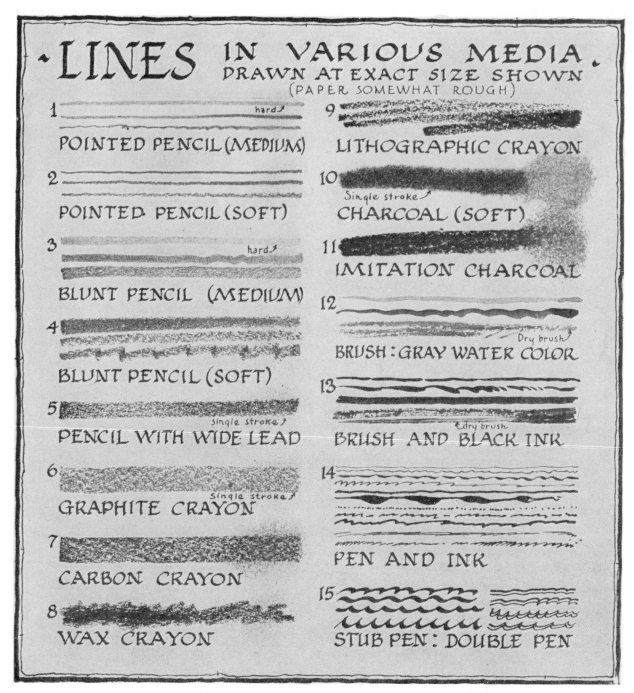

FIGURE 14

ONE SHOULD EARLY START EXPERIMENTING WITH SEVERAL MEDIA
Some are ideal for line; others are better for tone

means be continuous. Memorize and try to apply the advice "Practise the art of omission." This thought is again exemplified by the word "Tea" in Sketch 5. Often, as here, the lines which are omitted are on the side towards the light. Observe, as other points of value, the accents in Sketch 7, and the enrichment they cause; likewise the effect of roundness imparted by the

graded strokes in Sketch 6. This entire sheet, incidentally, hints that as your experience increases, you should still further vary your subjects.

Before you leave the matter of outline, try all sorts of applications, using various media. The wide points, such as charcoal, are at their best on drawings of considerable size. It is well to

PLATE 3 ·LINE: OUTLINE DRAWING·

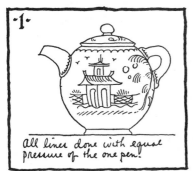

·1· All lines done with equal pressure of the one pen.

UNIFORM (1 WEIGHT)

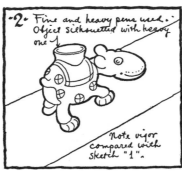

·2· Fine and heavy pens used. Object silhouetted with heavy one.

Note vigor compared with Sketch "1".

UNIFORM (2 WEIGHTS)

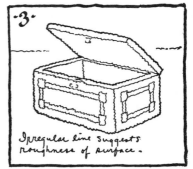

·3· Irregular line suggests roughness of surface.

COMPLETE: IRREGULAR

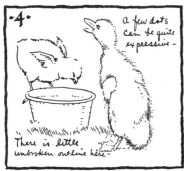

·4· A few dots can be quite expressive.

There is little unbroken outline here.

BROKEN: SUGGESTIVE

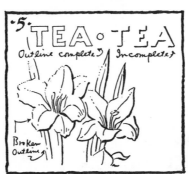

·5· TEA · TEA
Outline complete. Incomplete.

Broken Outline.

SHADOW SUGGESTED

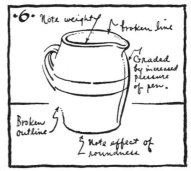

·6· Note weight. Broken line.

Graded by increased pressure of pen.

Broken outline.

Note effect of roundness.

GRADED IN WIDTH

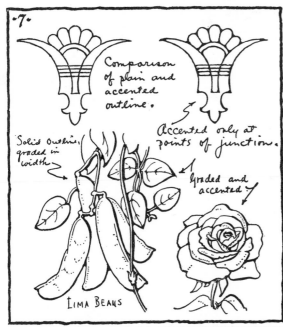

·7· Comparison of plain and accented outline.

Accented only at points of junction.

Solid outline, graded in width.

Graded and accented.

LIMA BEANS

ACCENTED AT INTERSECTIONS

·8· A·L·G

Observe frequent breaks.

Practice the art of omission!

·G·

GRADED · BROKEN · ACCENTED

OUTLINE OFFERS A NATURAL AND EXPRESSIVE MEANS OF REPRESENTATION
Numerous drawings should be made in a variety of media

experiment with sharper points first. Why not start by relining some of your earlier object drawings in pencil? Plate 1 offers a few suggestions. Note at 3, for instance, how the lines have been graded in weight to make the object seem more real. See how the table line fades behind it, giving a feeling of distance and detachment.

The rear inner corner of the box does the same thing, the nearer upper corner being more heavily outlined to bring it forward.

Outline is by no means used only by itself. See Plates 5 and 6. This is one reason, and an important one, why you must try to gain a good command over it.

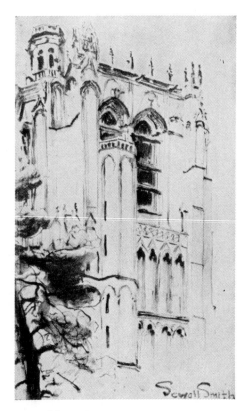

DRAWN BY SEWALL SMITH

CHAPTER VII

VALUE, COLOR AND TEXTURE REPRESENTATION
With Emphasis on Light, Shade and Shadow

IN THE opening paragraph of Chapter IV it was mentioned that in representative drawing one or more of the following factors must always be considered: 1, representation of form; 2, representation of tones of light and dark; 3, representation of color; and, 4, representation of texture. Having disposed of the first of these, I shall now proceed, in proper order, with the other three.

Values. All the tones of white, gray, and black which objects reveal, or which the artist produces, are called "values." Their representation is an extremely important matter. You *must* master values. I wish every student could be made to realize that the effect of a majority of drawings such as we have in this book largely depends on their values. It is far more important, and more difficult, to master values than to develop technique.

In art circles one is constantly hearing this word "values." It is used in many ways. Sometimes, in speaking of a drawing or painting, we say, "this area is *out of value*," meaning it is too light or dark in relation to the whole. Contrarily, if every part of a drawing is properly keyed to the whole and to every other part, the drawing is called "good in value," or simply "in value." Again we say, "these values are well composed." Entire drawings can often be made harmonious or inharmonious by the proper or improper adjustment of the values of their component parts.

Just now, however, we have in mind a somewhat more restricted meaning of the word, for our present thought is to discuss the values of individual objects and their immediate surroundings. It is by their representation that the natural relief or solid form of such objects—their modeling—is mainly expressed.

Values of this kind fall roughly into two classes. First, we have what may be called "local" or "natural" values. For an example see Sketch 3, Plate 4, where the jar is white, its pattern black, and the background of two tones of gray. Secondly, we have values due to light and its resultant shade and shadow. The sculptured stone at 4, Plate 4, is white, yet it reveals, wholly because of its shade and shadow, a great variety of tone. Usually in objects we find these two types of values combined, and in drawing treat them as one (see 5, Plate 4).

Color. Colored objects have their values, too, for value, like hue and intensity, is a quality of color. Color, in such drawing as this volume stresses, must be interpreted entirely in terms of white, gray, and black, much as it is represented in the typical photograph. We shall have more to say of it a bit later. Enough now to make clear that when we "shade" the average object we represent both its local values, including those of its colors, and its values of light, shade, and shadow.

Project and Aim: Subject. I suggest, as a first project in value study, that you draw in light and shade a simple object, colorless or nearly so, and rounded in shape. If available, a plaster cast is excellent; a white vase or pitcher is also fine. Simple geometric solids like those at 1, Plate 5, afford an ideal starting point. The primary aim is to learn to see the values correctly and to represent them on paper as naturally as possible.

Preparation: Materials. Arrange your equipment as for form representation, described in Chapter IV. Place the selected object on the object stand, shifting it, in relation to the window, until its light, shade, and shadow are simple and effective. See Figure 1, page 4. In this, your view-finder should be of help.

Among materials, pencil, charcoal, crayon, and wash are doubtless the best for the sort of work we now plan. For your immediate need I suggest a medium pencil; the exact degree will depend on the surface of your drawing paper.

Construction. Block out the proportions of your subject as demonstrated in Chapter IV. Don't bear on enough to crease the paper, for you cannot build good tone over creases. Bring

PLATE 4 · TONE · VALUES · LIGHT & SHADE ·

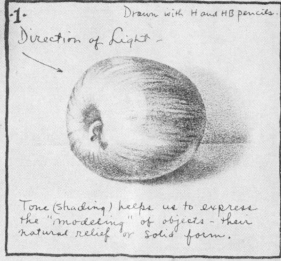

·1·

Drawn with H and HB pencils.

Direction of Light ·

Tone (shading) helps us to express the "modeling" of objects - their natural relief or solid form.

DARK TONE ON WHITE PAPER · ·

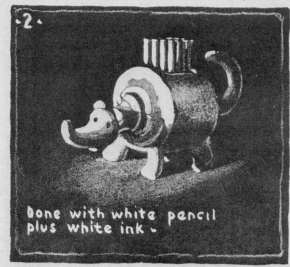

·2·

Done with white pencil plus white ink ·

LIGHT TONE ON DARK PAPER ·

·3·

Some values are "local". The jar is white, its pattern black, and the background gray.

·4· Carved stone

Many values are due to light and its resultant shade and shadow.

·5·

Usually, in drawing, no distinction is made between types of values.

·6·

A drawing may be done wholly in outline

·7·

or, as here and at "1" above, entirely in value.

·8·

A.L.G.

Often both outline and tone are employed.

SOME TYPES OF VALUES AND HINTS ON THEIR USE · · · · ·

VALUE MASTERY IS FAR MORE IMPORTANT THAN DEVELOPMENT OF TECHNIQUE

Perseverance at this point will be amply repaid later

PLATE 5 · PLANES, REFLECTIONS, ETC. ·

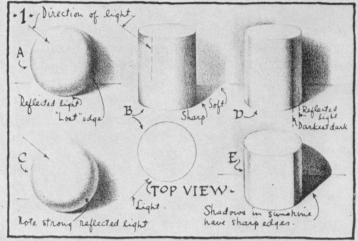

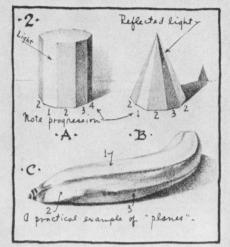

LIGHT AND SHADE ON CURVED SURFACES ·ON PLANE SURFACES··

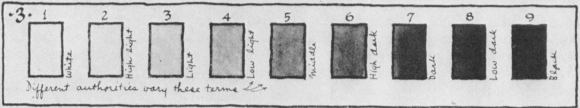

A VALUE SCALE ·· LIGHT AND DARK ARE MEASURABLE···

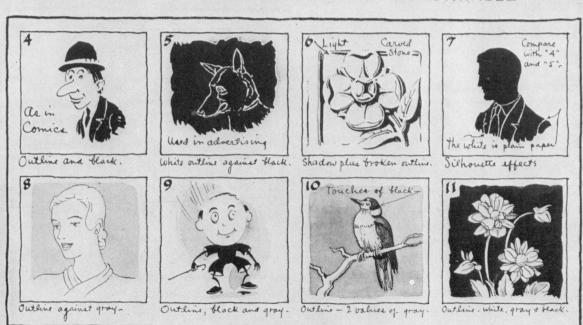

CONVENTIONAL USES OF OUTLINE PLUS VALUES OF GRAY AND BLACK

THE STUDENT SHOULD GIVE PARTICULAR ATTENTION TO NATURALISTIC EFFECTS

As time goes on he can work in a more conventional manner

your drawing to second or third stage, finally softening it with the eraser until it stands as a faint but accurate guide for the shading.

Analysis of Light and Shade. Before you draw farther, spend a few minutes trying to decide what you need to accomplish and how to go about it. Note the direction and intensity of the light, as these have much to do with the

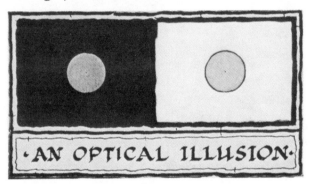

FIGURE 15

shape and quality of the shade and shadow areas. Compare the relative lightness and darkness of the tones which your object reveals.

Optical Illusions. Values sometimes are able to fool the eye. The deeper tones in light objects, for instance, often appear, through contrast, much darker than they really are. Figure 15 shows one way in which the eye can be tricked. The two gray disks are equally dark, though they do not appear so.

Visual phenomena of this nature follow rather definite laws, such as the so-called "laws of simultaneous contrast." There is the law, for instance, that "tones are modified in appearance by their proximity to other tones," and a second one, just exemplified in Figure 15, that "light tones in direct contrast with dark tones look lighter than when contrasted with light tones." We also have its converse, "dark tones in direct contrast with light tones look darker than when contrasted with dark tones."

This entire matter is so interesting that you may wish to investigate it farther; if so, turn to such books as *The Language of Color*, by M. Luckiesh (D. Van Nostrand Co.), and *Color in Everyday Life*, by Louis Weinberg (Moffat, Yard and Co.). Let me add that there are many illusions of hue as well as of value. Lines fool us, also; see Figure 16, described in Chapter XI.

Value Scale. Perhaps the best way for one, as he draws, to avoid being badly tricked as to the degree of light or dark in a given area, is by holding at arm's length, for comparison with it, a piece of white and a piece of black paper. The two can, of course, be pasted together; peek-holes through them are helpful. Sometimes, for use in like manner, a "value scale," carefully prepared on a strip of paper or cardboard, on the order of that at 3, Plate 5, proves a welcome aid. Note in this particular scale that nine values are shown, including white, black, and "middle."

"Shade" and "Shadow." There seems some confusion as to the relative meanings of these words, so let me explain my use of them here by quoting from H. W. Gardner's book on shades and shadows: "*Shade:* When a body is subjected to rays of light, that portion which is turned away from the source of light and which, therefore, does not receive any of the rays, is said to be in shade. *Shadow:* When a surface is in light and an object is placed between it and the source of light, intercepting thereby some of the rays, that portion of the surface from which light is thus excluded is said to be in shadow."

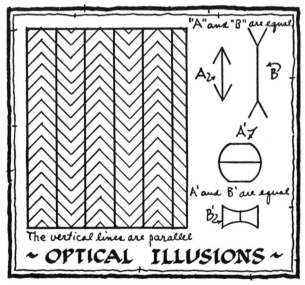

FIGURE 16

These terms are often used loosely, "shadow" being applied to what is, strictly speaking, "shade," and *vice versa*.

Shade: Shade Edges. When rendering objects in the literal way which I now have in mind, it

is not enough to get the values right: the edges of shade and shadow areas must receive careful attention. Shade on curved surfaces usually seems to merge so gradually with the light that there is no definite separating edge or line of demarkation. Nor are the shade areas uniform in tone; on the contrary, they grade from value to value as indicated at 1 (A), Plate 5. Plane surfaces, however, are usually more simple in value and, at their junctions, show definite contrasts of tone against tone, as indicated at 2, Plate 5. Objects which combine curved and plane surfaces ordinarily reveal both definite and indefinite shade edges.

Reflected Light. Though often, as on the cylindrical surface at B, Sketch 1, Plate 5, there is a gradual change in value from light to dark, at other times, particularly when objects are smooth, light reflected from such surfaces as the bottom or back of the object rest alters this simple gradation. In Sketches A and C (which were drawn from actual spheres) reflected light modifies the tone until it grades from light to dark and back to light again. At C this reflected light shows strongly at a point opposite the source of light—a very common condition—and at A, at the bottom of the sphere.

This is but one of the many modifications of tone due to reflected light, which in some manner affects almost every subject.

Lost Edges. In this latter example (A), the edge of the sphere a bit above and to the right of this reflection is almost lost in general gloom. When in one's subject an edge thus merges with shadow or some other tone it should be so drawn, unless there is a particular reason for emphasizing it. It is customarily well to suppress reflected light somewhat, also, in the interest of greater simplicity. Beginners are inclined to over-emphasize comparatively trivial things. If this is done in shade and shadow areas or like places where subordination would naturally be expected, these things may detract from more vital elements. The old masters seldom fell into this error. Study their paintings and you will generally find skillful subordination of reflections and other inconsequential details; likewise you will often discover shade, shadow, and background areas so merged as to form no distinct or distracting lines of junction.

Shadow: Shadow Edges. Shadow, like shade, varies in value and quality of edge. The shadows which appear the darkest and seem to have the sharpest edges are ordinarily those found in open sunshine. The brighter the light, the darker, through contrast, is the effect of shadow (see E at 1, Plate 5). Even in sunshine, however, there is variety in the values and edges of shadows. Shadows which fall on dark surfaces appear correspondingly darker than those on light, and the shorter the distance from an object to the surface receiving its shadow, the sharper the shadow's edges. As I write, I can see a clothes-post casting its shadow across bare ground and flagstones. The shadow on the rather dark naked earth looks darker than on the lighter stones. The shadow edges, quite sharp throughout, seem particularly clean-cut near the intersection of post and ground. Because of diffraction, they blur slightly as they become more distant.

Indoors, light is softer than outdoors, as a rule, and customarily much diffused. Not only does it spread in all directions from any given source, such as a window, but as each window in a room serves as a separate source, an object, in addition to showing wide diversity in its own tones, often casts several shadows. The many reflecting surfaces in interiors—floors, walls, ceilings, etc.—add to this complication. In short, though contrasts indoors are seldom as strong as out, interiors show greater variety and complexity of light, shade, and shadow. It is because of this that I insist, for the beginner, on a suitable working place where light can be somewhat controlled, and recommend the selection of comparatively simple objects, posed to produce simple effects. Even then one's problems are hard enough.

Returning to the matter of shadow edges, it is a general principle, particularly indoors where diffusion is so marked, that if an object is rounded, as is our sphere at 1 (A), Plate 5, its shadow edges are softer than where there is more definite division between light and shade, as in the case of the pyramid at 2 (B). At B, Sketch 1, and again in Figure 17, we have a demonstration of the fact that shadow edges, even when sharp near the object, often grade to softness as distance increases.

Shading. When you have studied your own object with all these things in mind, you are ready to begin your shaded work. As my thought is to have you represent the values of your object as accurately as you can, within reason, avoiding any display of tricks of technique, your drawing, when finished, should have much the appearance of those at 1, Plate 5, or that at 1, Plate 4. To get this effect, which takes considerable patience even for the trained man, sketch, very faintly, the boundaries of all light and dark areas (if you can discover them), and, penciling a pale foundation of tone within these boundaries as a guide, build your values gradually upon it, going over the same surfaces as many times as necessary. Keep a fairly sharp point on

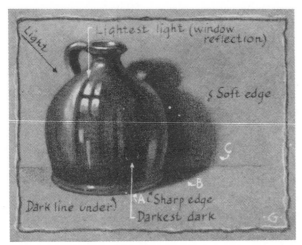

FIGURE 17

your pencil: you need not lift this from the paper, but merely push it back and forth in all directions until the desired effect is gained. Don't complete an area at a time, but jump from one to another, advancing the entire drawing as a unit. Leave white paper, if you wish, for the lightest tones.

Preliminary Work. Some students rather easily acquire the knack of laying smooth tone; some do not. Don't expect good results in a minute. If you experience much difficulty, practise for a while on scrap paper, attempting both flat and graded tones, and varying your paper and pencil, as well as pencil position. Don't deliberately smooch your work at this time; you *must* learn to build good tone, no matter what short cuts you may practise later. Give particular attention to the handling of soft edges.

Erasing: Lifting Tone. Eraser manipulation is an art in itself. One learns by degrees the different tricks his various erasers will perform, not only for erasing given areas entirely, but also for picking out highlights, lights around the edges of vignetted drawings, etc. An entire pencil tone can be lightened or "lifted" as desired: press kneaded rubber against it firmly, and when you remove it you will find it has considerably reduced the tone without smearing it. Repeat the operation as many times as proves necessary. Tiny dark specks in otherwise smooth tone can often be corrected by the same means.

Testing: Precautions. Many of the instructions I have given for form representation apply as well for present work. From time to time as your drawing develops set it beside the object and compare the two, area by area and edge by edge. And don't forget to rest the eye now and then by turning to something else. Try to finish each drawing before the light has greatly changed.

You will soon learn how easily pencil tones smudge. Prevent this, if possible, keeping extra paper between hand and drawing. If you do discover soiled spots, erase them at once. Abhor untidiness.

Fixatif. When your first drawing is completed to your satisfaction, spray it with fixatif to prevent damage by rubbing. A bottle of fixatif and an atomizer for applying it can be secured at small expense; one soon learns from experience how much is needed. As the fixatif is a sort of shellac or varnish, care must be taken not to blow it around promiscuously.

Further Projects. Now make several other studies of like subject and handling. If it is hard for you to judge values and edges you may find the following suggestions useful, especially if a subject is at all complex, as when several objects are grouped.

Numbering Values: Lettering Edges. First, when a drawing is ready for shading, search the subject for the lightest spot you can find; locate this on your drawing and faintly number it "1." If several are alike, number them each "1." Next locate on your drawing, as "9," the darkest spot or spots which your subject reveals. A value halfway between would be "5," for I am adopting the notation shown on the value scale

at 3, Plate 5. Number all the important values in this general manner.

Now try to discover the sharpest edge of shade or shadow and mark it "A." Mark others of like character the same way. Mark the next softer edge or edges "B," the next "C," and so on until you reach the softest one. Five or six letters will doubtless serve your purpose. Devise some system of notation of your own, if you prefer.

With this marking reasonably complete, go ahead with your shading, erasing each number or letter in turn when you are through with it. You don't need to do all this on many drawings. The main point is that the employment of some such method for a few times will force you to observe tones and their edges accurately; hence you will learn to draw them properly.

A New Project. When you have drawn several objects in which curved surfaces predominate, try some with plane surfaces such as are shown in Sketch 2, Plate 5, and in Plate 6. Plane surfaces are easier to do than curved, as a rule, as the tone areas are simpler and more definitely bounded. The general method is the same.

Objects combining plane and curved surfaces also afford excellent practice. Still others are a sort of compromise; see, for example, the banana in Sketch 2, Plate 5. Here the surfaces, though slightly curved, are rather plane-like, definite "edges" being visible where they meet. The human figure exhibits much this same type of surface, suggestions of planes being distinguishable despite the general roundness of form. In figure sketching, when you come to it, you must be ever on the alert for these suggestions of planes, no matter how faint they may be, for if detected and correctly located in your drawings, and in some cases even exaggerated in distinctness, more vigorous likenesses will be obtained.

Color Interpretation. After you have attempted a number of objects which are colorless, or nearly so (and these should include things both light and dark and regular and irregular in form), turn to colored objects. Sketch 1, Plate 4, shows a typical pencil study of a subject but a step removed from the plain sphere already discussed. No new suggestions seem necessary. Obviously you must now try to interpret definite hues in values of white, gray,

and black. You are greatly handicapped, of course. In the case of the apple there is no way to make clear whether it is red or green. If you do your shading well, however, the esthetic sensibilities will not be disturbed by such free translations as your medium enforces.

Black Paper: Tinted Paper. This apple drawing, together with Sketch 2 beside it, was made with the idea of introducing quite a different thought. Most so-called "black-and-white" drawings (this term including all such illustrations as we present in this volume) are done in dark media—pencil, ink, crayon, charcoal, etc. —on paper which is white, or approximately so. The white paper is left untouched for the lightest values and the darker ones are represented by tones of gray or black.

In a sense this is working backwards. In the darkness of night, objects are invisible. In the morning they are revealed to us because light falls upon them. The light parts are usually those which are turned towards the source of illumination; shade and shadow exist because certain areas are cut off from the light.

Is it not logical, then, to imitate this process of Nature, by working on black paper, as in Sketch 2, Plate 4, drawing or painting light values with white ink or paint (diluted for the grays) on such areas as would normally be exposed to the light? Certainly effects obtained in this way can be surprisingly natural, in addition to which they are quickly done, the method obviating the necessity of toning large areas of white paper.

It can be argued, of course, that an excess of black is as bad as an excess of white. This is perhaps true. The method does have the advantage, however, of forcing the eye to the essentials of the object depicted. Likewise the brilliant highlights of Nature can be more closely approximated.

Perhaps a compromise method, such as is shown in Figure 17, is still better. It is seldom that objects in Nature, or their surroundings, are either black or white; they lie somewhere between. One of the quickest and best ways of representing many subjects, therefore, is by selecting a gray or brownish-gray paper, letting this stand for the middle values, adding the lights, on the one hand, and the darks on the

PLATE 6 · VALUES · COMPARATIVE MEDIA ·

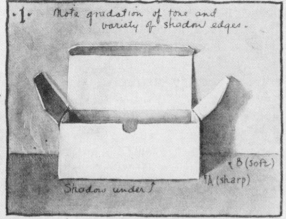

·1· Note gradation of tone and variety of shadow edges.

· B (soft)
· A (sharp)

Shadow under ↑

WASH (LAMP BLACK WATER COLOR)

·2· the background was "smooched".

CHARCOAL (PENCIL FORM)···

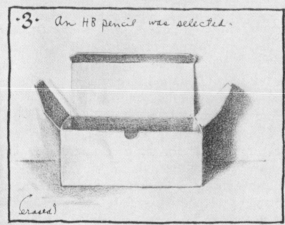

·3· An HB pencil was selected.

(erased)

PENCIL (TONE-MASS SHADING)·

·4· Pencils - HB and H.

PENCIL (LINE)···

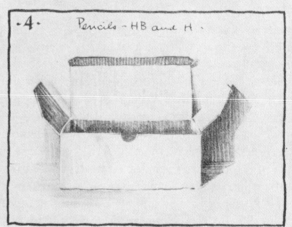

·5· Much of the paper is white.

The lines follow surface directions.

PEN AND INK ···

·6· a number 3 brush was used

A.L.G.

BRUSH AND INK ···

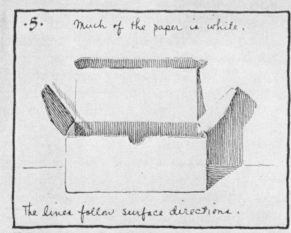
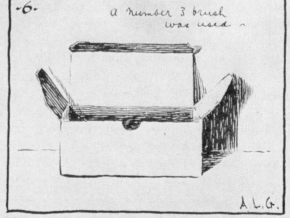

PROBLEMS COMPARING A NUMBER OF MEDIA ARE OF EXCEPTIONAL BENEFIT
Each medium has its own possibilities and limitations

other. Note in Figure 17 that the highlights seem brighter and more natural than they could be made to appear, at least without great effort, on the competing surface of white paper, yet not so artificially glaring as in Sketch 2, Plate 4. The shadow effect is convincing, also.

A Further Exercise. Let me strongly urge you to do some projects on black or neutral paper, particularly the latter. If a gray is unobtainable, a colored paper will do, if dull in tone. Figure 17 was drawn on paper such as is used by printers for covers of booklets, etc. A black wax pencil was employed. The highlights were painted with Chinese white. Note the "lightest light," the "darkest dark," and the variation of tones. Observe the different shadow edges and their gradation from sharpness to softness, as at A, B, and C.

Charcoal, Crayon, Etc. Now comes the time to make light and shade drawings in such media as charcoal, crayon, and wash, all of which serve the purpose admirably. You should first read, in the following pages, the technical suggestions on each. Practically all the instruction so far offered applies as well to one medium as another.

Comparative Studies. Plate 6 shows the development of a project such as the student could advantageously undertake, once he has acquired a bit of experience with the media involved. Sketch 1 was done with considerable care in lamp-black water-color, an attempt being made to gain as truthful an appearance of the object as possible in a reasonable time; observe that the effect is somewhat photographic. In Sketch 2 the purpose was the same, charcoal in pencil form being substituted for the wash. Both these media lend themselves well to this sort of subject and treatment. The remaining drawings need no explanation. They are offered in demonstration of the fact that values can frequently be simplified or otherwise changed with little or no detriment to general effect. One adapts his treatment to medium and purpose. It would be unnecessarily tedious to represent all the values shown at 1 with the pen employed at 5, while the brush and black ink used at 6 would be ill fitted to this undertaking.

Trial Sketches. When you draw with any thought of technique in mind, it usually pays (even when pencil is the medium selected) to make first a small trial sketch, perhaps on the margin of your paper. This forces you to do much of your thinking ahead of time, especially as it concerns your scheme of values; with such work planned you can then give added attention, on your final study, to the technique.

Memory Sketches: Time Sketches. You should make memory drawings from time to time, and quick sketches to develop your speed.

Other Uses of Values. Though for all this first practice I urge you to try to interpret Nature's values with reasonable fidelity, let me remind you that artists do not always use this same approach. In many drawings values are employed with extreme freedom, the artist pleasing his own fancy. The small sketches from 4 through 11, Plate 5, illustrate a few of many possible applications of this thought. Hunt for others elsewhere, and gradually apply some of them. Note especially the use of outline and tone in combination, as in Sketches 8 and 10, endless variety being possible. Plate 4 offers at 6, 7, and 8 additional suggestions bearing on this matter.

Texture Representation. Now for the last leading topic in our present group, though I shall not say much on this subject, as one needs to develop considerable facility in technique, as discussed in later chapters, before he can cope successfully with the many kinds of textures which the artist is called upon to express. I do want you to realize, however, how important the subject is.

Theoretically, if one represented form, values, and colors correctly and completely, textures would take care of themselves. In practice, however, one must give marked attention to textures if he hopes to do them well. Half the battle, in representative drawing, is to show whether surfaces are rough or smooth, dull or polished, old or new. You need to learn every trick you can. You must always select the right paper for the subject, as well as the right method and medium.

Some subjects, like the sphere and cylinder at 1, Plate 5, vary greatly in effect according to whether they are of wood, plaster, glass, metal, or other material. Glass or polished metal, for example, usually mirrors all sorts of reflections, both light and dark; plaster is com-

monly dull. One must allow for all this in his rendering. Note how the lines used in representing the different surfaces in Plate 16 differ in character, yet these subjects are relatively simple and the drawings by no means exceptional. You should try all such things as how to make glass shine; how to make felt appear rough; how to make wood look dull or polished. For this practice there is no better type of subject than such objects as we have discussed—the ordinary things found about the house (especially when battered and worn). So, as you proceed with the

later problems designed in particular to acquaint you with a variety of media and techniques, utilize, from time to time, these humble subjects.

Other kinds of subjects should not be wholly neglected, of course. They are all good, so whether one's aim is to represent form, value, color, or texture, he should not concentrate for too long on one type of thing. But the point is to stick to simple things for awhile, so harder subjects, when you finally turn to them, will not prove discouragingly difficult.

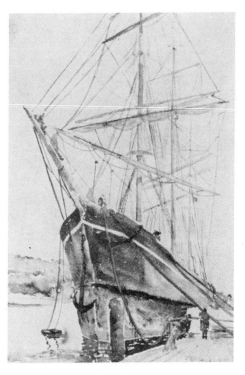

DRAWN BY SEWALL SMITH

CHAPTER VIII

PENCIL DRAWING FULLY DESCRIBED
Fine Line, Broad Line and Solid Tone

I SHALL now offer a number of chapters, each designed to give instruction in the use of some particular medium at present in high favor. The pencil offers a logical starting point. First a word regarding materials.

The Pencil. The humble graphite pencil has rightly been called the most versatile of all instruments of drawing. Truly it is remarkable. It is relatively cheap to buy, as is the equipment for use with it. It is available almost everywhere, and can be carried about conveniently. It comes in many degrees, ranging from extreme hardness to extreme softness, and capable of a surprising variety of line and tone. It holds its point well. It is economical; if used in a pencil-holder such as the draftsman employs, it is "good to the last inch." It marks on almost any surface; by varying the paper numerous effects are obtainable. Pencil drawings do not buckle as do those done in wash. Best of all, they can usually be changed or corrected easily at any time.

The pencil is especially good for early practice, not only on account of its amenability to correction but also because the beginner's long familiarity with it as a writing instrument makes its mastery for drawing just that much easier. Yet its use is not limited to elementary work. Either alone, or in combination with other media, it is well fitted to the making of many kinds of highly finished drawings in a wide variety of techniques, while equally valuable for quick sketching and preliminary study. It is splendid, too, for foundation lines or layout work for drawings in pen, ink, wash, etc.

In addition to the regular graphite pencils, there are others adapted to special purposes. See Plate 11. For color work, excellent pencils are available in a full gamut of hue.

Pencils have faults, of course. The softer leads break all too easily, and the shine of pencil work is not wholly pleasing. Unless sprayed with fixatif, pencil drawings rub badly: it is no simple matter to keep the paper clean. The pencil lead of customary size, when compared with charcoal or wash, proves ill adapted to covering large surfaces, though if supplemented with graphite sticks like that at 1, Plate 13 (the square stick), this criticism no longer holds.

Grades. Most makers offer seventeen degrees; you can limit yourself, for freehand purposes, to five or six, and even these need not all be employed on a single drawing. One's choice is usually controlled largely by paper surface and intended technique. At 1, Plate 7, a typical selection for freehand work is shown; the F and B are also excellent. For preliminary construction, F and HB are popular: the B and 2B are good for all-around purposes.

Identification. Most pencils are plainly stamped with letters or numbers indicating their degree. Some such identification is necessary, as the artist often uses several on a single drawing, changing frequently from one to the other. Be sure not to remove such marks in sharpening. In some makes they are on every other face, so, regardless of a pencil's position, its degree can be seen at a glance. This is most convenient. If a pencil is not so marked, mark it yourself. Some artists invent systems of identification of their own, perhaps cutting notches or dipping the pencil tips in colors (see the sketch at 1, Plate 7).

Refillable Pencils. Many prefer the adjustable pencil-holders with separate leads. The first cost is greater, but they are more convenient.

Paper. There are plenty of excellent papers on the market, choice being mainly a personal matter. Buy several and test them thoroughly. You will soon develop your own preferences. I have already spoken of sizes.

Erasers. You require two or more, including one of the ordinary red or green type (not ink) and a soft one. Art gum and soft white rubber are popular. Kneaded rubber is especially liked (see Figure 18).

PLATE 7 · THE PENCIL · FIRST PRACTISE · ·

·1· PENCIL GRADING·

HARDEST 9H, 8H, 7H, 6H, 5H, 4H.
HARD 3H, 2H, H, F.
MEDIUM HB, B, 2B, 3B.
SOFT 4B, 5B, 6B, (7B rare).

a good selection

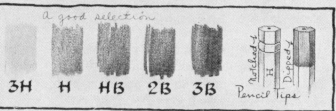

3H H HB 2B 3B Pencil Tips

AT LEAST THREE GRADES OF PENCIL ARE ESSENTIAL · · ·

·2· THE SHARP POINT·

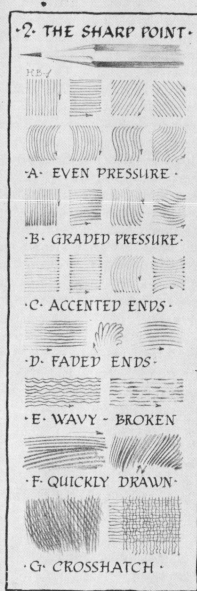

HB.

·A· EVEN PRESSURE·

·B· GRADED PRESSURE·

·C· ACCENTED ENDS·

·D· FADED ENDS·

·E· WAVY · BROKEN·

·F· QUICKLY DRAWN·

·G· CROSSHATCH·

PRACTISE MANY STROKES·

·3· EXAMPLES OF FINE LINE WORK· ·

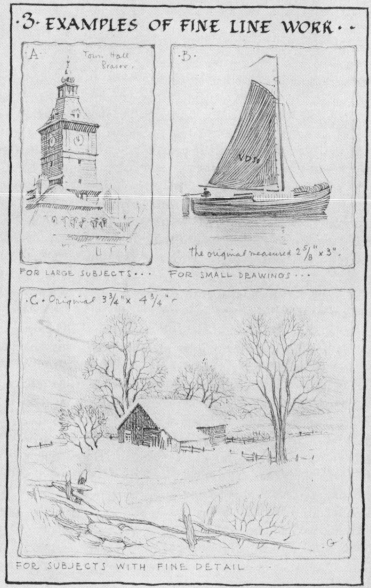

·A· Town Hall Brasov.

·B· VD50

the original measured 2⅝" x 3".

FOR LARGE SUBJECTS · · · FOR SMALL DRAWINGS · · ·

·C· Original 3¾" x 4¾" r

FOR SUBJECTS WITH FINE DETAIL

THIS PREPARES ONE FOR PEN DRAWING · · ·

THE LEAD PENCIL OFFERS THE STUDENT AN IDEAL STARTING POINT

It is generally rated as the most versatile of all media

Erasing Shield. A draftsman's shield (Figure 18) is necessary. It permits the correction of limited areas without disturbing the surroundings.

Knife: Sandpaper Pad. You require a knife for cutting away the wood of your pencils, and a sandpaper pad for pointing their leads. See Figure 18.

Your drawing board, thumbtacks, and fixatif, already described, complete the essential equipment. A soft dust-brush is convenient.

The Sharp Point. In view of our earlier instructions, the sharp point seems to offer a natural introduction to pencil drawing. Point your pencil as at 2, Plate 7. The F, HB, and B are perhaps the best grades for this sort of thing. For very faint lines where firmness is needed,

FIGURE 18

a much harder pencil, such as the 3H, is splendid. Use hard pencils sparingly, however. Never bear on so as to groove the paper conspicuously; such technique suggests too much muscular effort.

Practice Strokes. As a preliminary, make many strokes on the order of those at 2, Plate 7. Do strokes long and short, straight and curved, even, graded, wavy, and broken. Build tones by combining strokes of various types in different ways.

Finished Drawings: Subjects. When you attempt finished work you will discover that some subjects cannot be done to as good advantage with this sharp lead as with a blunter one. For smooth, simple objects (see Plate 8) the blunt point is rapid and expressive. Buildings, on the other hand, with their many courses of bricks

and stones, together with other fine details, often call for a sharper point, especially if at small scale. At 3 (A), Plate 7, we have a fairly large and complex subject drawn at small size; the sharp pencil was ideal for the purpose. The landscape at C, with its lacy trees, also seemed to require the etching-like treatment accorded it. The Dutch boat at B could be drawn as well, and more quickly, with a wider point. So, in picking your subjects, use common sense as to what pencil or technique is appropriate.

Pen and Pencil Related. A glance at the sketch at C should make clear that fine line pencil practice is the best of preparation for subsequent work in pen and ink. Incidentally, pen and ink reproductions offer many pointers applicable to fine line pencil work, the two having much in common. Values are usually simplified in both media, with considerable reliance placed on outline.

When working with the sharp point, one generally keeps practically all lines clean-cut and crisp, though not necessarily black. So sharpen your pencil frequently, remembering to wipe off the graphite particles. Strokes as a rule follow the directions of the surfaces which they represent. In the case of buildings, as at 3 (A), Plate 7, lines representing shingle and brick courses, etc., are frequently drawn to converge towards the vanishing points. In shadow tones, as under the cornice on the light side of the tower, the lines often slant in the general direction of the light. Lines with accented ends give sparkle.

Before we turn to the next subject, see pages 70 and 71 for typical fine line examples. Read the accompanying comments.

Medium Line Work. As the point of a pencil has a tendency to wear away rapidly, the fine line method, demanding constant repointing, seems somewhat forced or strained. A great deal of pencil drawing is therefore done with a medium point. This is usually well sharpened at first, but allowed to wear naturally until the wood is nearly reached. Not until then is it repointed unless a few fine lines or crisp touches are needed. Turn through our supplementary drawings and you will recognize that many of them were made with this medium point.

Broad Line Work. In recent years more and more artists have adopted a very blunt point,

PLATE 8 · THE PENCIL: BROAD LINE · · ·

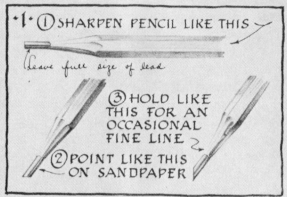

·1· ① SHARPEN PENCIL LIKE THIS

Leave full size of lead

③ HOLD LIKE THIS FOR AN OCCASIONAL FINE LINE

② POINT LIKE THIS ON SANDPAPER

POINTING THE PENCIL · · ·

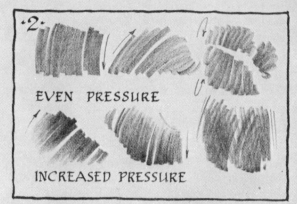

·2·

EVEN PRESSURE

INCREASED PRESSURE

TRY MANY PRACTISE STROKES · ·

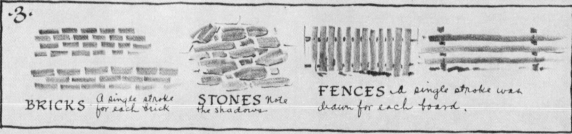

·3·

BRICKS *a single stroke for each brick*

STONES *Note the shadows*

FENCES *a single stroke was drawn for each board.*

SOME ELEMENTARY INDICATIONS · · ·

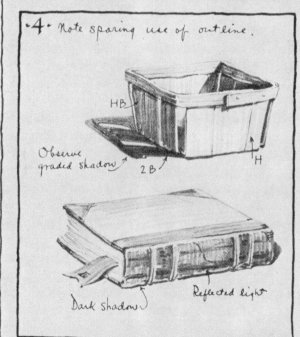

·4· *Note sparing use of outline.*

HB

2 B H

Observe graded shadow

Dark shadow *Reflected light*

STRAIGHT LINE OBJECTS · · ·

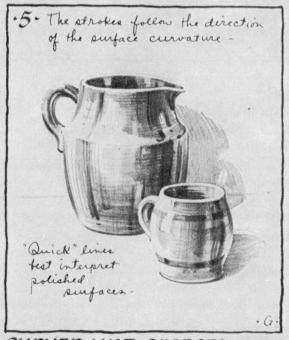

·5· *The strokes follow the direction of the surface curvature -*

"Quick" lines best interpret polished surfaces.

·G·

CURVED LINE OBJECTS · · ·

THE BROAD LEAD SAVES TIME AND PROMOTES SPLENDID RESULTS
It is suitable for either sketches or highly finished work

doing work somewhat like that in Plate 8. Such work has quite aptly been called "pencil painting" because of the brush-like appearance of the stroke and wash-like character of the tone. The pencil may be sharpened as at 1. This provides a point which gives a broad line, if held in the customary manner, but a fine line, as for occasional accents, if inverted. All four sides of the lead may be flattened, if desired, so its end forms an approximate square or rectangle, capable of a very even stroke or tone.

You should practise strokes on the order of those at 2, experimenting with different pencils until you find one which, with firm, even pressure, gives crisp effects like those shown. You cannot produce such results if you use too soft a pencil or too little pressure, or if your paper is too rough. Glance at Plate 9 to see to what extent paper surface controls appearances; as to pressure, note at 1 (A and B) how differently the 4H and 4B lines appear, though in this case on the same paper.

The indications at 3, Plate 8, further demonstrate what a practical instrument the broad lead is. Note the economy of method, very few strokes being used. Sketch 4, Plate 11, offers examples done with a still wider point.

In Sketches 4 and 5, Plate 8, we have typical object drawings in broad line, the few narrow accents having been added with the lead inverted. For large drawings it is sometimes convenient to have two pencils of each grade at hand, one sharpened for broad and the other for fine lines. Note here that the lines follow the surface directions. Three pencils were used on these drawings, as indicated on the berry-box sketch.

Whatever the size of one's point, he will learn to draw some lines slowly and some quickly. A halting, wavering line is often best for the representation of rough surfaces; contrarily, a quick stroke is the thing for smooth surfaces, especially if polished. See Sketch 5.

Solid Tone or Mass Shading: Values. Though a majority of pencil drawings are in fine, medium, or broad line, we have occasional examples, such as the apple sketch at 1, Plate 4, in what might be described as solid tone or mass shading, few separate strokes being distinguishable. Sketch 4, Plate 9, could also be classified

under this general heading. Scumbled work, demonstrated on this same sheet, is often of this type, too (see Sketch 3).

An advantage of mass shading over line work is that it usually results in a better relationship of values than is common where greater attention is given to individual strokes. Whether you draw in line or tone or a combination of the two, don't forget that values are more important than technique. Don't become so much interested in your handling of either lines or tones that you neglect to compose all your lights and darks as well as possible. As a rule be sure every drawing has some black, some white, and some gray.

One common mistake of the beginner is to break up his values needlessly. Though there are exceptions, it is a good rule that tones should be quite solid, regardless of the size of your point. Don't space your strokes too widely. Many of the best effects come when the larger areas of black and dark gray are merely interrupted here and there with tiny lights, to give interest and sparkle. In the same way the lights should be kept comparatively free of conspicuous darks. In general, avoid effects which show greater spottiness than do the objects represented. This also applies to most other media.

Erasing. In order to preserve crispness and cleanliness, erase as little as possible and, when you do erase, use your shield. Sometimes, to be sure, lights are erased without the shield—there are one or two near the center of the pitcher at 5, Plate 8—but in such case care must be used not to smooch the drawing. Don't forget that if a tone is too dark you can lift some of it by pressing clean kneaded rubber hard upon it, without rubbing. Always brush your paper lightly to remove the erasings; it is impossible to form perfect strokes over gritty dirt particles.

Scumbled Tones: the Stump. We have seen in Sketch 1 (A and B), Plate 9, that two grays of similar value, the first drawn with a hard pencil and the second with a soft, can vary greatly in effect. Note the wash-like character at A and the fuzziness at B, though the paper was the same in both instances. The hard pencil tone would not smooch easily, while the other, done with a 4B, would.

Advantage is often taken of the fact that soft

PLATE 9 · THE PENCIL: TEXTURES · ·

·1· THE TORTILLON STUMP

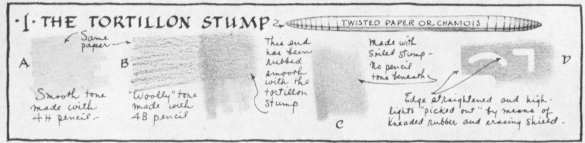

TWISTED PAPER OR CHAMOIS

A — *Same paper*

Smooth tone made with 4H pencil.

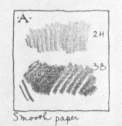

B — "Woolly" tone made with 4B pencil

This end has been rubbed smooth with the tortillon stump

Made with soiled stump — No pencil tone beneath

C

D

Edge straightened and highlights "picked out" by means of kneaded rubber and erasing shield.

"SCUMBLED" TONES HAVE THEIR OCCASIONAL USES · · ·

·2· THE PAPER SURFACE IS HIGHLY IMPORTANT · · ·

·A· 2H 3B Smooth paper

·B· Rough

·C· Charcoal paper

·D· Linen finish

·E· Ross board

ONE SHOULD LEARN THE ADVANTAGES OF VARIOUS SURFACES

·3· Rather photographic effects are obtainable by this smoothing process.

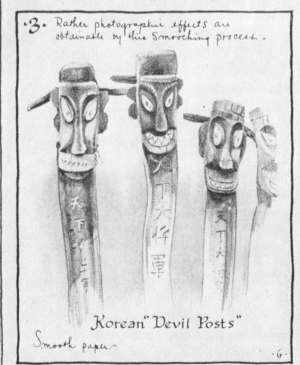

Korean "Devil Posts"

Smooth paper

·G·

A SCUMBLED EXAMPLE · · ·

·4· Roman Ruins Fiesole

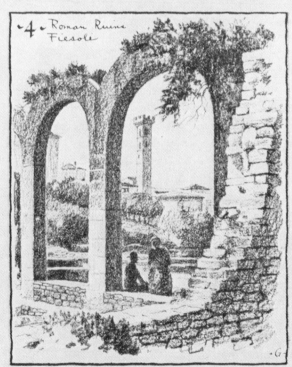

·G·

SKETCHED ON ROUGH PAPER · ·

THERE ARE PAPERS AND TRICKS OF TECHNIQUE ADAPTABLE TO EVERY NEED
One is unwise to restrict himself as to materials or methods

pencil work does tend to smooch, by deliberately rubbing it with the finger, or, better yet, with a "stump" made for the purpose. Note in 1 the sketch of a typical stump; at B the right ends of the soft pencil lines have been rubbed with it. This "smooching" or "scumbling" has smoothed the tone and at the same time darkened it, while spreading it beyond its former boundaries. The soiled stump was used for toning the areas at C and D, neither of which had any penciling. This gives us a new method for the application of tone, of which the artist occasionally takes advantage, first preparing the stump either by rubbing on a soft pencil lead, or on penciling on spare paper, or on powdered graphite, scraped from a pencil. As it is difficult to keep scumbled tone within bounds, he usually cleans up the edges and erases highlights, as it proves necessary, by means of his kneaded rubber. The erasing shield can be of real help in this process (see D).

In the sketch at 3, Plate 9, the devil posts were rendered quite fully in pencil and then smooched sparingly. The background was done wholly with a soiled stump, the edges being touched up with a kneaded rubber, worked to a point.

Don't lean too heavily on scumbling. Though it offers the best means of getting certain desirable effects, it is not viewed with particular favor.

Paper: Textures. I have already spoken several times of the importance of paper surface. One soon learns that if he can select the right paper for his purpose his problem is greatly simplified, particularly so far as texture representation is concerned. We have seen how the tones of the 2H and 3B pencils vary in the examples at 2, Plate 9. You should make similar samples on your own papers and preserve them for reference.

The paper used in the drawing at 4 was deliberately selected because it seemed well suited to the subject, with its rough stonework. In representing the stone textures it was therefore unnecessary to resort to tricks of technique. The whole treatment is honest and straightforward, though the natural contrasts, as of the vine-clad arches against the sky, were somewhat emphasized, while values as a whole were simplified.

Compare Sketches 3 and 4 and see how they differ in effect.

Projects. As you perform your various pencil exercises, don't forget to investigate this matter of texture representation, using different papers and pencils, and undertaking a wide choice of subjects. Try scumbling. Try everything which occurs to you as logical. Don't discard a trick merely because you don't succeed with it at first.

Rendering Methods. After a pencil drawing is blocked out there are various methods of proceeding with the rendering, regardless of the paper or type of point determined upon. Here are a few. Some artists like one and some another. Try them all and decide on their relative merits. You may develop one of your own.

Method 1. For the beginner the method shown as 1, Plate 10, meets with considerable approval. The proportions of the subject being established with light lines, a pattern of tone is laid in gray, as at A. On this foundation the darker tones are gradually added, as at B, the strong darks being reserved until last. See C. A good feature of this method is that the picture gradually evolves, being at all times under the artist's control. It offers a technical difficulty, however, for the application of the light foundation tones often kills the "tooth" of the paper, forming a glaze over which it is somewhat difficult to work. The crisp, professional look so much admired in many pencil drawings can be obtained more easily by direct attack, each area being completed at once.

Method 2. In this respect the method shown as 2, Plate 10, is better. It reverses the previous one, the blacks being done first, then the middle grays, and, finally, the light grays. This makes for crispness of technique, but offers two difficulties. First, it is hard, once the blacks are drawn, not to smooch them. Secondly, the method is not explorative or experimental; there is no chance for trial; one is forced to come to a decision regarding the blacks with only plain white paper before him. For the beginner this is not always easy; he prefers to build his values more gradually. If, as a preliminary, he lays tracing paper over his construction lines, however, and makes a trial study, struggling with

PLATE 10 · THE PENCIL : METHODS · ·

METHOD 1 · DRAW GRAY STROKES FIRST ; ADD BLACK · · ·

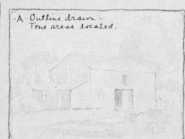

A · Outline drawn · Tone areas located.

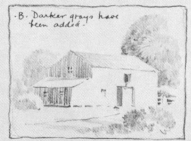

B · Darker grays have been added ·

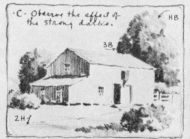

C · Observe the effect of the strong darks. · HB · 3B · 2H

USE SEVERAL PENCILS ; WORK BOLDLY ; DRAW FIRMLY · · ·

METHOD 2 · DRAW DARK TONES FIRST ; ADD GRAYS · · ·

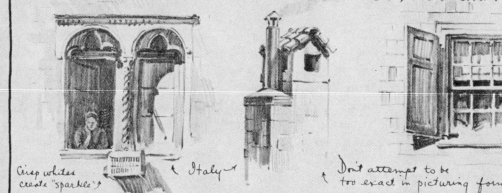

Crisp whites create "sparkle"! ← Italy → Don't attempt to be too exact in picturing form

AVOID WEAK, PALE WORK · USE BLACK · SEEK CRISPNESS · · ·

METHOD 3 · FREE HANDLING · · · Lights and darks applied as needed.

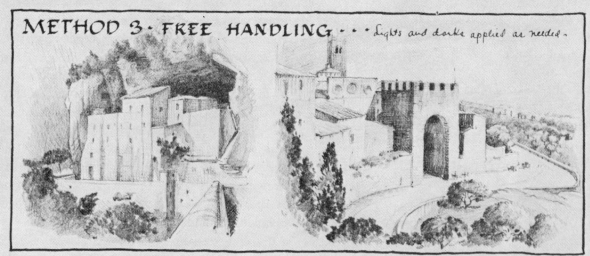

EXPERIMENT WITH VARIOUS METHODS AND SUBJECTS · · ·

IT MATTERS LITTLE HOW ONE WORKS IF HE PRODUCES GOOD RESULTS

Direct attack, with few changes, is generally advisable

his values as long as he likes, he should then be able, with the study as a guide, to apply this method advantageously. Or he could vary his procedure by doing as the professional often does, starting to render in the upper left-hand corner of his sheet, gradually advancing the drawing diagonally down the paper until the lower right-hand corner is reached. With care, it proves unnecessary to go back over the work, with risk of rubbing it, unless for a few finishing touches.

Method 3. On Plate 10 we offer, under the term "free handling," a third method. This title does not mean that the resultant drawings are free in the sense of being sketchy or loosely assembled. Quite the contrary. It simply means that the student who follows this method works without feeling that he must proceed by any definite rules or arrive at any particular type of result. It is an experimental method in the sense that after one's layout is made he sketches freely here and there, going over each surface as many times as he wishes, building up his tones gradually, even through the employment of the somewhat ill-reputed cross-hatch.

The sketches shown were done from snapshots made abroad, and I purposely gave them a more photographic appearance than some pencil drawings present, for my thought was to emphasize, pictorially, my reiterated assertion that it is far better to strive for good values than mere technical excellence. With such studies as these finished, the student, if dissatisfied with the technique, could redraw the subjects with the studies as a guide.

Black. Let me again stress the importance of black. It makes for strength. Many students are afraid of dark tones and produce wishy-washy drawings of little character. See to what extent black was used in Plate 10.

Fixatif. Fix all drawings when completed. File them for future reference.

Special Pencils. We should not turn from the subject of pencil drawing without making clear that one is by no means confined to the ordinary pencils, as there are many others available. Not only are there thick-lead graphite pencils of various kinds (to say nothing of the graphite sticks, like the square one pictured at

1, Plate 13), but there are pencils of carbon, wax, and the like. Plate 11 shows examples of work in several of these.

Lithographic Pencils. Though primarily made for drawing on lithographic stone, these are excellently suited to work on paper. They are available in several grades, the softer ones capable of an intense black, even when little pressure is used. They are particularly well liked for work on the coated paper commonly known as "cameo," giving crisp, snappy results. They can be used to advantage, also, on glazed papers and Bristol boards on which the graphite pencil would scarcely mark. The best-known make, apparently, is Korn's, which comes in both pencil and crayon form. Lithographic pencils are not well suited to work requiring many changes, as they cannot be erased as easily as graphite. See Sketch 1, Plate 11.

Carbon Pencils. These are also in considerable demand, partly because of their dense blackness and freedom from shine. Those known as "Wolff" are readily obtainable in a number of degrees; Hardtmuth offers a similar line under the term "black chalk."

The softer degrees produce results similar to charcoal; they are amenable to scumbling—see Sketch 2. They are perhaps at their best on rough paper. Finished work must be fixed.

Charcoal. Several manufacturers now put out charcoal in pencil form. It is convenient for many purposes. Read Chapter IX.

Wax Pencils. There are a number of kinds of black pencils of waxy character, some of which prove very useful. They have a marked virtue over graphite or carbon in one direction, for they offer greater resistance to smooching. The Koh-i-noor "Negro" is a good pencil of this class, as is the Dixon "Best Black No. 331." Such pencils are excellent in connection with wash or water-color (see Sketch 3, Plate 23).

Large Graphite Leads. Graphite pencils with unusually large leads, square leads, etc., are sometimes just the thing, whether employed by themselves or to supplement the familiar type.

Sketch 4, Plate 11, was done with a pencil of this sort, having a rectangular lead 3/16" wide. Despite the reduction of our drawing, it at least offers a hint as to what a time-saver

PLATE 11 · SOME SPECIAL PENCILS · ·

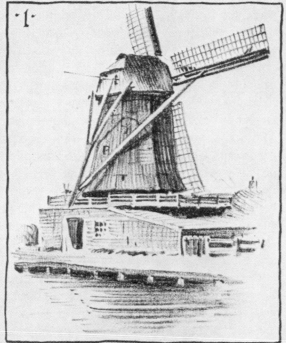

LITHOGRAPHIC PENCIL · · ·

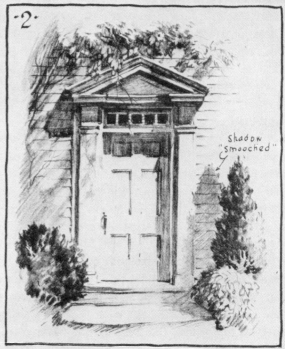

Shadow "Smooched"

CARBON PENCIL · · ·

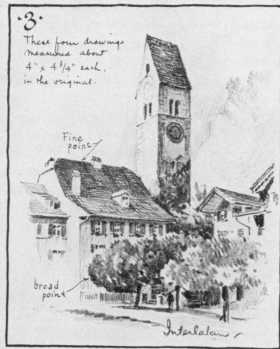

These four drawings measured about 4" x 4¾" each. in the original.

Fine point

broad point

Interlaken

WAX PENCIL · · ·

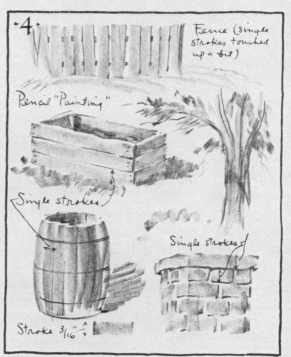

Fence (single strokes touched up a bit)

Pencil "Painting"

Single strokes

Single strokes

Stroke 3/16"

WIDE LEAD (GRAPHITE) · · ·

ONE SHOULD BY NO MEANS OVERLOOK SUCH SPECIAL MATERIALS AS THESE

There are purposes for which each is peculiarly suited

such a pencil can be. It is well suited to outdoor sketching. It is cleaner to handle than the graphite sticks described in Chapter IX.

Mannerisms. If I seem to offer too many generalities and too little definite instruction on the technique of the pencil's use, it is because long experience has taught me that it is only by actual drawing, with frequent reference to such examples by other artists as one can find, and an occasional criticism from some qualified adviser, that any real progress can be made. I can sum up my feeling by repeating that the thing to do is to draw and draw and draw, trying honestly to record such things as you see with your own eyes. No one can tell you just how to represent trees and mountains, water and clouds, for these all vary in appearance under different conditions. There are no definite rights and wrongs, so don't waste your time seeking them. Go out and observe true appearances and try

conscientiously to interpret them, simply and directly. Don't, I beg of you, get the notion that you should undertake at once to develop a distinctive style of your own. Postpone this. If you work faithfully for a while, sooner or later such style will come (along with what tricks and short cuts you need) in spite of yourself. Attempt to hasten the process by trying to be original and you'll probably merely develop silly mannerisms or peculiarities. This is true not only of the pencil, but of all media.

Inasmuch as most of the examples by other artists offered in our supplementary pages are in pencil or closely related media, you should now study them, along with the comments which accompany them. If you feel the need of more detailed instructions, I have covered many points quite fully in my *Sketching and Rendering in Pencil* (The Pencil Points Press, Inc., New York).

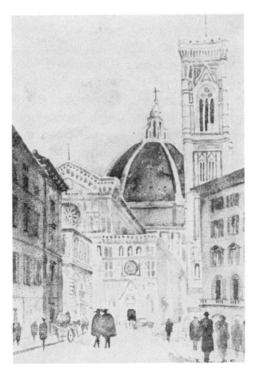

DRAWN BY SEWALL SMITH

CHAPTER IX

ON CHARCOAL, CRAYON AND CHALK
Some Common Kinds and Their Application

IN A single chapter it is impossible to do more than point to a few highlights on the above topic, for the market is flooded with such a wealth of materials of this class that even to describe them all would take many pages. First I shall discuss charcoal and its uses, later offering brief pointers on its relatives, crayon and chalk.

Charcoal. As a medium of artistic expression, charcoal has been in high favor ever since the days long ago when, in many cases, it was the only one available. That it possesses real merit is demonstrated by the fact that it still holds its own now that it is brought into competition with all the newer materials. It is a particular favorite in the art school, where it serves so admirably for many types of work, including cast and life drawing. It is especially fine for quick effects; not only do its softness and generous size make it ideal for filling large areas of tone hurriedly, but if errors are made they can be easily corrected: if necessary the paper can be dusted clean again in a moment. Charcoal is capable of the most vivid blacks, too, an obvious advantage.

There are many kinds and grades, the price usually being a fair indication of quality. One needs a few assorted sticks, some soft and some hard. For cleanliness, the sticks wrapped in foil are convenient, though you can easily wrap your own.

The market offers a number of imitation or synthetic charcoals in crayon and pencil form. They are more uniform and reliable than the real thing, but generally higher in price.

Paper. Though charcoal drawing can be done on many papers, that made for the purpose is recommended. It comes in tints as well as white; on the former the highlights are added in white crayon or chalk, extremely effective results being possible. It is also good for drawings produced entirely in chalk or crayon. For most student work the inexpensive grades do very well.

Chamois: Erasers. A chamois skin is excellent for dusting drawings clean, etc. Kneaded rubber is ideal for lifting tone, and picking out highlights. An erasing shield is useful.

Crayon Holder. A *porte crayon*, with split ends and rings for adjustment, protects the hands and enables one to utilize short lengths. It is equally practical with many forms of crayon.

Fixatif: Atomizer: Stump. These are indispensable. A knife is also convenient, as is a sandpaper pad.

Procedure. Because of the crumbly nature of charcoal, it is at its best on work of fairly large scale. Still-life objects are often drawn at full size, or approximately so. In laying out a subject, select a rather hard stick. Point it every few minutes with your knife, drawing the blade towards you; if you sharpen away from you the point is liable to break. Use sandpaper, if you prefer. Block in the proportions freely, with an arm and wrist motion, placing the paper nearly vertical; an easel is helpful. If you get the layout wrong, dust it off with your chamois and begin once more.

When you have properly established the salient points, strengthen them, using slightly increased pressure, and dust the entire drawing again. They will still show as a guide for the shading, as in pencil work.

There are two common ways of laying tone. In the first, illustrated at 1 (A), Plate 12, no smooching is done; each area is gone over and over with a fairly hard, sharp point, the tiny pits or depressions in the paper being allowed to show through the tone to give sparkle and vibration. The little sketch at 2 was made in this way. If you get a value too dark, either dust it off for a fresh start or lighten it by gentle application of the kneaded rubber. If you erase in the ordinary manner you will probably get a messy result. Try to keep your hands off the drawing lest you unintentionally smudge it.

In the second method, you apply some charcoal as before (powdered charcoal is sometimes

PLATE 12 · CHARCOAL PRACTISE · · ·

·1· The effect depends considerably on kind of paper selected ·

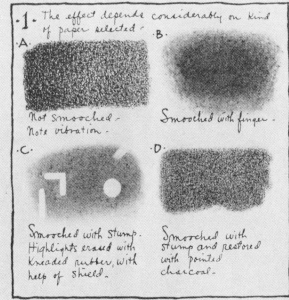

·A·

Not Smooched · Note vibration ·

·B·

Smooched with finger ·

·C·

Smooched with stump. Highlights erased with Kneaded rubber, with help of shield ·

·D·

Smooched with stump and restored with pointed charcoal ·

FIRST CONSIDERATIONS · · ·

·2· NOT SMOOCHED · · ·

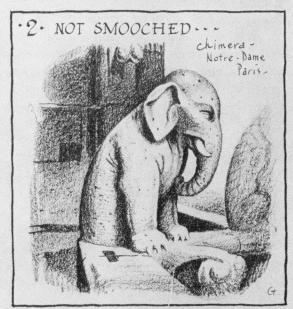

Chimera · Notre-Dame · Paris ·

A SIMPLE APPLICATION · · ·

·3· BUILT UP ON SCUMBLED (SMOOCHED) BACKGROUND · · ·

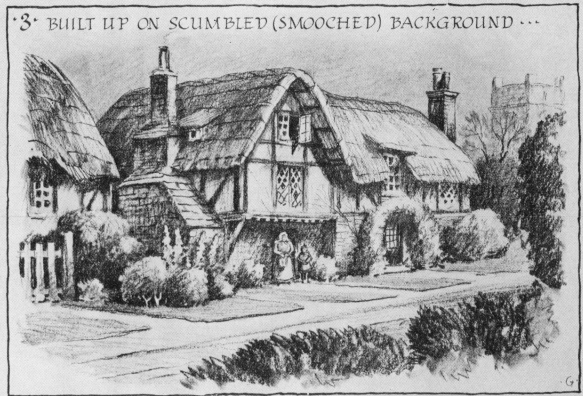

TRY MANY PAPERS AND TYPES OF SUBJECTS · · ·

CHARCOAL, LIKE PENCIL, IS CAPABLE OF A WIDE RANGE OF TREATMENTS

It is particularly fine for many sorts of quick effects

used) and scumble it with finger or stump (see B and C, at 1, Plate 12), cleaning edges and picking out highlights with your kneaded rubber, using your shield or not, as you choose. Note at C what clean-cut highlights can be erased by means of the shield. In using kneaded rubber it is well to break off a piece at a time, as required; otherwise the whole cake will soon be hopelessly black.

These two methods can be combined in various ways. The area at D exemplifies this thought, as it was first smooched and then restored with the pointed charcoal, giving a smooth yet vibrant texture. In Sketch 3 the entire background was scumbled; then the light areas were erased, after which the charcoal, well sharpened, was used for touching up. Considering the subject, this sketch was made very quickly; with greater patience far more highly finished effects are possible.

When one does charcoal work at small scale, the fine detail can be added with the Wolff or other carbon pencil; the two media blend perfectly.

Charcoal is ideal for preliminary studies for drawings in other media. When a drawing in pencil, pen, or wash is ready for shading, lay rough tracing paper over it and study your values in charcoal. Smooch where you please. Wipe out highlights at will. Don't strive for finish, but watch your composition. When generally satisfactory, spray with fixatif and retain as a guide for the final.

Charcoal can be successfully used as a base for work in wash or water-color, providing the necessary texture and weight. In this case it must be well fixed before the washes are applied; paper suited to withstand water must be selected. See Sketch 5, Plate 19.

Crayon and Chalk. Here we have a great range of materials, as is suggested at 1, Plate 13. Particularly fascinating are the large square sticks of the type first pictured. Hardtmuth puts these out in graphite and carbon and the ever-popular sanguine (red). A single stroke of the side measures 3″ and of the end ¼″ (see Sketch

2). This permits amazing speed. The three sketches at 4, for example, were done with the end stroke from actual objects within a space of ten minutes. A carbon crayon was used, the strokes being plainly visible. Smudging with the stump was sparingly done. The same medium is equally practical for carefully finished work, with or without smudging. If desired, a pencil of like composition can be used to supplement the crayon. In fact, there is no real difference between pencils and crayons excepting that the latter are usually larger and often have no reinforcing wood.

Conté crayons are very well known. They come in both pencil and crayon form in black, white, red, and sepia.

The Soluble Crayon. A thing not commonly recognized is that some crayons, such as the Conté sepia and Hardtmuth sanguine, are soluble in water, and so capable of unique effects seldom seen. Sketch 3, Plate 13, was drawn very hurriedly with a sanguine crayon, and then touched up with a damp brush. Sometimes the paper is puddled with water and the crayon drawn across the wet surface. It is even possible to take pigment from soluble crayons with a brush, as from cakes of water-color.

Chalks. Ordinary blackboard chalks are suited to many kinds of work. There are also huge chalks, customarily known as lecturers' crayons, as large as an inch square and three inches long. They come in black and white as well as colors.

Pastels are chalklike crayons, commonly used in colored form.

Wax crayons have one advantage over softer chalks as they require no fixatif. Even the cheap school sets are capable of surprising results.

Projects. When you have tried out your charcoal, as suggested, experiment with a few crayons and chalks, one at a time. Deliberately test each as to its characteristics; find out how well it blends; how easily it erases; whether it requires fixing. You will thus gain an acquaintance with many media and methods, a matter of tremendous advantage.

PLATE 13 ·· CHALKS AND CRAYONS ··

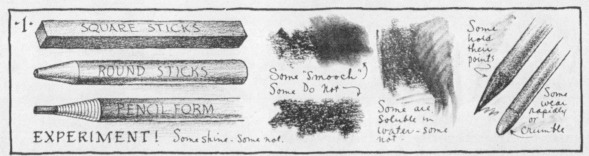

·1· SQUARE STICKS

ROUND STICKS

PENCIL FORM

EXPERIMENT! Some shine. Some not.

Some "Smooch" Some Do Not

Some are Soluble in Water—some not

Some hold their points

Some wear rapidly or Crumble

THERE ARE NUMEROUS TYPES AND MANY METHODS OF APPLICATION·

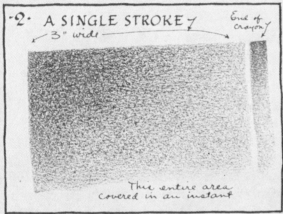

·2· A SINGLE STROKE — 3" wide

End of crayon

This entire area covered in an instant

IDEAL FOR LARGE AREAS · · ·

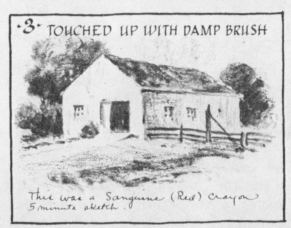

·3· TOUCHED UP WITH DAMP BRUSH

This was a Sanguine (Red) crayon 5 minute sketch.

A WET METHOD · · ·

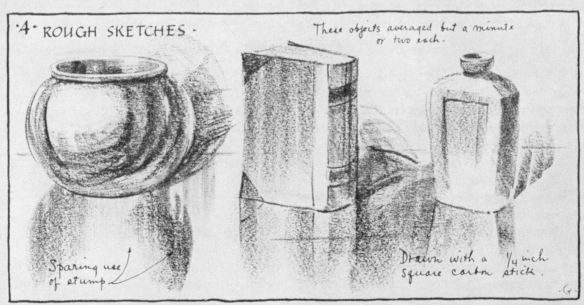

·4· ROUGH SKETCHES ·

These objects averaged but a minute or two each.

Sparing use of stump

Drawn with a ¼ inch square carbon stick.

·G·

SPLENDID FOR QUICK WORK REGARDLESS OF SUBJECT · · ·

THE POSSIBILITIES OF CHALKS AND CRAYONS ARE ALMOST UNLIMITED

Wise, indeed, is he who early makes their acquaintance

CHAPTER X

THE ART OF WASH MANIPULATION
Flat and Graded Washes: Familiar Faults

A WASH drawing is one in which pigment, such as India ink or black water-color, is flowed over the paper where wanted, diluted to suit. Wash is a remarkable medium, capable of a wide range of results, reaching all the way from quick, free indications to effects quite photographic in appearance. It can be used either for covering large surfaces quickly, or for painting fine lines! Wash drawings are clean to handle, requiring no fixatif.

As to faults and limitations, wash drawings buckle unless heavy paper is used. One must wait for washes to dry, too, and when dry they often prove disappointingly light. If too dark, it is hard to change them. It is difficult, in wash alone, to represent rough textures. Wash-laying is tricky (see the faults at 3, Plate 14). Wash must, nevertheless, be rated as one of the best media for all-around purposes.

Materials. At 1, Plate 14, is shown most of the necessary equipment. You need a suitable pigment (I like ivory-black or lamp-black water-color), a medium brush or two, cups for water and pigment, blotting-paper and a rag. Heavy paper or board such as water-colorists use is also desirable.

Flat Washes. Start your practise with wash-laying, beginning with flat washes. See 2 (A). Thoroughly stir some pigment into water. Then, with the board slightly tipped, apply this mixture at the top of the selected area, forming a puddle. Guide this gradually down the paper with a back-and-forth or rotating motion of the brush, leaving an even tone behind it. Don't work back into this while it remains damp. Replenish the puddle frequently. Always keep the mixture well stirred. At the bottom, dry the brush and use it to absorb the superfluous pigment as it accumulates.

Graded Washes. For a grade like that at 2 (B), mix ample light pigment and form a puddle as before. Stir more pigment into the saucer and, working some of this mixture into the lower edge of the puddle (merging the new with

the old), advance the whole a bit farther. Repeat this process as many times as is necessary. Work quickly. For washes like that at C, merely reverse the process.

For complete descriptions of wash-laying see *Architectural Rendering in Wash*, by H. Van Buren Magonigle (Scribner's).

Sediment Wash. Some paints dry out to show a mottled effect (see D). Though not suited to all purposes, they are desirable for interpreting rough textures. Use them when needed.

Faults. See 3. The wire edge at E resulted from leaving the board flat. Runbacks are usually caused by failure to absorb the superfluous pigment at the bottom. Streaks are due to careless mixture or application. Persevere and you can soon lay even washes. It's a knack.

Method. In making a wash drawing, the common method is to start with light tones, building darker ones upon them by superposing wash on wash, the blacks being added as finishing touches. If this process is reversed, mussiness may follow, due to the solubility of the dark underlying tones. As a rule the fewer times you go over an area the better.

Sometimes flat washes are used in drawings, as at 2, Plate 23. Often greater freedom is employed (see Sketch 4, Plate 14). In this latter example, line work, done with the same brush, was added to the wash work; see floor cracks, rug details, etc.

Highlights can be carefully erased, as at 2 (D), or produced through alternate dampening and blotting. Tones can be lightened in the same manner.

Work in pencil and wash, or pen and wash, are often combined (see Plate 23).

Projects. Wash work, once mastered, is comparatively rapid and easy. It will pay you to stick to it until you gain some proficiency. Try a number of papers and pigments. Make both large and small drawings, some sketchy and some well finished. Combine wash with other media.

PLATE 14 · WASH MANIPULATION · · ·

·1· EQUIPMENT ·

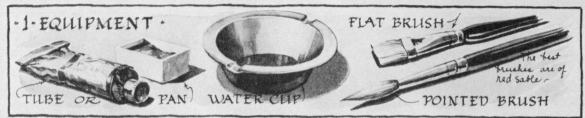

TUBE OR PAN WATER CUP FLAT BRUSH

The best brushes are of red sable ·

POINTED BRUSH

THE MATERIALS ARE FEW AND INEXPENSIVE · · ·

·2· TYPES OF WASHES (Practise washes should be quite large) · · ·

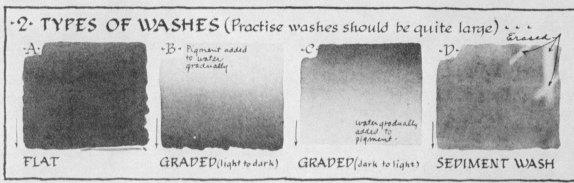

·A·

·B· Pigment added to water gradually

·C· water gradually added to pigment

·D· Erased

FLAT GRADED (light to dark) GRADED (dark to light) SEDIMENT WASH

KEEP PAPER ALMOST FLAT: WORK VERY WET: DONT GO BACK!

·3· FAULTS ·

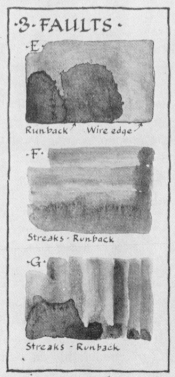

·E·

Runback Wire edge

·F·

Streaks · Runback

·G·

Streaks · Runback

PRACTISE!

·4· A TYPICAL SKETCH ·

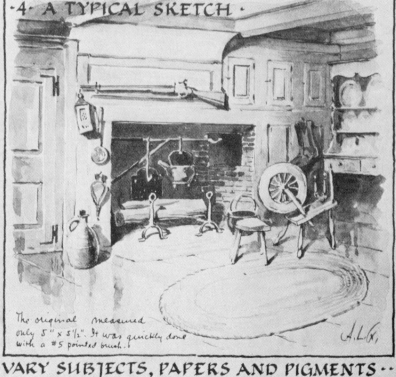

The original measured only 5" x 5½". It was quickly done with a #5 pointed brush.

A.L.G.

VARY SUBJECTS, PAPERS AND PIGMENTS · ·

FOR COVERING LARGE SURFACES QUICKLY AND WELL, NOTHING EQUALS WASH

Paradoxically, it is splendid for work requiring fine detail

CHAPTER XI
AND NOW COMES PEN·AND·INK
Elementary Exercises to Finished Work

PEN drawing is so complex a subject that our aim is scarcely more than to introduce the reader to it. If curious, he can find excellent books of instruction, including G. Montague Ellwood's *The Art of Pen Drawing* (Scribner's), and *Pen Drawing*, by Charles D. Maginnis (Bates and Guild). The author also offers extremely complete instruction in his *Drawing with Pen and Ink* (The Pencil Points Press, Inc., New York).

The popularity of pen-and-ink is to a considerable extent due to the fact that cheap, yet good, reproductions of a type which will print well on almost any paper can be made of it, suiting the medium splendidly to newspaper work, advertising drawing and the like. Aside from these factors of economy, the pen has many virtues in its own right. For sharp, definite delineation of form it has no equal. Pen drawings are clean, also, and need no fixatif. The requisite materials are few and easily secured at low cost. Pen drawing offers particularly fine opportunities for originality of style.

Yet the pen has many limitations. Unlike the brush, it is poorly adapted to covering large areas and to expressing values accurately. Pen lines or tones are hard either to lighten or to darken. Therefore one must work as directly and exactly as possible, resorting to such conventionalities as the use of outline. This at least has the advantage of forcing one into definite and painstaking habits.

Materials. Secure a bottle of waterproof black ink—Higgins' is a reliable stand-by—and a few Gillott pens such as the 404 (medium), 303 (fine), and 170 (very fine). The tiny "crow-quill" is well liked. The danger of the finer pens is that they may lead one into finicky ways. Select a paper not too soft or porous; smooth Bristol boards are excellent. Have a penwiper and use it frequently. Keep blotters at hand in case of accident.

Preliminary Exercises: Lines. You must first get acquainted with your pens. Draw lines of all kinds (see Plates 15 and 16 for suggestions). Copy portions of pen drawings, too, in order to learn additional possibilities, bearing in mind that reproductions are usually much smaller than originals.

Values: Tone Building. Learn to combine lines to form tones, remembering that exact portrayal of values is not expected. See 2, Plate 15, reading the notes with care. When it comes to finished drawings don't make your tones too complex, as by spacing heavy lines so widely that they become individually conspicuous.

Optical Illusions. The eye can be tricked by lines as it can by tones, as Figure 16, page 26, demonstrates. Illusions similar to these sometimes develop in pen drawings. If objects look distorted when finished, analyze them with this in mind. Learn to profit from such errors.

Projects. Block out your subjects in pencil and then render them in pen, simplifying and conventionalizing your values and utilizing outline. For first practice I suggest subjects like that at 3, Plate 15, with simple local values and inconspicuous textures. Draw both straight- and curved-line objects. See Plate 16 for the latter; the drawings explain themselves. Try some with rough textures, as at 3 and 4. For smooth surfaces, as on the base of the jug at 4, draw quickly; you cannot represent them with wavering lines, though such lines may prove ideal for rough or irregular ones. Don't try to cover too much of your paper area with tone; with rare exceptions this merely wastes time.

Eventually, choose a great variety of subjects. You may like to do some of them in a rather decorative technique, or to combine the pen with other media. Early pages offer a number of examples; see Plates 18 to 23, inclusive. Study also Group IX, Part 2.

PLATE 15 · ELEMENTARY PEN EXERCISES ·

·1· STRAIGHT LINE PRACTISE : TONE BUILDING · · ·

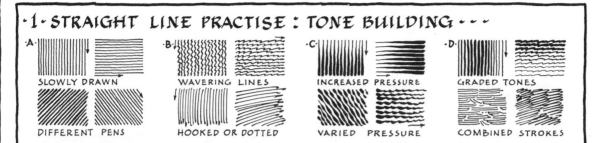

·A· SLOWLY DRAWN ·B· WAVERING LINES ·C· INCREASED PRESSURE ·D· GRADED TONES

DIFFERENT PENS HOOKED OR DOTTED VARIED PRESSURE COMBINED STROKES

INVENT OTHER EXERCISES : TRY DIFFERENT PENS · · ~

·2· IT IS DIFFICULT TO OBTAIN EXACT VALUES IN PEN · · ·

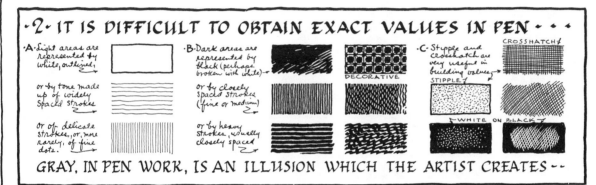

·A· Light areas are represented by white, outlined,

or by tone made up of widely spaced strokes

or of delicate strokes, or, more rarely, of fine dots.

·B· Dark areas are represented by black (perhaps broken with white)→

or by closely spaced strokes (fine or medium)

or by heavy strokes, usually closely spaced

DECORATIVE

·C· Stipple and crosshatch are very useful in building values→

CROSSHATCH

STIPPLE

←WHITE ON BLACK→

GRAY, IN PEN WORK, IS AN ILLUSION WHICH THE ARTIST CREATES · ·

VALUES ARE USUALLY SIMPLIFIED OR SUGGESTED · · ·

·3· SOME COMPARATIVE METHODS · · ·

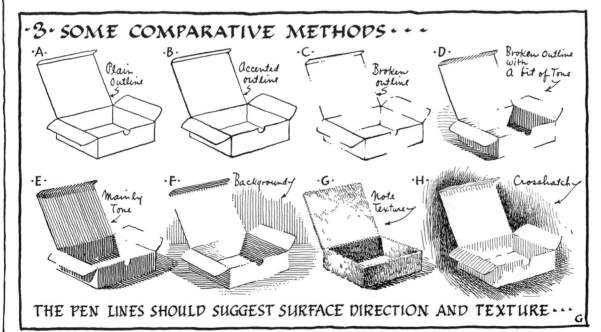

·A· Plain Outline ·B· Accented outline ·C· Broken outline ·D· Broken outline with a bit of Tone

·E· Mainly Tone ·F· Backgroundy ·G· Note Texture ·H· Crosshatchy

THE PEN LINES SHOULD SUGGEST SURFACE DIRECTION AND TEXTURE · · · G

A SIMPLE APPLICATION · · · EXPERIMENT ! · · ·

THE PEN IS DOUBTLESS AT ITS BEST FOR ACCURATE DELINEATION OF FORM

It is splendid, too, for the indication of texture

PLATE 16 · THE PEN : CURVED STROKES ··

·1· CURVED LINE PRACTISE : TONE BUILDING ···

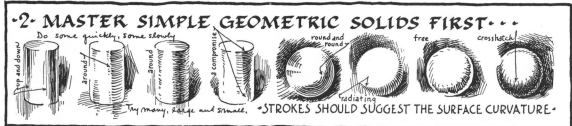

A. B. C. D.

FREE STROKES ARE MOST IMPORTANT

DEVISE AND PRACTISE A VARIETY OF SUCH EXERCISES ···

·2· MASTER SIMPLE GEOMETRIC SOLIDS FIRST ···

Do some quickly, some slowly

up and down

around

around

a compromise

round and round

free

crosshatch

radiating

Try many, large and small.

·STROKES SHOULD SUGGEST THE SURFACE CURVATURE·

MOST OBJECTS ARE BASED ON JUST SUCH SOLIDS ···

·3· AN ANTIQUE CHURN ··

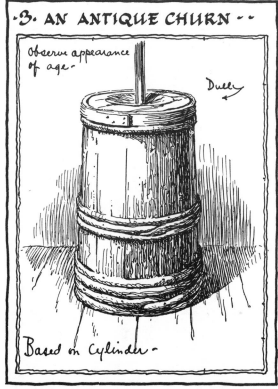

Observe appearance of age.

Dull

Based on Cylinder ·

WATCH YOUR TEXTURES! ···

·4· OLD OBJECTS ARE GOOD ··

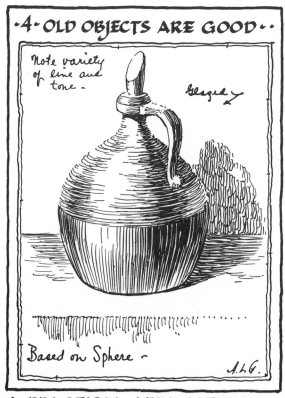

Note variety of line and tone.

Glazed

Based on Sphere ·

A·L·G·

A PRACTICAL APPLICATION ···

IN PEN DRAWING, TECHNIQUE DEMANDS MORE THAN CUSTOMARY ATTENTION
One gradually acquires a repertoire of suitable tricks

CHAPTER XII

THE BRUSH AND BLACK INK
Practice Strokes and Their Utilization

THE brush is by no means confined to wash treatments: it is fully as practical for the application of black ink, undiluted. For examples see Plates 17 and 18. Sometimes it is employed by itself, as in the former, and again, in combination with the pen, as at 1 in the latter. Though many such drawings are bold and poster-like, large areas being solid black, a brush which points well can also produce, without forcing, lines surprisingly like those of the pen. A hint of this is seen in Sketch 5, Plate 17.

Projects. After you have practised all sorts of brush strokes, including a number much finer than those at 1 and 2, Plate 17, apply them to drawings of different kinds. The examples at 3, 4, and 5 show a few possibilities. Make some studies in a style similar to that at 3, representing all the darkest areas of the subject in pure, or only slightly broken, black, leaving plain white paper for the lightest tones. Build your grays of separate strokes, much as you would in pen work. As poor relationships of light and dark are certain to be conspicuous, watch your composition. Trial sketches frequently prevent errors: these can be done in ink on tracing paper placed over the layout. Attempt, also, some drawings more like that at 5, depending mainly on lines of rather pen-like character.

If you make mistakes, an ink-eraser may prove necessary. Commercial artists, interested more in final reproductions than in the effect of their original drawings, often touch up faulty pen or brush work with opaque white, or patch paper over it and redraw. These corrections do not reproduce to show.

Always wash your brushes thoroughly when through with them or they will soon be ruined.

The Split-Hair Brush. From time to time you may want to relieve your practice by turning to the rather tricky methods shown at 2 and 3, Plate 18. In applying the first, select an old brush with hairs which tend to separate, and experiment with it on an extra sheet of paper until it produces strokes more or less like those

at 2. Then advance your sketch very directly and quickly; a pointed brush or pen is sometimes needed for finishing touches. The little bridge sketch was done in a few minutes, the separated hairs proving highly efficient for representing the rough grass, uncoursed masonry, water, and leafage. Illustrators frequently use this method.

The Dry Brush. If a brush containing but a moderate amount of ink is used on rough paper, the strokes are usually interrupted with lights, as at 3, Plate 18. Such strokes can produce extremely pleasing drawings. The hairs may separate, as in split-hair work, or not. Try your brush on extra paper until you get just the stroke desired; then proceed with your sketch. The tree at 3, though done in pure black ink, has rather a gray, crayon-like character in places, yet could be reproduced by the relatively inexpensive method used for pen drawings. Because dry brush work does reproduce cheaply and well, it is frequently employed in newpaper drawing and the like.

The Brush and Pen Combined. Many are the treatments in which black ink is applied with brush and pen used in combination. For example, see the sketches at 1, Plate 18. At A the line work was done entirely in pen, with the brush held in reserve for the solid black areas. At B the fine lines were drawn in pen and the coarser ones and the blacks with the brush. Sometimes a wide pen is used instead of the brush.

Sketch A, incidentally, represents a rather decorative sort of treatment, applicable, with variations, to a wide range of subjects. Though done from an actual object, the handling is studied and highly conventionalized, the aim having been to make a decoration rather than a literal portrayal. Sketch B, as to values, is the opposite of A, the figures forming a sort of silhouette. The brush is unexcelled for silhouette work (see the ship at 4, Plate 17).

PLATE 17 · THE BRUSH AND BLACK INK · ·

·1· POINTED BRUSH EXERCISES · ·

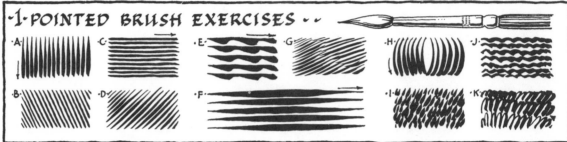

INVENT MANY STROKES, FINE & COARSE, STRAIGHT & CURVED·

·2· FLAT (BLUNT) BRUSH EXERCISES · ·

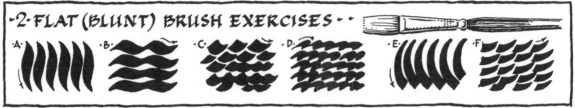

TRY VARIOUS BRUSHES : PRACTISE DURING SPARE MOMENTS · ·

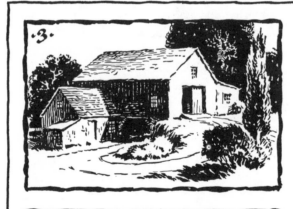

·3·

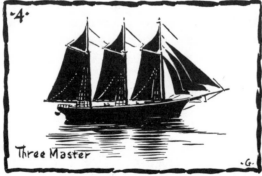

·4·

Three Master

·G·

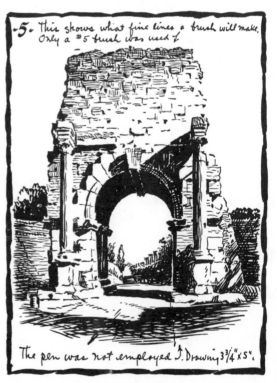

·5· This shows what fine lines a brush will make. Only a #5 brush was used ↓

The pen was not employed. I. Drawing 3¾" × 5".

PLAN YOUR CONTRASTS CAREFULLY : ERRORS SHOW PLAINLY · ·

THE STUDENT SELDOM REALIZES HOW VERSATILE THE BRUSH CAN BE

Even with black alone, innumerable effects are possible

PLATE 18 · MORE ABOUT BRUSH AND PEN·

·1· DECORATIVE WORK (HIGHLY CONVENTIONALIZED) · · ·

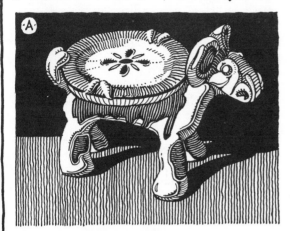

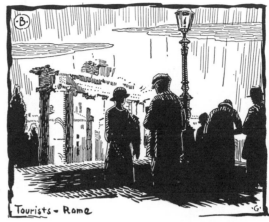

Tourists — Rome

THE LARGER BLACK AREAS WERE DONE WITH THE BRUSH· · ·

·2· THE SPLIT-HAIR BRUSH · ·

The hairs should separate →

One stroke → crosshatch

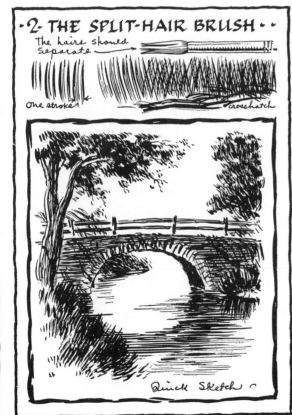

Quick Sketch

·3· THE DRY BRUSH · · ·

The hairs may or may not separate →

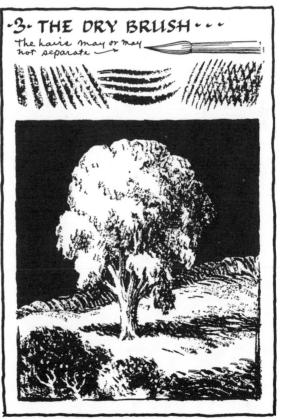

ENDLESS VARIETY IS POSSIBLE· THIS PAPER WAS ROUGH· · ·

IN WORK LIKE THIS, THE BLACKS MUST BE "SPOTTED" WITH CARE

Trial sketches save time and insure better composition

CHAPTER XIII

UNUSUAL MEDIA: COMBINED MEDIA
The Development of Speed and Versatility

WE HAVE seen that each medium has characteristics peculiar to itself, making it particularly well suited to certain purposes and types of subjects. It naturally follows that there are numerous instances where two or more media can be successfully combined (see Plate 19). It is equally evident that the artist familiar with such combinations can work more rapidly and to better advantage than his less versatile brother.

At 1 we show combinations of wash and black ink, applied with both pen and brush. Such combinations have been unusually frequent the last few years among our book and magazine pages. At A the border and the mountain profile were done in pen, the waves and larger blacks being added in black ink with the brush; the grays were applied last with a wash of diluted lamp-black. Innumerable variations of this combination can be found. At B, for instance, the light columbine is thrown into relief against a background washed with gray and made more decorative with closely spaced pen lines. Pure black is used in limited areas only. At C is a rather free treatment, particularly in the background, while at D we have a light object, in pen and wash, thrown in sharp relief against dark gray and pure black.

Combinations of such media are not all as conventional as these; witness that at 2 which was sketched very freely in pen and diluted ink directly from the subject. The sketchily handled washes were of ivory-black.

In Sketch 3 we have another combination of pen and brush, though here the method was quite different. As a matter of fact so was the medium, for this was drawn with an ordinary fountain pen filled with blue fountain-pen ink. When the whole had been sketched in line, the pen was laid aside for the brush, which, dipped in plain water, was used for softening and distributing the soluble ink. No other pigment was needed. When dry, the pen was used once more for touching up. Sometimes, if the pen lines do not dissolve to give sufficiently rich values, the brush is charged with ink, as often as necessary, merely by touching it to the pen point. This fountain-pen method is well adapted to outdoor sketching.

We have mentioned that it is not always easy, with wash alone, to express rough textures, a bit of penciling being of great help. This is illustrated in Sketch 4. If a shiny pencil like graphite is used, it is advisable to apply the wash over the penciling to kill the shine. I prefer special pencils such as the Dixon Best Black No. 331 and Koh-i-noor Negro (Hardtmuth). These have little shine. A roughish paper is desirable; Sketch 4 was done on Bainbridge illustration board. If you chance to make a pencil (or pen) drawing which on completion proves out of value, tint it with washes of varying strength and you can quickly improve its effect.

Sketch 5 was developed with extreme rapidity. A few strokes of the charcoal, not too well pointed, a spray of fixatif, a free but sparing application of diluted lamp-black and the thing was done. Both charcoal and pencil are also used in connection with water-color of brighter hue.

Projects. The student should try all sorts of experiments, utilizing such combinations, attempting to discover some of his own. Let me suggest that both dry brush and split-hair brush combine with wash advantageously. I have mentioned tinted paper as another source of interesting effects, working to advantage with almost any medium; highlights can be picked out in chalk or Chinese white. Brown ink and sepia water-color, applied with pen and brush, respectively, are often combined; these were used in Sketch 1, Plate 23. One desirous of developing an individual technique frequently gets the hint which starts him in this direction as a result of such experimentation. It is surprising what a diversity of treatments is possible. Don't be afraid of blacks in all these combinations; with experience you will learn to "spot" or arrange them well.

PLATE 19 · ·COMBINED MEDIA· · ·

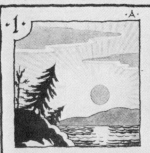
·A·

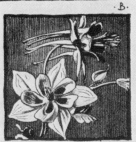
·B·

·C·

·D·

·1·

WASH AND PEN ARE COMBINED IN MANY WAYS· · ·

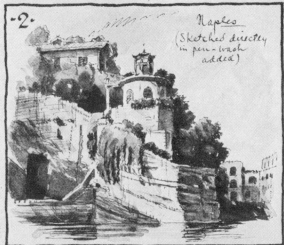

·2·

Naples
(Sketched directly
in pen—wash
added)

WASH AND PEN (SKETCHY)· · ·

·3·

Sketched, Blurred—Touched Cup·

·G·

FOUNTAIN PEN (BLURRED)· · ·

·4·

·G·

WASH AND PENCIL· · ·

·5·

The charcoal was "fixed" before the wash was applied·

WASH AND CHARCOAL· · ·

ONE SHOULDN'T MAKE THE MISTAKE OF SPECIALIZING IN A SINGLE MEDIUM

The more media he masters, the better his results will be

CHAPTER XIV

SCRATCH BOARD : ROSS · BOARD
Demonstrations of These Unique Materials

PLATE 20 shows some uses of a particularly interesting type of drawing board commonly classified as "scratch board." We are glad to call the attention of the student to this, for though long known among commercial artists, it seems more or less of a stranger outside this somewhat restricted field.

Most scratch board looks much like ordinary drawing board of the "Bristol" family, but its appearance is deceiving, for it is finished with a chalk-like coating which can be scratched with a sharp knife or other pointed instrument to produce novel effects, as here indicated. There are many surfaces manufactured; these fall, roughly, into three general classes, shown at 1, 2, and 3, respectively.

The first embraces perfectly plain white boards, generally glazed. In using them the artist customarily covers large areas with black ink, applied with the brush. When dry, he scratches (engraves) whites, where wanted, with any instrument or instruments suited to his purpose. Many drawings which one sees published as "wood-cuts," "wood-blocks" or "block-prints" are really nothing but scratch board examples, for this material is superb for imitations of this nature. The drawing at 1 of the old farmhouse is of somewhat this wood-cut character; here practically the whole paper, with the exception of the roof areas, was blackened, after which the whites were scratched with a knife held to give the width and character of stroke desired. If one makes scratches in the wrong places he can paint them out again with ink; these same areas, unless badly damaged, can be rescratched.

The pen can also be used on this board, though it has a tendency to clog with chalky particles. For this reason work of pen-like character is often done with a fine brush, after which any desired portions are scratched. See the specimens at 1 (C).

While it is possible to use the pencil on this smooth board, its surface is not as well adapted to it as is that of the second class, illustrated at 2, which is pebbled, ridged, or otherwise roughened. As the brush can still be employed (and the pen, in many instances), great diversity of result is obtainable. Often pencil and brush, or pen and brush, or all three, are used on a single drawing. In the tree sketch at 2 the bulk of the work was done with the lithographic pencil, pen and knife being employed sparingly for finishing touches. As the scratching of boards of this class destroys the raised surface, which cannot be restored to take the pencil advantageously again, it should preferably be done the last thing.

At 3 we illustrate the third class of scratch boards (named "Ross-boards" by their manufacturer). These come in a wide variety of surfaces, both smooth and rough, each printed with a pattern of lines or dots. Such special surfaces are great time-savers for the artist, who, selecting a board suited to his purpose, adds grays and blacks with pencil or ink, and scratches the printed tone or his applied tone into lighter gray or white at will. No description of these unique boards can be of much value. One has to experiment with them for a while in order to discover their possibilities. The sketches of the Chinese river boat and Welsh cottage at 3 (A and B) give some idea of the kind of result obtainable with comparatively little effort: these combine brush work, penciling, "scrapes" and scratches.

Perhaps the greatest virtue of all these scratch boards and Ross-boards is that the work done on them, whether in pencil or ink, can be reproduced at low cost by the process commonly known as line engraving. This makes them popular wherever inexpensive reproductions are wanted; in this they can be classed with ordinary pen drawings, and brush work in black ink.

PLATE 20 ·SCRATCH BOARD: ROSS·BOARD·

·1· SMOOTH SCRATCH BOARD

Ⓐ Paint board black, like this↗ | Ⓑ Scratch with sharp knife like this↗ or this↗

Ⓒ Or draw lines with pen or brush and scratch like this↗ or this↗ or this↗

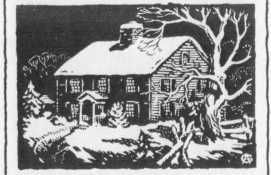

MANY EFFECTS ARE POSSIBLE - - -

·2· ROUGH SCRATCH BOARD

Ⓐ Draw with soft pencil↗ | Ⓑ Scratch with sharp knife like this↗ Ink may be used↗

 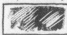

Ⓒ Many surfaces are available, suited to various purposes. Each can be scratched.

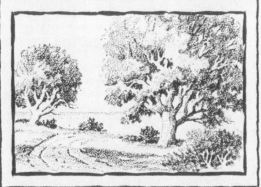

CORRECTIONS ARE EASILY MADE

·3· ROSS-BOARDS (Numerous patterns are available, each a scratch board)

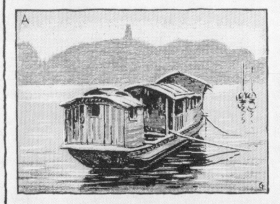

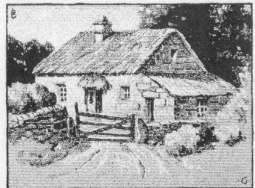

Courtesy of CHAS. J. ROSS Co., Philadelphia, Pa.

STUDY NEWSPAPERS AND MAGAZINES FOR ADDITIONAL EXAMPLES

THESE UNIQUE MATERIALS ARE NOT AS WELL-KNOWN AS THEY DESERVE
They offer astonishing possibilities in numerous directions

CHAPTER XV

DRAWING FROM THE PHOTOGRAPH
Pertinent Pointers and a Few Examples

FOLLOWING object drawing, the photograph affords a logical next step. In many ways it is easier to do than even the simplest object as it already has interpreted the original subject in a simplified manner on a flat surface and without color. Its values and forms do not alter with every change in light and shift in the artist's position; it looks the same one hour as the next.

Selection of Subject. Not all photographs are suited to sketching, however. Only interesting and well-composed subjects should be selected. Despite the oft-repeated assertion that "the camera cannot lie," it does not see things as we do. Distortion of perspective is frequent, while dark tones which the eye could penetrate often photograph black.

With a photograph selected, one must decide whether or not to do the whole of it. If he experiments with four strips of paper, placing them around it as a frame, sliding them here and there as a sort of view-finder, he will usually discover that it is not best to include it all. A comparatively small portion may prove enough for a single sketch; some photographs contain plenty of subject-matter for several.

Preparation. With a good photograph selected, it is well to clip the strips framing the subject securely so the unwanted portions will not prove distracting. After this, the photograph should be placed where it can be easily seen, as in an upright position at the far edge of the drawing table. If laid flat it will appear distorted and so be harder to do.

Blocking Out. The method is the same as for an object, though proportions are commonly enlarged.

Tracing and Transferring. The commercial artist, figuring his time is worth money, sometimes takes a short-cut in this construction, assuming his drawing is to be the same size as the photograph. He thumbtacks thin tracing paper over the latter and traces the main lines with a medium pencil. Removing and inverting this tracing, he relines each line on the back. Then, centering the tracing on the drawing paper, face up, and holding it securely, he once more relines the whole or rubs it vigorously with his knife handle, thus making a transfer. This method is excellent: it robs one, however, of the eye and hand training he usually needs.

Silverprints. Pen drawings of complex machinery and the like are often drawn directly on specially prepared photographs which are later subjected to a bath which bleaches the photographic images away, leaving only the drawing.

Preliminaries. With proportions laid out, one is wise to make a study before starting to render. An easy way is to lay tracing paper over the photograph and sketch the main values upon it. If the photograph has good values there is no point in altering them. As a rule, however, an increased amount of white is shown on a drawing, and other adjustments generally suggest themselves. The student does his real thinking at this time; if certain features seem to do more harm than good he eliminates them; he sees where something might be changed or added to advantage and he sketches the change or addition. In other words, he seeks to improve the subject, or at least to emphasize those elements of it which best serve his purpose.

Sometimes this preliminary is made over the outline layout; thus its development can be easily watched, as there are no tones beneath to puzzle the eye.

Final Drawing. No particular instructions seem necessary so far as the final is concerned; much depends on the medium. The preliminary is kept in sight while the final is in the making.

Plate 21 presents three sketches from the accompanying photograph. These, while not literal copies, exhibit comparatively few major changes in the subject. In adding figures and accessories, their scale must be watched. Here I have experimented. If the figure at 2 is right, isn't the vehicle at 4 wrong? Which seems correct to you?

PLATE 21 ·DRAWING FROM PHOTOGRAPH·

·1·

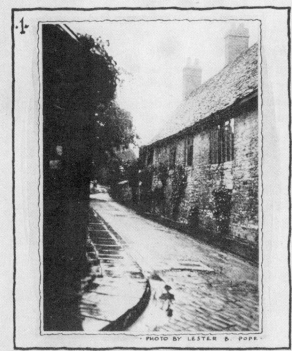

PHOTO BY LESTER B. POPE.

A VIEW IN LINCOLN · · ·

·2·

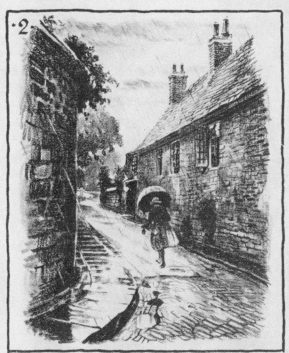

A CRAYON STUDY · · ·

·3·

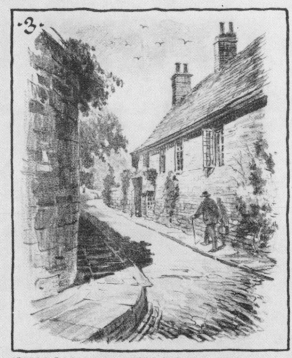

PENCIL AND WASH · · ·

·4·

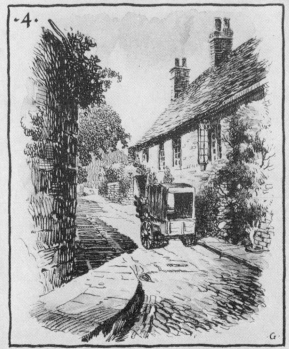

PEN AND INK, TINTED · · ·

THE PHOTOGRAPH CAN PROVE OF INESTIMABLE HELP TO THE STUDENT

It brings subjects of great diversity within constant reach

CHAPTER XVI

CAST DRAWING: FIGURE DRAWING
An Introduction to This Vital Subject

PLASTER casts have long been used as subjects for freehand drawing. They have many assets. Some of them, including those presenting the human figure and its details (heads, torsos, hands, etc.), offer a splendid transition between object drawing and work from the living model. Casts have no complex local values or colors to confuse one; they hold their pose indefinitely —a thing which living models can scarcely be expected to do—and they can be used at any time. They are not cheap enough, unfortunately, to permit most students to acquire a home collection.

So far as instructions are concerned, none are necessary; casts are handled exactly like the objects already described, any medium being selected. Charcoal and soft pencil are favorites; wash is suitable.

If casts of the human form are chosen as preparation for figure work, great care should be taken to draw them accurately, both as to proportion and value. Mistakes which in the case of most still-life objects would not be at all evident, are glaring when a subject of this type is used, so such casts offer a real test of skill. One should not turn to the living model until he has gained a fair mastery over them.

The Living Model. You realize, of course, that you cannot go far as an artist, excepting in a few rather limited fields, until you can represent people with considerable dexterity. Yet such dexterity is not easily acquired, especially if one works by himself. Therefore you should, if possible, join a suitable class where you can draw, under competent instruction, from the living figure, both draped and in the nude. In our limited space I can scarcely do more than offer this word of advice, cautioning you at the same time not to undertake such work until you feel sure that you have qualified yourself for it through such preliminary study as I have already described.

In such an art class you would not only make many drawings from living models, both male and female, but you would parallel this practice with serious study of anatomy, composition, and the like. In anatomy you would start with the skeleton, later turning to the muscles, etc. You would learn how the figure looks when running, walking, sitting and reclining—what positions the bones and muscles assume. You would learn how the entire pose of the figure reacts to such emotions as joy, sadness, fear, surprise. You would study facial expressions—what really happens when people smile, frown, talk or whistle. You would compare the characteristics of youth and age, and of the different races. You would make innumerable action studies, memory drawings and time sketches.

Gradually you would learn how to compose figures in relation to one another and to their surroundings. If particularly interested in illustration you would be made to realize that to the illustrator figures are much like actors under his direction: in placement, pose, facial expression, costume, lighting, etc., he must handle them intelligently.

This should be enough to give some inkling of the difficulties of figure drawing, and of the need of proper instruction. If one cannot attend a class, there is much that he can learn through constant practice. He should have a sketch book and draw people at every opportunity—people of all sorts doing all kinds of things under the greatest possible variety of conditions.

Then, too, there are excellent books. The Bridgman Publishers, Pelham, N. Y., offer some splendid ones, including *Constructive Anatomy*, *Bridgman's Life Drawing*, and *The Book of a Hundred Hands*, all by George B. Bridgman. Then there is *Anatomy and Drawing*, by Victor Perard, published by its author. If you study some of these they should prove of real help. Let me close, however, by again urging you to put yourself under capable instruction.

CHAPTER XVII

ON SKETCHING OUT·OF·DOORS
Let Mother Nature Be Your Teacher

OUTDOOR sketching is great fun! And it's mighty fine practice as well, testing one's best ability. Not only are all sorts of subjects available—buildings, ships, water, mountains, trees, etc.—but, for one reason or another, they constantly change in appearance, involving different problems from those usually faced indoors.

Medium. If we except color, the pencil or crayon is probably the most popular medium for such work; the lithographic pencil on cameo paper is a great favorite. The fountain pen is also fast gaining new adherents; it is frequently used in connection with the brush; see Plate 19. Wash is well liked; it offers splendid preparation for work in water-color.

Materials. Don't burden yourself with an excess of materials. Take all you require, but no more. Have an old newspaper along to sit upon. Dark glasses or an eyeshade may prove convenient if the sun is bright.

Subject. What shall you sketch? Almost anything you see! Don't roam for miles hunting for impressive subjects; simple, everyday things having character and individuality are better—back doorways, chimney tops, windows, wheelbarrows, sheds, and cabins. Vessels of all kinds have universal appeal. Dilapidated or extremely humble things often result in particularly fine drawings. Above all, avoid unusually large or complex subjects.

Point of View. Once you discover something which appeals to you, study it from various angles; walk around it, squinting at it through your finder, so as to locate the position from which it can be seen to best advantage. Don't stand too near; things a bit away are easier to do and insure more satisfactory results. Sit in a spot which permits reasonable comfort—a shady one if possible.

Spectators. Though you must gradually accustom yourself to spectators, I suggest that for a time you work where you will be at least comparatively free from them. There are problems enough to deal with without this added one.

Lighting. Some things are much more attractive under one lighting than another: there is a time of day when every subject appears to best advantage. Therefore in choosing your position lighting may prove a leading influence. Always seek an interestingly lighted subject.

One of the real difficulties in drawing outdoors comes from the constant change in the shapes of the light, shade, and shadow areas. A sketch should give the impression of a single instant of time. Don't try to alter your drawing from minute to minute to keep up with every shift in the sun's position.

Procedure. Once you have taken your position, go about your work as you would indoors, though here speed is more essential. First, analyze your subject. The most significant elements are to be well expressed, and non-essentials subordinated or omitted. Constantly aim to simplify. Don't include so much in your sketch that the eye will be disturbed by a rivalry of conflicting interests; the beginner generally tries to picture altogether too much. It is often well to concentrate the attention around the central areas of the subject, rendering these more completely and definitely than the remainder. With such a "center of interest" your drawing, when finished, can be read at a glance.

When you draw, draw boldly. A fearless, bad sketch is better than a timid, inoffensive one. So attack the drawing vigorously. Don't be afraid of black. And don't work too long. Many a drawing has been ruined by excessive finishing.

Keep persistently at your sketching and you will be amazed at the progress you make. Sketch at every opportunity.

Study the outdoor sketches among the coming supplementary drawings; copy some of them, if you wish, as preparation for your own outdoor work. And by all means read F. Hopkinson Smith's *Outdoor Sketching*.

CHAPTER XVIII

TREES AND OTHER LANDSCAPE FEATURES
Comparative Treatments in Several Media

OF THE various subjects which the student of outdoor sketching encounters, few prove more difficult than trees and like landscape features. He would therefore do well to concentrate on them for a while.

The Skeleton. A logical starting point in tree study is the skeleton of trunk and branches. It is highly advisable to draw trees when they are leafless in order to get a real understanding of tree anatomy: see the winter study at 3 (C), Plate 7. Even in summer the skeleton is often evident, as at 1, Plate 22.

Foliage. When one has sketched tree skeletons until he has a fair mastery over the common systems of growth, he should turn to foliage representation. This is somewhat tricky, for obviously it is impossible to draw each individual leaf. One must learn to suggest or indicate. Methods vary according to species, media, and the whim of the individual; the main thing is to try to represent leaf masses as living things, soft and yielding. One should not take his position too close to trees; like other subjects, they look far more simple from a little distance and hence are easier to do.

Silhouettes. Most species of trees have distinctive characteristics, one of which is basic form or contour. We can usually identify the common varieties such as elms, maples, and pines by silhouette alone, as when seen against an evening sky. One should draw many such silhouettes in solid black in order to memorize these forms; later, in rendering trees in full value, he should make sure they are correctly profiled.

Lighting: Values: Shadows. Excepting for this silhouette work, trees, both skeletons and leafage, must customarily be modeled to express normal light and shade: the direction of light should always be noted. See Sketches 1 and 3, Plate 22, both of which were done outdoors. Notice in these how the "bones" darken as they run up into the gloom of the leafy shadow. Tree trunks and branches, incidentally, are by no means of the middle value in which students so often represent them. Instead, they appear extremely light in sunshine and equally dark in shade. Branches often cast conspicuous shadows on trunks or other branches. The shadows which trees cast on one another and on the ground, sidewalks, buildings, etc., also need study. They vary in shape and value according to the surfaces on which they fall. Shadow edges must be treated with extreme care.

Technique. I have said that foliage indication is tricky. One would do well to experiment with various media and methods. Plate 22 offers a number of suggestions. The pen, used in Sketch 1, is quite well suited to this purpose, though rather slow. The pencil is splendid, and adaptable to many treatments; for a typical one, see Sketch 3. Charcoal and crayon are also good, especially when the scale is large. In Sketch 2 the pen was used rather hurriedly, washes being added to simplify the values. Pencil and wash are often effectively combined in much this same manner. Wash alone was employed in Sketch 4; we have mentioned elsewhere that this medium is capable of very photographic effects, making it splendid for careful studies.

Note in Sketch 4 that the more distant trees are quite light in value and reveal relatively little modeling. Nature gives us this effect, distant foliage masses often showing as practically flat planes.

Grass: Bushes. Shrubs and bushes are, of course, much like trees, while grass can be handled with somewhat similar indications, though the strokes are generally considerably straighter. If one sketches from Nature, logical methods will doubtless occur to him. If not, he should turn to drawings by others for pointers.

The main thing in all such practice is to have the patience to try repeatedly; one will gradually pick up the needed tricks if he works intelligently and perseveringly.

PLATE 22 · TREES : LANDSCAPE · · ·

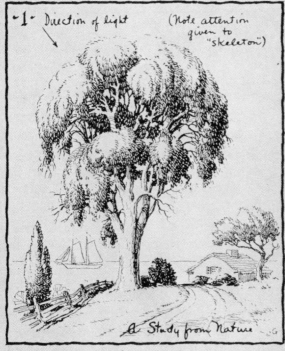

-1- Direction of light (Note attention given to "skeleton")

A Study from Nature · G

PEN AND INK · · ·

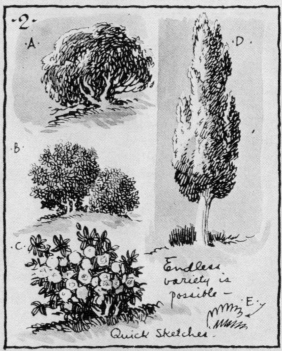

-2- ·A· ·D·

·B·

·C·

Endless variety is possible — ·E·

Quick Sketches·

PEN AND INK, TINTED · · ·

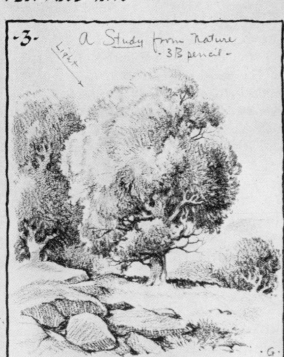

-3- A Study from Nature - 3B pencil -

Light

·G·

PENCIL · · ·

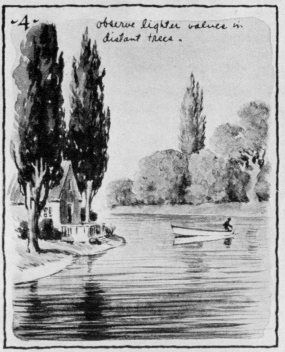

-4- observe lighter values in distant trees.

WASH · · ·

OUTDOOR FEATURES OF EVERY TYPE DEMAND EARNEST CONSIDERATION
Almost every subject offers its individual problems

CHAPTER XIX

A WORD ON INTERIORS AND FURNITURE
A Number of Techniques and Their Uses

THERE really is no great difference between drawing indoors and out; the same methods apply to both. Appearances indoors are quite different from out, however, as already explained. This is mainly because a large part of the illumination indoors is indirect. Outdoors the light is usually very strong, and the rays, falling from a single source, far away, may be considered as parallel. With rare exceptions an object in sunshine casts but one shadow, and this is distinct, with its edges comparatively sharp. Indoors, contrarily, if we overlook such surfaces as may chance to be in sunshine, illumination is much softer. The light, instead of coming in the form of parallel rays from a single source, is diffused, every window or other opening acting as a separate source from which the light spreads in all directions. To complicate matters further, this light, striking walls, floors, etc., is reflected from surface to surface. A ceiling beam—to show the action of reflection—frequently casts a shadow on the ceiling because it interrupts light thrown from below (see Sketch 3, Plate 23). A lighting fixture, where it contacts the ceiling, may show a number of radiating shadows.

Under artificial illumination indoors, although we usually find contrasts in light and shade more definite than under natural illumination, with a majority of shadow edges sharper, the radiation is even more marked than before, and if there are several lamps, each proves a center of radiation, the light and shade areas crossing and recrossing, one modifying another. So, both night and day, indoor light and shade can be very complex.

This may prove either to the advantage or to the disadvantage of the student. It is to his advantage in that in making interior drawings he can do much as he pleases with his lighting effects, within reason, and no one can question his truth. It is to his disadvantage in that the complication of effect in real interiors may sometimes confuse him; he must constantly aim, in his studies of real things indoors, to simplify his tones, merging them and sacrificing those which seem unimportant or ill suited to his purpose.

Plate 23 shows several interior treatments. The first was sketched freely in brown ink and toned with sepia. Objects contrasted with bright light seem much darker than they actually are; here the light was emphasized by deepening the surrounding values. Note also how the window sill and table top, horizontally placed beneath the light source, mirror the brilliancy from above.

Whereas the perspective of this sketch was laid out by eye (the little seat shows faulty convergence), Sketch 2 was accurately constructed instrumentally. Its value scheme is less realistic than that in 1, however, as is fitting, for this is a conventional drawing such as is often made for advertising purposes or to illustrate articles on home furnishing or decoration. Comparing Sketch 2 with Figure 1, Chapter II, the latter shows more natural light and shade, but less natural local values; pen, rather than wash, was used for the grays.

Sketch 3, Plate 23, is again somewhat realistic. Based on a photograph, it was quite freely and fully completed with a wax pencil, after which a tint of warm gray was added. See how a center of interest has been built about the fireplace, the extremely dark opening of which intensifies, through contrast, the surrounding area of light, which is further reinforced by its frame of gray.

Compare this drawing with that of the similar subject, Plate 14. Though in composition these are related, the center of interest of each being built in much the same manner, texturally there is little resemblance. Which do you like better? Why? Note that though both these drawings have strong contrasts of tone and quite definite detail near the center, they are softer at the edges; this is good practice.

PLATE 23 · INTERIORS AND FURNITURE · ·

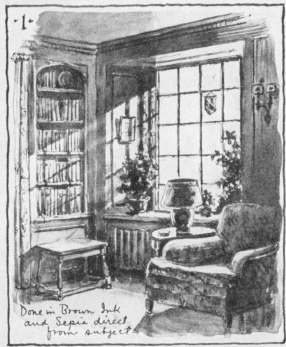

·1·

Done in Brown Ink
and Sepia direct
from subject

·2· ·NOTE SIMPLE VALUES·

·G·

A QUICK SKETCH (HALF HOUR) · · A CONVENTIONAL TREATMENT

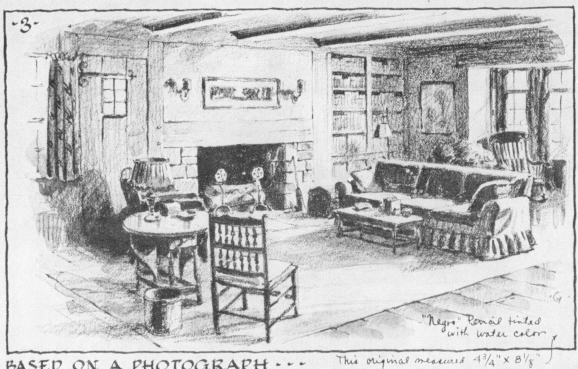

·3·

"Negro" Pencil tinted
with water color

BASED ON A PHOTOGRAPH · · · This original measures 4¾" X 8⅛"

INTERIORS CAN BE HANDLED IN PRACTICALLY ANY MEDIUM AND TECHNIQUE
They present splendid contrast to other types of subjects

PART 2

A PORTFOLIO OF SKETCHES

PRESENTING EXAMPLES BY
MANY ARTISTS, SHOWING A
WIDE VARIETY OF SUBJECTS,
MEDIA AND TECHNIQUES

*Each with a Few Words of Comment
by the Author*

GROUP I · THE GRAPHITE PENCIL, FINE LINE

THOUGH the same artist, C. Westdahl Heilborn, was responsible for the two accompanying examples of fine line pencil drawing, it will be noted that they are quite dissimilar in handling. The pleasing subject below is on the whole more delicate and far less daring than the other, the individual lines appearing for the most part to be rather slowly drawn. The way in which many of the grays of the shadowed areas have been constructed of groups of strokes alternating in direction is worthy of notice. When this is done care must be taken, as here, that these groups are brought into close contact in order to form a homogeneous whole; otherwise a very patchy effect may result. The economy of line used in suggesting the timbering and roofing materials is commendable; the reinforcement of the shadow edges by bounding lines is interesting, too, as is the variation in weight of all strokes throughout, according to their purpose.

In the larger drawing opposite, the subject, with its motley array of quaint buildings, is again attractive; the viewpoint is skillfully chosen and the difficult perspective capably handled. The values are well composed, too; the smaller black touches are nicely distributed and add vitality to the whole. The dashing technique should be carefully studied. Not only is it consistent with the subject, but it offers a pleasing variety of line and tone—there is not a square inch of surface which is tiresome.

The danger in such a subject lies in getting too wide a distribution of interest. Here the close massing of the separate structures, their similarity of form and character, and the excellent value composition, help to unify the whole. The lines of the long stairs, leading the eye into the picture, prove another unifying factor. Real skill was used to keep the subject from "flying to pieces." This drawing was produced, incidentally, as a study for an etching.

See, at this time, Plate 7, and read the accompanying text, page 35, Part I.

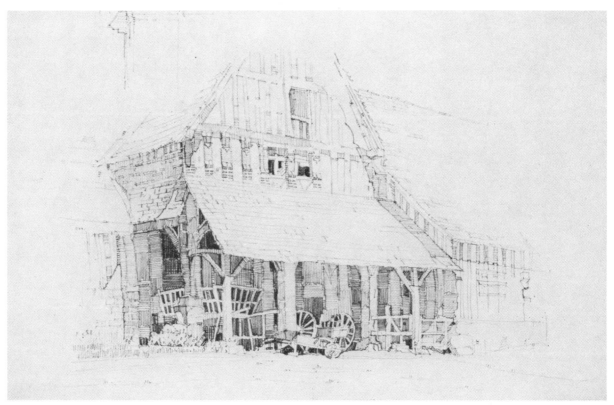

Original, 9" x 5½"

A FINE LINE PENCIL DRAWING ON CAMEO PAPER BY C. WESTDAHL HEILBORN

The interest is concentrated about the center, the edges being skillfully vignetted

[70]

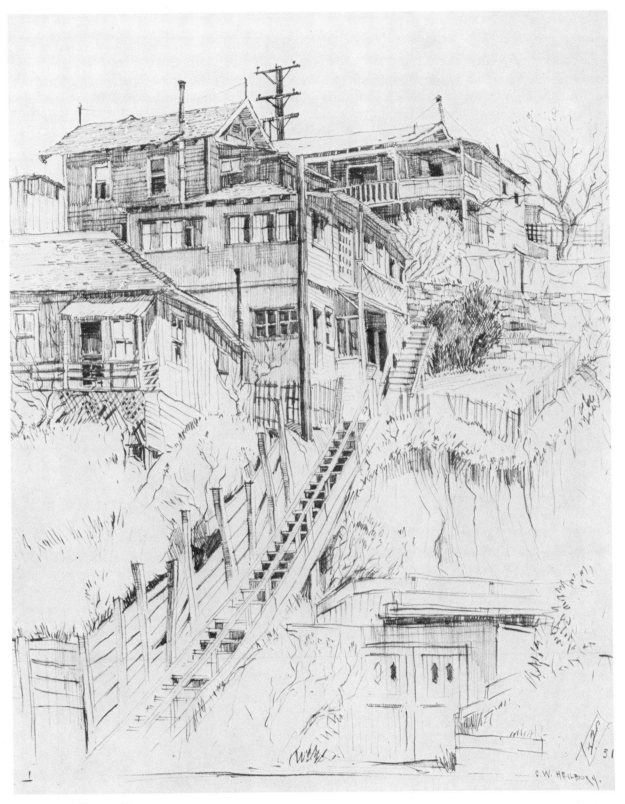

Original, 10¼″ x 12¾″

"HOUSES ON THE HILL,"—PENCIL SKETCH BY C. WESTDAHL HEILBORN

This free treatment (a study for an etching) sympathetically interprets the picturesque subject

GROUP II · THE GRAPHITE PENCIL, MEDIUM LINE

LOIS HOWE'S little sketch below portrays another subject of unusual appeal; few of us have been privileged to see the interior of a windmill such as this one at Bass River. The technique, which the beginner should note is free from the self-conscious quality which is all too apt to characterize his own work, is well adapted to the expression of the age and condition of the subject. The values are well distributed. The whole thing, in short, is splendid.

Clinton Loyd's sketch exhibits much the same apparent freedom of effort. The spectator likes to feel that an effect is easily arrived at. Subjects like this at Bruges offer one point of danger: unless care is taken to prevent it, two competing centers of interest may develop, one above and one below. Here the life in the street, plus the strong surrounding contrasts, effectively prevents any such difficulty. A technical point of interest is the way in which the back-and-forth strokes on the receding wall at the left converge towards a distant vanishing-point.

Mr. Wilson's sketch opposite, done on cameo paper, shows a particularly free, buoyant technique which gives it a breezy individuality. Some develop such a technique with little effort, but it is the despair of a majority of students, most of whom are afraid to "let go" in this way. Their work clearly shows the restraint they feel.

Even a man of experience might have some misgivings about tackling this massive structure, with its many visible complexities. Mr. Wilson has managed it very well, however. He exercised rare judgment in seizing upon the real essentials, and equal skill in recording them. With a few deft strokes he caught the mass and weight of the uncompleted building. Note, too, the clever indications of the scaffolding, derricks, and fence; study the suggestive, but adequate manner in which he has interpreted the people and automobile. This procession of people, by the way, performs an important function in leading the eye into the picture.

Original, 7″ x 10″

"WINDMILL INTERIOR," BY LOIS LILLEY HOWE

Unusual subjects offer splendid possibilities

Original, 8″ x 11″

"BRUGES," AS SKETCHED BY CLINTON F. LOYD

The various materials are capably indicated

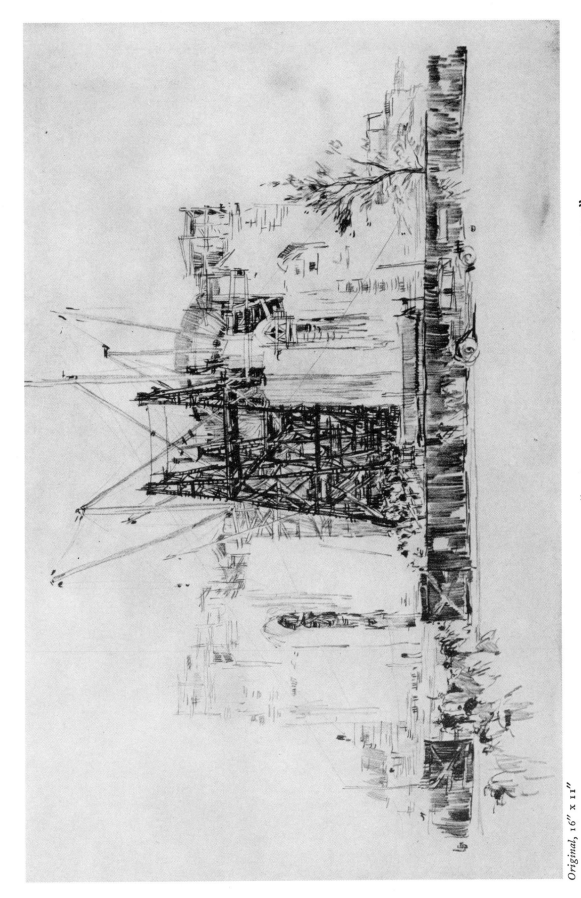

Original, 16" x 11"

PENCIL SKETCH BY A. L. WILSON, "SUNDAY, CATHEDRAL OF SAINT JOHN THE DIVINE"

With delightful freedom and spontaneity, coupled with economy of method, the artist has recorded the essentials of this complex subject

OUR street scene below, with its many buildings of contrasting size and type, is a subject which, as originally seen outdoors, might well have proved so confusing as to be rejected as too difficult, yet as Mr. Lantz has handled it, with alternation of lights and darks, order has been produced where chaos could easily have resulted. The beginner is strongly urged, if he attempts a subject as difficult as this, to lay tracing paper over his outline layout and make a preliminary study, deciding what to include and how to treat it. Suggestion, rather than literal interpretation, is what is usually sought.

Mr. Knobel, however, has chosen in his sketch to adopt a more photographic method, particularly as to tone relationship, but so well has he managed his values, and so ably is the whole vignetted, that the effect is by no means labored or over-exact. It would be helpful for the student to apply both these methods to like subjects.

Thornton Bishop's pencil sketch, opposite, is reproduced at sufficient size to show clearly its application of the broad point. Like so many of our examples, this was drawn on cameo paper, which not only takes the wash-like tones of the broad point to advantage, but permits sharp touches to be used where needed—note those on the brickwork and foreground figures. Erasure is not easy on this surface, so one should draw as directly as possible.

Observe that the darks of the archway and to the right of it were arranged to count vigorously against the lighter areas in the foreground and to the left. This helps to produce a feeling of bright sunshine and does much towards centralizing the attention. The dark tones towards the top of the structure help to heighten this effect of brilliancy below.

The student would do well to copy this unusually fine example, as it shows the strokes so distinctly. Compare this, too, with the broad line example by Ernest Watson, Group XI.

See likewise Plate 8 and read page 37.

Original, 11¼″ x 14¼″

"BROKEN MASSES," BY F. W. LANTZ

A complicated grouping restfully composed

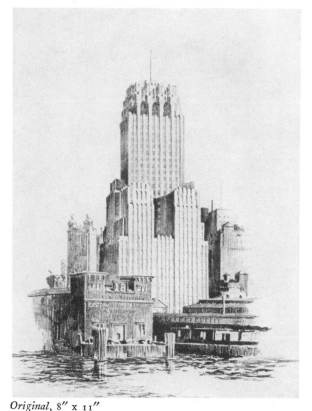

Original, 8″ x 11″

A PENCIL STUDY, BY JOHN W. KNOBEL

The "spotting" of light and dark is good

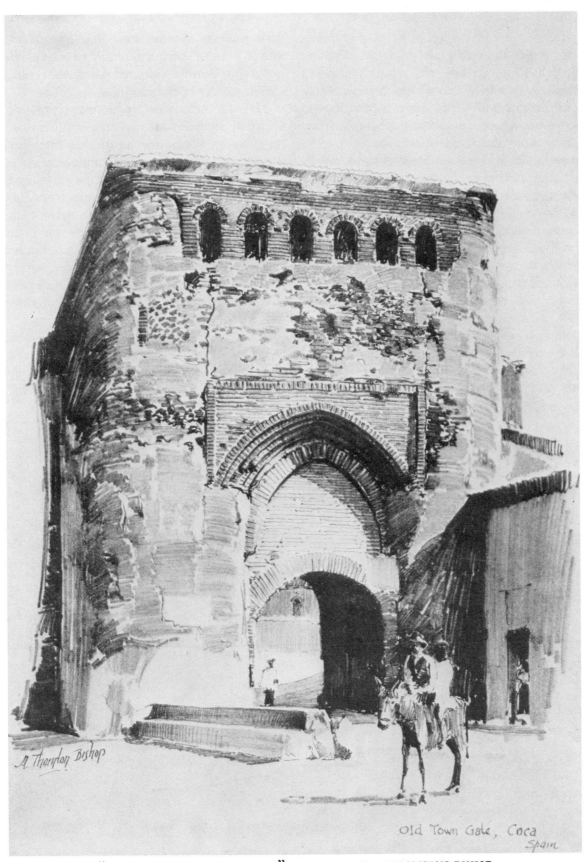

"OLD TOWN GATE, COCA, SPAIN," SKETCHED BY A. THORNTON BISHOP

Especially notable is the treatment of the different materials, including the brickwork

[75]

GROUP IV · THE GRAPHITE PENCIL, SOLID TONE

NOW we turn to John Frank's drawing, which depends mainly on mass shading rather than line, utilizing also a highly effective scheme of composition which Nature often shows us and which has many applications in Art. In the foreground is the main subject, appearing as an almost flat silhouette against the sky and a flat background plane beyond. Sometimes three or more separate planes are used, one against another, producing splendid distance.

When an object is in silhouette, like the fountain and balustrade here, its form must be carefully composed, for this is practically all that the eye sees. Mr. Frank has made of his sketch a pleasing pattern or design, both the near and far planes showing contours which, as the result of careful planning, complement one another. Even the figure at the right is part of a definite scheme.

The irregular texture of this drawing is another point of interest—with a rough paper a mere suggestion of detail or of coarse-grained

surfaces goes a long way. Rough paper also makes possible with minimum effort an interpretation of atmospheric vibration, the scintillation of sunshine, and the like.

Mr. Hechenbleikner's drawing presents a variation of somewhat this same scheme of contrasty composition, for he utilizes his near-by derrick and members of structural steel as a sort of marginal silhouette to frame the view beyond.

This is, incidentally, an extremely painstaking study—witness the handling of the derrick —yet its composition, including its tonal qualities, is so excellent that one thinks only of the splendid impression of the whole, with no thought of any over-elaboration of detail. Nor is one conscious of the technique, for, though well managed, it is inconspicuous; as usual, it is the values, more than the technique, that make this drawing an outstanding one.

Another lesson brought to our attention by this example is that industrial subjects of many kinds are excellent for sketching.

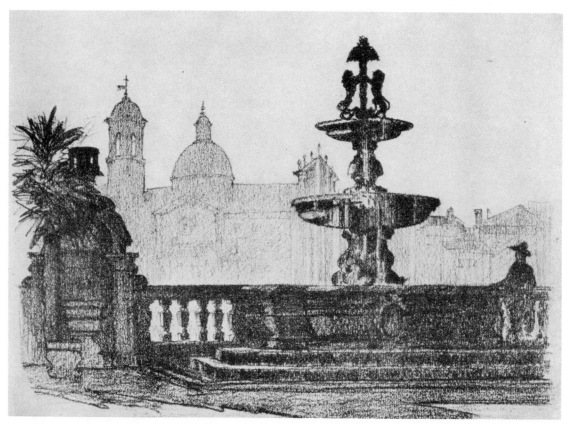

"FOUNTAIN IN VITERBO,"—A PENCIL INTERPRETATION BY JOHN A. FRANK
Note the two distinct "planes," one nearby and one distant: Nature offers like contrasts

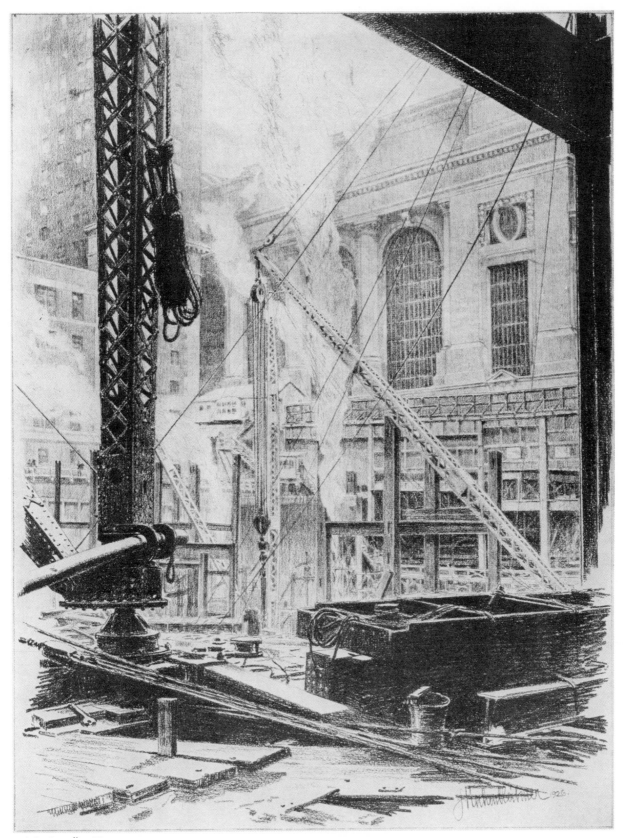

Original, 16" wide

AN INDUSTRIAL SUBJECT DONE IN PENCIL BY LOUIS HECHENBLEIKNER

Though separate strokes can be discovered, the effect depends on a capable balance of tone

GROUP V · LITHOGRAPHIC AND CARBON PENCILS

THE lithographic pencil, originally developed for drawing on lithographic stone, seems to gain greater and greater popularity from year to year for ordinary sketching, mainly because it gives off its black so freely and glides so smoothly over the paper. Below, opposite, and on the following page we present typical sketches in this medium.

Mr. Ulrich's drawing shows a somewhat unusual, and for that reason attractive, subject. It was sketched from a satisfactory viewpoint and the interest is well centered, the use of strong contrasts of black and white emphasizing the area of focus. The line is crisp and free. Especially well handled are the piles with their cross bracing. The dark foreground mass gives distance. It is helpful to compare this sketch with others by the same artist, pages 88 and 92.

Mr. Schiwetz, in his "Broad Street," has also chosen cameo paper, which is ideal for work with the lithographic pencil. With his subject so

complex he wisely decided on a suggestive treatment. Much detail has been omitted entirely. In the tall structure at the left, for instance, note the gradual omission of windows, etc., as the walls drop below the foreground buildings. See how the contrasts have been kept strong about the center of interest, and how nicely the entire subject has been vignetted. The indication of automobiles and people is notable. More than this, the artist seems to have caught a sense of the pulsating life of the city—even of such intangible things as its sounds and odors. The student should try some impressions of this same general type, from either photographs or real places; it might be well to copy this first.

Stanley Johnson's sprightly drawing is not unlike Ulrich's in its values and general handling. As a point of similarity note the treatment of the shadow tone beneath the main-roof overhangs. In both examples the shadows are represented by vertical lines, accented at their lower

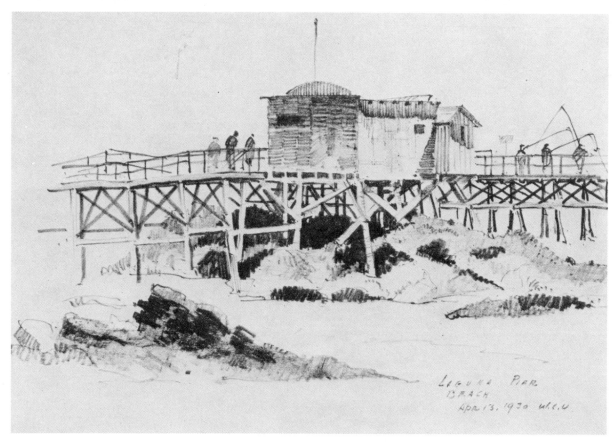

FROM A LITHOGRAPHIC PENCIL DRAWING BY WILLIAM C. ULRICH

A crisp, snappy example with a decidedly evident "sketched on the spot" character

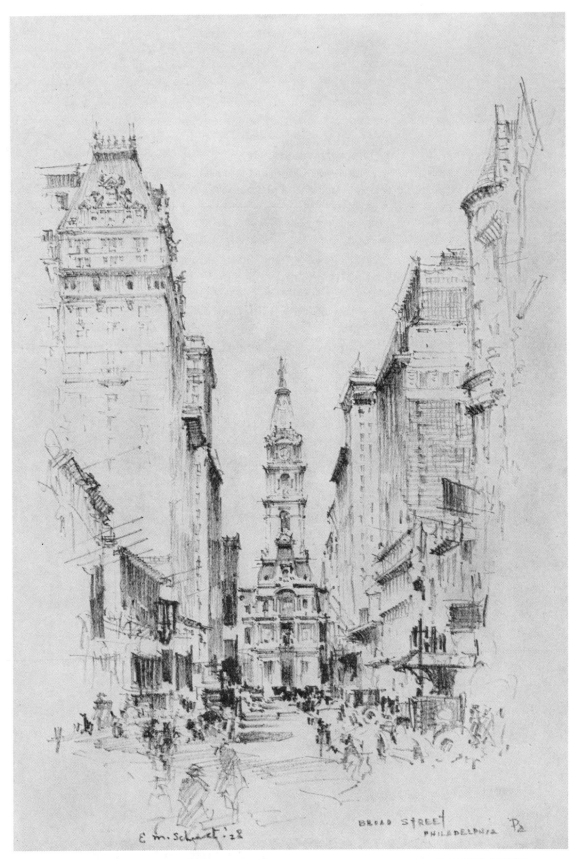

EDWARD M. SCHIWETZ DREW THIS LITHOGRAPHIC PENCIL SKETCH ON CAMEO PAPER

This pencil and paper offer great possibilities, as the sketch so effectively demonstrates

ends; this increases the effect of sunshine below and of transparency within the shadow. The use of black is another common factor. We can profit by comparing the diverse strokes which Johnson has used in interpreting his foliage masses.

When the artist faces a view as broad as that offered by Mr. McCall, he is frequently confused by its intricacy. So many things fall within his range of vision that he scarcely knows what to put in and what to leave out. He must eliminate, suppress, suggest. In the present case the artist, with a minimum of apparent effort, has arrived at a superb result. He has shown enough of the view before him, and just enough, and he has so arranged the selected elements that they form a pleasing pattern or design. More than this, he has been particularly successful in catching the spirit of the time and place; one can almost sense from this sketch the life and movement of this huge metropolis.

The rough paper selected made McCall's task far easier than it might otherwise have been. Distance, atmosphere, and detail have all been adequately indicated by choosing the right paper and using it in the right way.

Now let us turn to Hubert Ripley's dramatic study. Here the carbon pencil was employed, a certain amount of smudging being done. Only a half hour or so was spent on this sketch, for the artist, with rare powers of perception and consummate skill at delineation, was quickly able to produce this graphic, animated record. He has caught a fleeting impression, his drawing clearly conveying the feeling of a single instant of time. How often we all see just such effects in Nature but how seldom we find them satisfactorily imprisoned on paper!

Observe the manner in which Ripley has utilized contrasts of light against dark and dark against light, noting, too, the richness of his deeper tones. In short, analyze the whole thing; it is worthy of the most careful study.

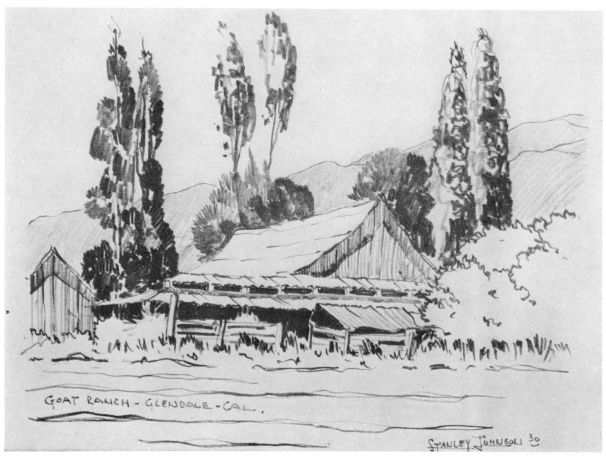

Original, 9″ x 7″

STANLEY JOHNSON WAS THE ARTIST OF THIS LITHOGRAPHIC PENCIL DRAWING
Its directness and vigor are highly commendable; the student should emulate these qualities

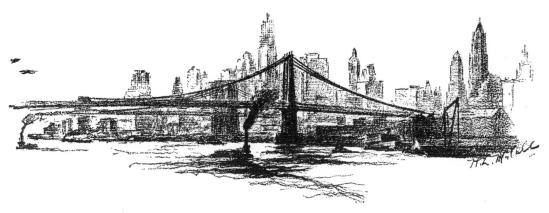

A SIMPLE BUT DELIGHTFUL IMPRESSION BY H. L. McCALL
Rough paper was responsible for the interesting texture, with its suggestion of atmosphere

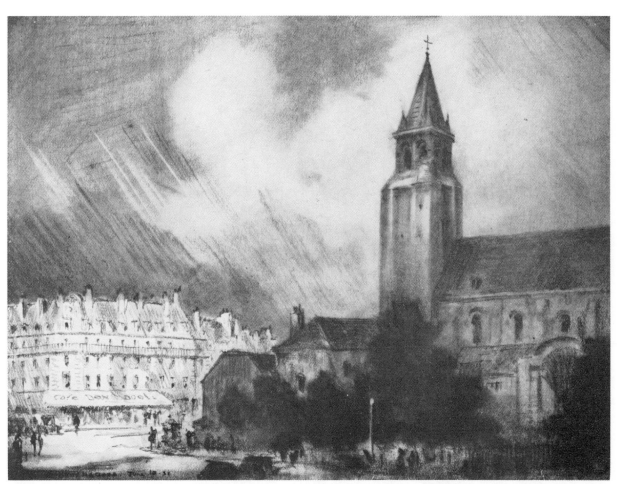

Original, 8″ x 6″

"THE CAFÉ DES DEUX MAGOTS AND ST. GERMAIN DES PRÈS," BY HUBERT G. RIPLEY
Here the carbon pencil has been capably employed in a rather charcoal-like manner

[81]

DRAWINGS and paintings of the water-front seem to hold a strong interest for most people; artists as a rule enjoy making them. Mr. Viele's sketch shows a scene which in a way typifies the entire shore line of New York City. Tugboats, freight cars and sheds, masts and stacks are all woven into a sort of decorative fabric of great appeal. For such subjects, where one customarily seeks broad effects rather than labored delineation of detail, crayon and charcoal have many advantages. Here the former was employed, while Mr. Chrystie, in his similar subject, Group XI, chose the latter. In all such work values are of the utmost importance. Mr. Viele's are simple, considering the complexity of the matter included, yet the "busy" lines of

stacks, masts, and the like suggest the hustle and bustle of the neighborhood.

Ernest Born, in his characteristically masterful treatment opposite, has interpreted quite a different place and mood. His sketch was made entirely from Nature late one evening, the sky being afterwards washed in with ochre.

It is hard to offer worth-while comments on such a sketch as this, for it acts on the feelings rather than on the mind. Despite its technical vigor, it bestirs somewhat the same feeling of reverence as is awakened by the ancient structure itself. One thing which is tangible is the excellent treatment of the values, the distribution of the lights and darks being particularly fine. The darkening of the tower and other upper features

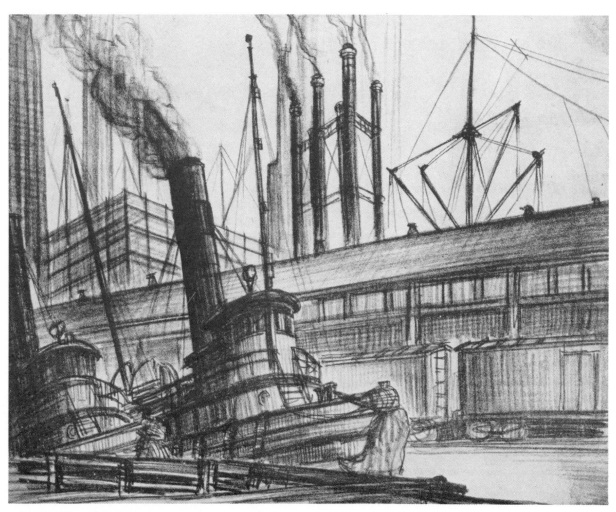

Original, 17" x 13½"

"THE WATERFRONT, NEW YORK," SKETCHED IN CRAYON BY SHELDON K. VIELE
This demonstrates plainly the value of crayon where speed or strong contrasts are essential

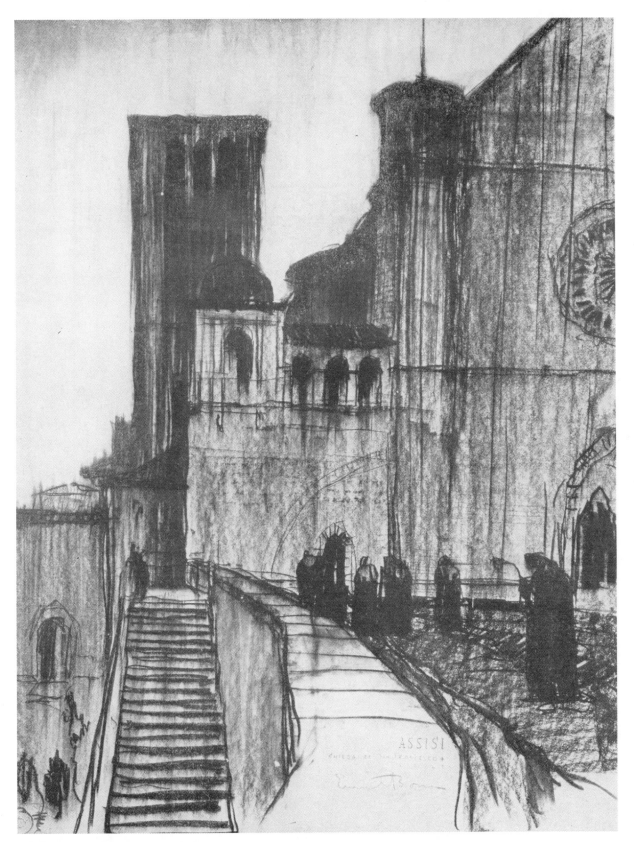

Original, 19″ x 25″

A CRAYON DRAWING BY ERNEST BORN, "CHURCH OF SAN FRANCISCO, ASSISI"

This masterly sketch, in black crayon on creamy-white paper, adequately portrays this famous subject

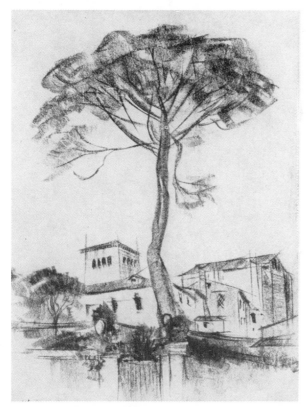

RED CONTÉ CRAYON SKETCH BY A. C. WILLIAMS
Quickly done yet extremely expressive

"spot" on the paper, which, in turn, is subdivided into additional spots of interest, their distribution and character being managed without the slightest display of effort.

Mr. Skidmore's sketch, with its exceptionally wide strokes, points to a method which the student would do well to imitate in outdoor work where time is at a premium. It is suggestive of shorthand notes in its brevity and conciseness of statement, though unlike them in that its message is clear to all at a glance. Observe that the verticality of the architecture is emphasized by vertical strokes, while horizontal strokes interpret the flatness of the ground. Take a ¼″ crayon, like that pictured in Plate 13, and play with this fascinating method.

of the building to join as a silhouette against the sky, as they would at this late hour, is worthy of note, as is the introduction of the complementary darks below, particularly the hooded figures. The worshipful attitude of these figures is consistent with the subject. In fact, the entire drawing is consistent, as Born's work invariably is.

Technically the drawing is capably managed. It is a matter of despair to many a beginner that when he attempts a bold, free treatment of this sort he develops only a mussy mess. Sketches like this by Born, which seem to have been produced easily (and often were), are actually harder to imitate than are studies in more exact detail or done with greater finish.

Added evidence that crayon, in its varied forms, is adaptable to many subjects and handlings is offered by the two jolly little sketches on this page. What could be more delightful than the subject by Mr. Williams? Or more expressive, time and effort considered, than that by Mr. Skidmore? The former presents a marked pattern quality, the whole producing a pleasing

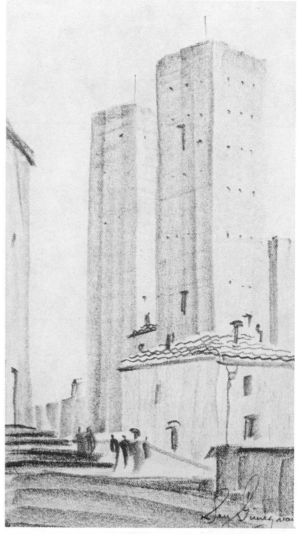

"SAN GIMIGNANO," DRAWN BY LOUIS SKIDMORE
A convincing result of an economical method

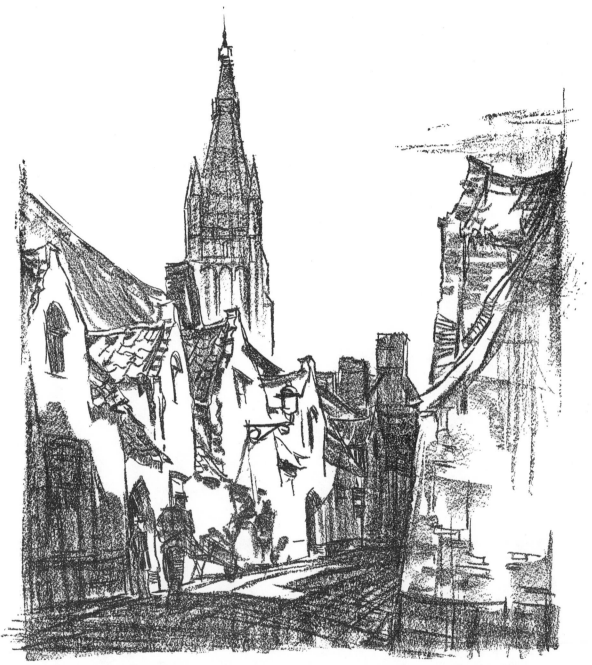

"OLD BRUGES,"—A LITHOGRAPHIC CRAYON SKETCH BY WALTER R. RHODES, PAINTER
The crayon is ideal for suggestive indications such as this admirable drawing offers

Walter R. Rhodes, for his drawing of a Bruges street, selected a lithographic crayon and a roughish paper. With a modest amount of tone and a few deft touches of line he succeeded in quickly producing a sketch eloquent of his picturesque subject. He used little black—even his shadow tones are of a vibrant transparency—yet his sunshine seems bright. Particularly interesting is his suggestion of textures, as on the

wall in the right foreground. The solidifying of the distant tower to count as a pale, simple silhouette against the sky is laudable; observe how this tower has been detached from the buildings below, taking its proper place in the distance.

An important part of the artist's training is to learn to choose the right medium and method for his subject and mood. How, excepting with a rough paper and the crayon, could Mr. Gon-

zalez have given us his rarely successful representation of a scene in Italy? Though definite to a point, with a well-reinforced center of interest, this sketch has just enough vagueness to permit the spectator to use his own imagination in its interpretation. For many purposes such a treatment has more appeal than has a dry statement of fact, as this drawing so well proves. Especially interesting are the figures. Not one of them is fully depicted, yet our esthetic sensibilities are satisfied. Such suggestions look easy, but try them!

As pastel is synonymous with color, and as color is scarcely within our scope, we show Mr. Henderson's decorative study opposite only to introduce the reader to this medium of many possibilities. The drawing, with its buoyant, decorative character, needs no praise; it speaks for itself, though not with the moving utterance of the colored original. The reader interested in this medium could scarcely do better than study Richmond and Littlejohns' *Art of Painting in Pastel* (Pitman). It offers a practical text and contains numerous illustrations.

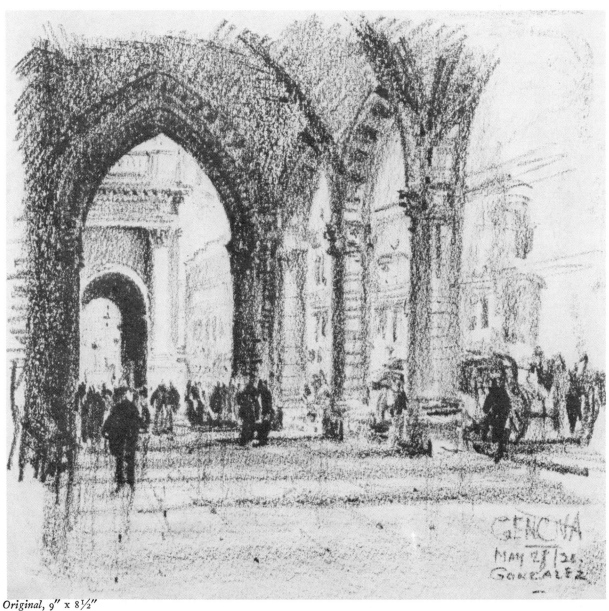

Original, 9″ x 8½″

"GENOA,"—A BRISK YET SUBTLE CRAYON INTERPRETATION BY GUILLERMO GONZALEZ

The strong center of interest and the texture due to rough paper are features to study

"THE KNOLL,"—PASTEL BY HARRY V. K. HENDERSON, DRAWN ON VIOLET-GRAY PAPER

A reasonable amount of work in black crayon is excellent preparation for this pastel drawing in color

GROUP VII · COMPARATIVE CHARCOAL TREATMENTS

CHARCOAL as a linear tool is not as well known as it deserves to be. A rather hard stick, sharpened to a point, is well suited to many types of line work.

In the sprightly example below, Mr. Ulrich has relied on charcoal for a combination of line and tone, with emphasis perhaps on the former. Though he has made no pretense of a faithful and complete delineation of every detail of his extremely interesting subject, he has nevertheless succeeded remarkably well in bringing before us its vital attributes, presented with a zest and vigor which is highly stimulating. A feature worthy of attention is his use of strong slanting lines across the main façade, opposed by slants in the sky, approximately at right angles.

Mr. King's study, quite unlike that by Ulrich, makes use of tone, rather than line, and places emphasis on quiet and repose. It is a straightforward, unmannered presentation, which, though offering subtle suggestions rather than blunt statement, seems extremely true and convincing. Of particular interest to the student should be the somewhat indefinite, yet wholly adequate handling of the trees and foliage: the foreground bushes are particularly well done. The tree shadows, as across the walk, lawn, and near-by building, are also unusually pleasing. The architectural detail is managed with rare skill, too,—observe, for instance, the clever indication of the Ionic caps at the right. Mr. King understands the art of omission.

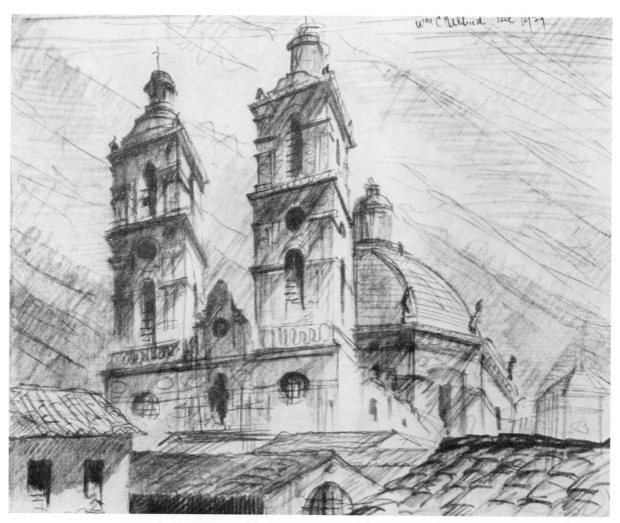

THIS FREE, DASHING CHARCOAL SKETCH IS BY WILLIAM C. ULRICH

The medium was used mainly in a linear manner, mass shading appearing in limited areas only

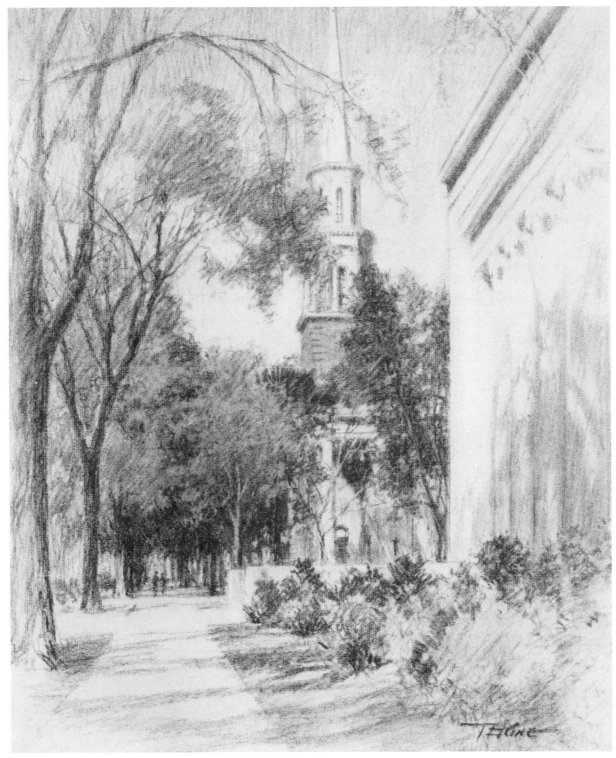

Original, 17″ x 20″
"UNITARIAN CHURCH, TOLEDO, OHIO," DRAWN IN CHARCOAL BY THOMAS EWING KING
Though some lines are evident, this pleasing effect results mainly from good relationship of tones

THOUGH we have classified the accompanying examples as "wash drawings," this is, strictly speaking, a misnomer, for they were, in the original, water-colors. Hence they have lost much in reproduction. Despite this, they are so like wash drawings in general character that they serve our purpose perfectly; furthermore they stand as proof that in doing work in color as careful attention should be given to value as to hue.

Mr. Wank's subject and point of view are capital. Though probably not deliberately sought, a somewhat decorative effect results from the representation of so many similar wall and roof planes, with the dome crowning all. The whole is bathed in sunlight, made the more evident by the contrasting sky and the crisp, dark shadows, together with the accented windows. The sharp edges of the shade and shadow areas make the whole seem even brighter. As a matter of detail, the simple indication of the tile work should be studied, as should the texture suggestions in the foreground. Note the typical wash on the line, and its shadow.

Mr. Bailey's example, which photographed with the values for the most part somewhat lighter than in Mr. Wank's sketch, suffers in particular for want of the color of the original, though it still offers a suggestion of its freshness and bloom. Whatever subject this noted artist chooses, and whatever his medium, he unerringly selects just the right point of view and stresses with perfect discrimination the vital elements. His technical skill is too well known to require comment. Furthermore, his work always seems to convey the feeling that sketching is fun (as it is); he imparts to each drawing something suggestive of his own enthusiastic personality. One

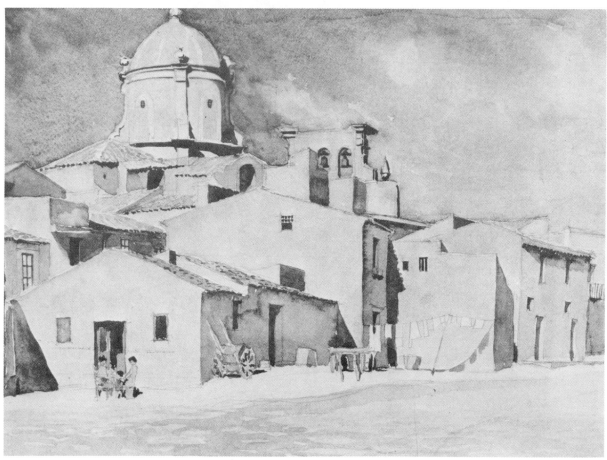

Original, 19" wide

SIMPLE BUT BY NO MEANS BARREN IS THIS SKETCH, "SIRACUSA," BY ROLAND A. WANK

The subject is interesting and the choice of viewpoint happy. Note the punctuating accents of dark

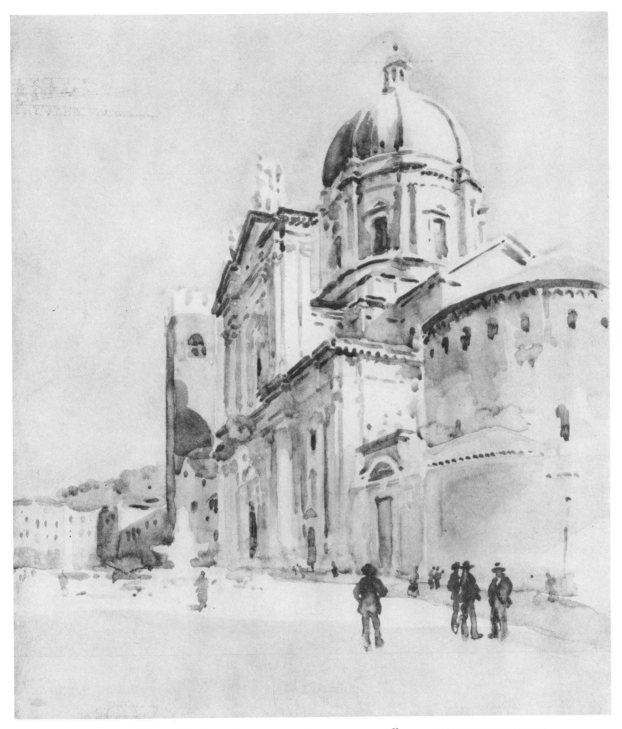

"THE DUOMO NUOVO AND DUOMO VECCHIO AT BRESCIA," BY VERNON HOWE BAILEY
With his customary freshness and vigor the artist has recorded the vital elements of his subject

of the most interesting things about our present example is the manner in which the rather complex architectural detail is suggested. Note the columns and pilasters, and particularly the ornate cornices. All these have been handled with extreme freedom.

It is helpful to compare these wash drawings with those in pen in the coming group. No two media, if we except color, have less in common, as Chapters X and XI, Part 1, make clear, yet, paradoxically, the two blend extremely well if employed on a single drawing.

IN MR. ULRICH'S animated sketch we have a typical example of pen work in that it shows no attempt to represent all the values of Nature. The effect depends mainly on rather scrawly but expressive outline, plus small areas of black or near black, with a bit of gray here and there to round out the whole. That such a treatment can be entirely adequate is here convincingly demonstrated.

Mr. Rowe's drawing is more meticulously managed and perhaps places a bit more dependence on tone. The light center of building, lawn, and shrubbery becomes a focal point almost surrounded by dark which gives it emphasis. This white is punctuated by the darks of doorway, windows, shrubbery shadows, etc. It is through these contrasts that the interest is centered where wanted, while at the same time an extremely sunny effect is produced. The sketch is a spirited one, which should be analyzed down to its last detail.

In R. E. Curtis's sketch the interest gradually increases, vertically, from a foundation of nicely suppressed foreground buildings, until it culminates in the steel skeleton above. This high placing of the center of interest, and gradation to it from light to dark, is rather unusual, though appropriate for subjects of this type. Attention is called to the employment of cross-hatch in the central areas. Some authorities object to cross-hatch in pen work, but there seems no logical argument against it, providing one does not lean on it too heavily. This subject is also vignetted with skill, the edges, though generally suppressed, showing an interesting variety of both form and value. It is not a hard thing, as a rule, to develop the center of a sketch, where customarily the interest focuses, but as the edges are reached it is far from easy to know how to manage them. It is partly for this reason that so many beginners carry their rendering to an inclosing margin line. Sometimes this is the best treatment but it often calls for extra work and can easily prove monotonous.

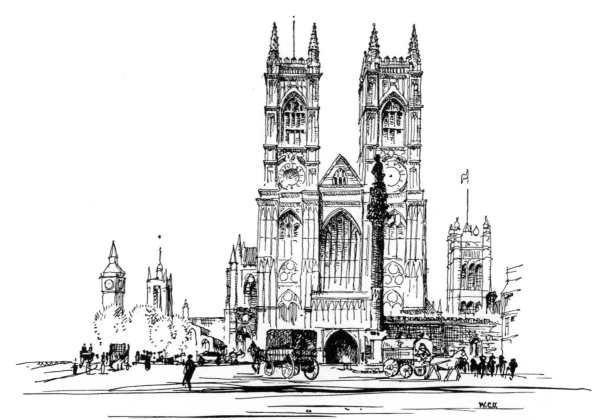

"WESTMINSTER ABBEY," ABLY DRAWN IN PEN AND INK BY WILLIAM C. ULRICH
The well-distributed staccato accents of black are effectively relieved by the contrasting lights

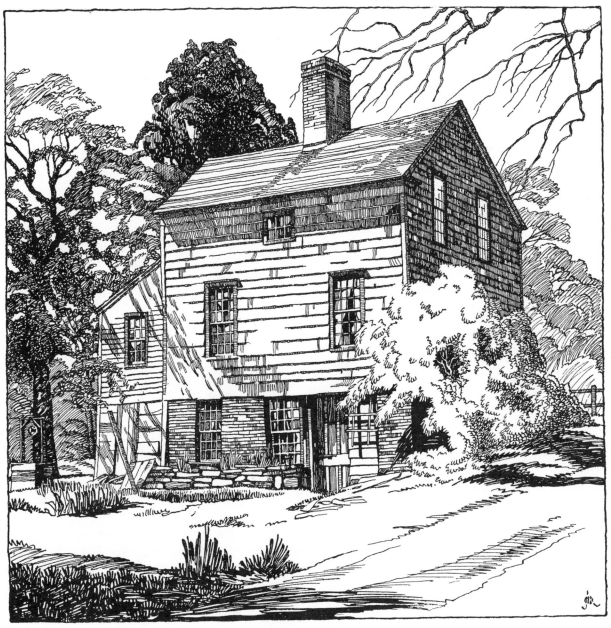

Original, 9¾" x 9¾"

PEN DRAWING, "AN OLD HOUSE IN CONNECTICUT," BY JOHN RICHARD ROWE
The sunshine and shadow are skillfully handled; note also the varied foliage indications

It is instructive to turn from this carefully studied example to the energetic treatment of the Ponte Vecchio by Alwin Rigg. This is a frank, open sketch, revealing plainly the speed with which it was drawn. Observe the dependence placed on vertical strokes and the terse but satisfying suggestion of the waters of the Arno. One could scarcely fail to profit from a comparison of this example with the still more sketchy treatment of the same subject by Oliver Wilson, Group X.

We now come to Sanchez Felipe's ambitious study. Here is a subject and handling showing both the skill and patience of the artist. A subject of this close-woven pattern of architecture offers the danger of coming out monotonously gray—here this is capably prevented not only by the broken profile which the structure projects against the sky, but by the introduction of the small but potent blacks throughout, and the scintillating whites below.

This drawing offers a striking demonstration

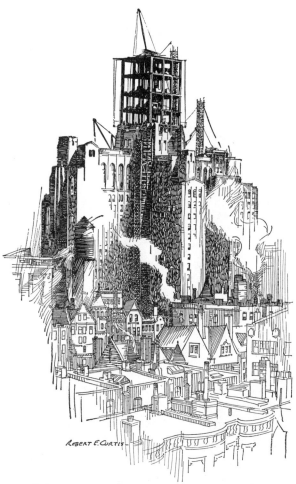

A CAPABLE PEN STUDY BY ROBERT E. CURTIS
Observe the highly placed center of interest

of one of the laws of simultaneous contrast. Observe how much more powerfully the black of the open door counts than do some of the similar darks elsewhere, for it is contrasted with whites while they tend to merge with the surrounding tone.

The fountain-pen sketch by Louis Rosenberg is quite unlike our other illustrations. It was done with blue ink on blue-gray paper at the exact size here shown. The washes were also of fountain-pen ink. The sketch was rapidly made direct from Nature as a study for an etching to be done later in the studio—it shows how the etcher collects his notes in the field. Like so many quick sketches made for the artist's own use or amusement, this is a masterful thing, seemingly inspired by genius. The subject has appeal, the composition is superb, and the spontaneous line and tone exactly right. The whole has a somewhat decorative quality, in both composition and handling, as is frequent in this artist's work. As a small but pleasing trick of indication, observe the grouped dots and dashes. Note, too, the simplicity of the washes.

The really vital drawings are so often these sketches which are not dressed up for inspection, and the fountain pen is gradually coming to play so important a part in their making, that

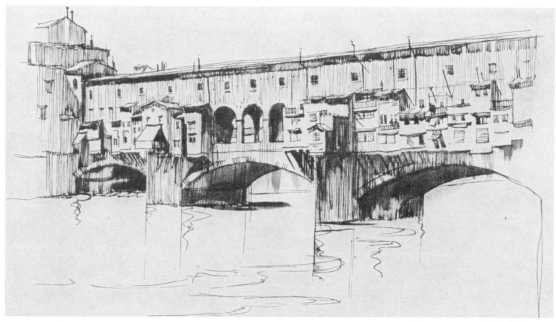

ALWIN RIGG WAS THE ARTIST OF THIS PEN SKETCH OF THE FAMOUS PONTE VECCHIO
Compare his treatment with that by Oliver Whitwell Wilson, Group X

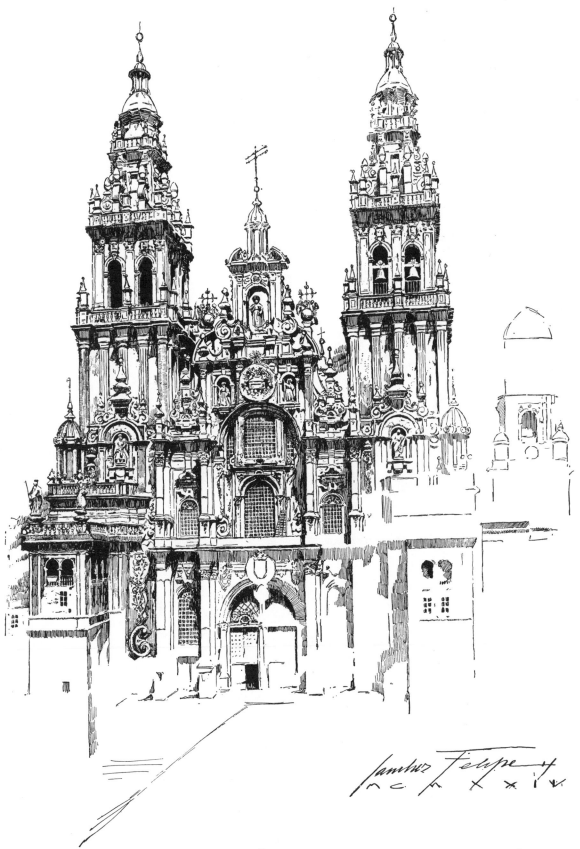

"SANTIAGO DE COMPOSTELA, SPAIN," DRAWN IN PEN AND INK BY SANCHEZ FELIPE
The student should be interested in the lightening of the drawing at the lower right-hand corner.

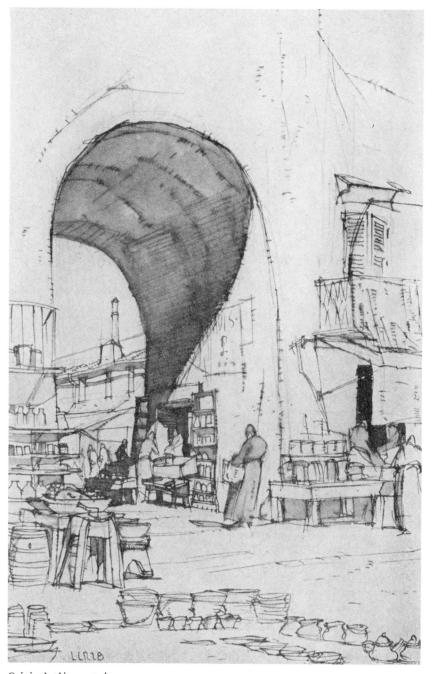

Original, this exact size
"COURS SALEYA, NICE," SKETCHED IN FOUNTAIN PEN BY LOUIS C. ROSENBERG
This is a clever example of this artist's inimitable style

we add to Mr. Rosenberg's example a second one, drawn by the noted stained-glass designer, Nicola D'Ascenzo. Some artists make numerous studies of this general type, not so much as documents to record facts on paper (for photographs and measured drawings can do that) but more to give them, as they sketch, a broader appreciation and sounder understanding of their subjects.

Attention is particularly directed to the freely drawn back-and-forth strokes in Mr. D'Ascenzo's sketch, crossed and recrossed to produce the needed values and textures. The indication of ornament should also be noted.

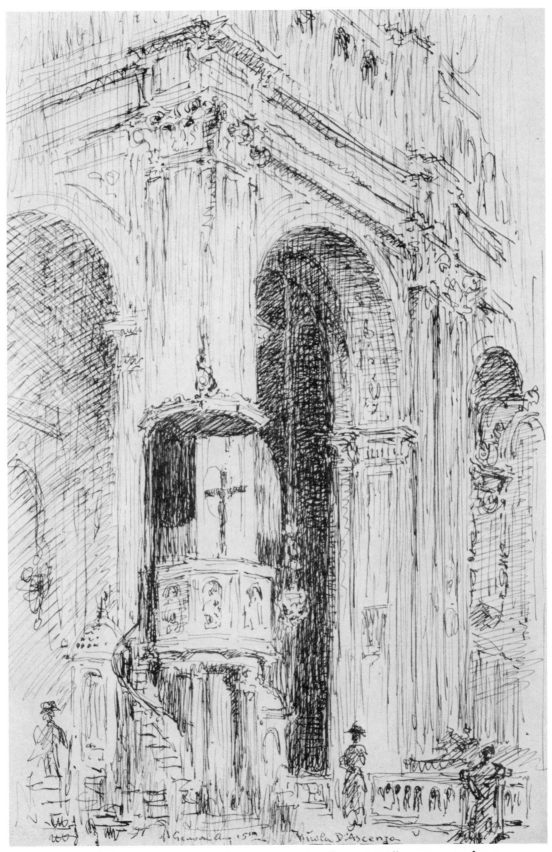

A FREE BUT SYMPATHETIC FOUNTAIN PEN SKETCH, "IN GENOA," BY NICOLA D'ASCENZO
Such a drawing is far to be preferred to the labored results of many beginners

[97]

HERE we have brought together a number of types of drawings to demonstrate how helpful combinations of media can sometimes be.

Our first, by Edna Lawrence, was done in pencil on a rough, tinted paper, the smoke being highlighted in white. The result, though quickly obtained, is particularly attractive, having that pleasing quality so often lacking in more ambitious treatments. It shows enough, and just enough, of the detail, the imagination being allowed to exercise itself in its own way. The rough paper promotes a vibration wholly consistent with the place and moment. Like effects are often gained with charcoal on charcoal paper, highlights being added with chalk, crayon, or opaque water-color.

Wholly different in subject, though similar in handling, is the little house in Wilton Center, N. H., which Mr. Ripley, with his customary vivacity, has drawn for us. Why do beginners so often select complex subjects when these simple things can be made so attractive with far less effort? One virtue of tinted papers, such as Miss Lawrence and Mr. Ripley have used, is that they permit the direction of marked attention to any such features as may be highlighted. Mr. Ripley's sketch is clearly "House, with Landscape Setting," and not "Landscape, with House."

When white paper is chosen it can often be toned, as with wash, leaving the white areas in contrast, producing an effect not unlike these we have just seen. This is what Henry Rushbury, A. R. A., has done in his incomparable interpretation of the Coliseum, opposite. He has employed pencil for outline and black, adding washes of varying strength for his grays. Though only a master can manage a subject as cleverly as this, the method, with variations, is adaptable to no end of applications.

Not only are pencil and wash combined in many ways, but pen and wash lend themselves

Original, 10″ x 14″

A PENCIL SKETCH BY EDNA W. LAWRENCE

The paper was tinted: Note the added highlights

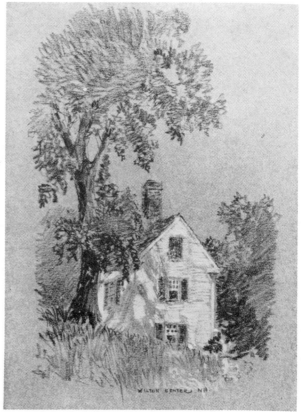

Original, 6″ x 8″

"OLD HOUSE," DRAWN BY HUBERT G. RIPLEY

The highlights focus the attention where wanted

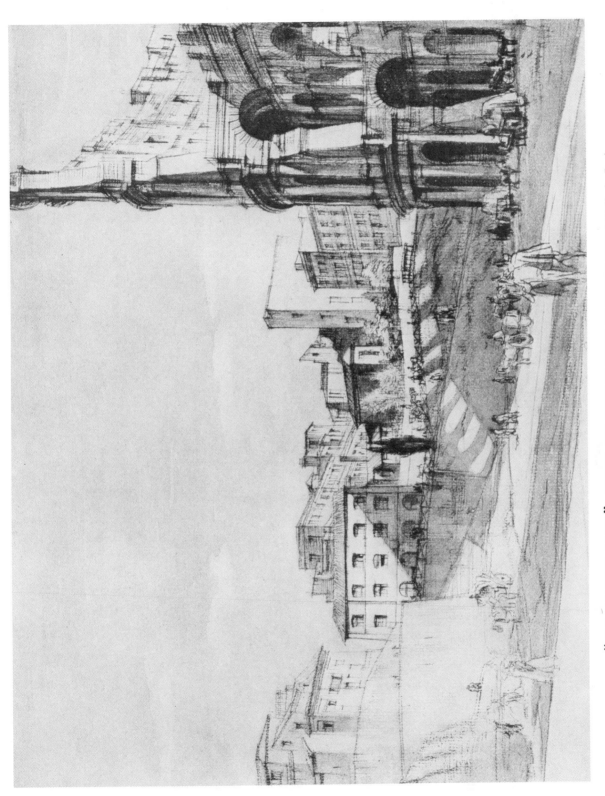

"THE COLISEUM, ROME,"—PENCIL AND WASH DRAWING BY HENRY RUSHBURY, A. R. A.

The hand of the master is everywhere evident: Study the figures, the shadows, the textures

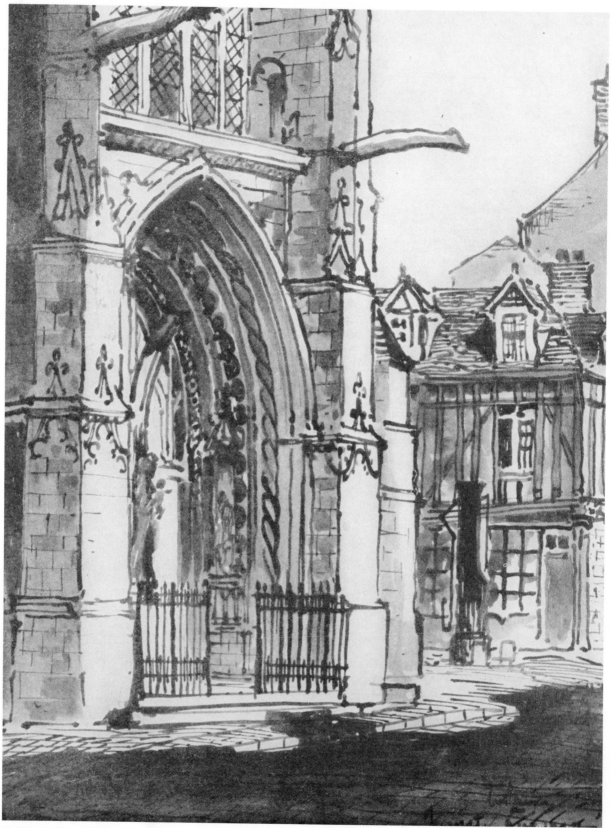

Original, 9″ x 11¾″

FROM A DRAWING IN SEPIA WITH REED PEN AND BRUSH, BY WENDELL P. LAWSON

Bold and vigorous is this handling of the "Portail de l'Église, Moret, France"

to at least an equal number of combinations. We have an extremely forceful example of this in Mr. Lawson's drawing. This was made in dark sepia ink with brush and reed pen, the ink diluted for the washes. A warm white water-color paper, smooth, was selected. The interesting quality of line which is obtainable with the reed pen gives an individuality to a drawing that makes us wonder why it is not more commonly employed. The old masters used it, of course; the charm of many of their sketches resulted in no small measure from their capable adaptation of exactly the combination which Mr. Lawson gives us here, sepia or bister or sometimes gray being applied with brush and pen. This is, therefore, an ideal combination for imitations of this old work.

The pen may likewise be employed in conjunction with water-color. We illustrate, by means of Jovan de Rocco's agreeable drawing, a common but excellent one of the many possibilities. The lines serve to define the larger forms and interpret the smaller details, leaving

a majority of the values to be cared for by the brush. How much more attractive sketches like these last two are than the painstakingly correct and complete drawings which one so often sees!

The pencil, like the pen, is also frequently used in conjunction with color. Ray Marks' fascinating little sketch on the following page exemplifies this condition, though, like our other color examples, it loses much in reproduction. In such work the color sometimes predominates and sometimes the pencil; it is generally advisable not to give the two equal importance. Tinted papers also work well with some of these same combinations. Mr. Marks' drawing gives further emphasis to the point we have so often reiterated—that simple subjects can result in extremely attractive drawings.

Oliver Whitwell Wilson's robust sketch of the Ponte Vecchio, reproduced directly from a page in a pocket notebook, introduces still another selection of media, for this was done on a colored "Lefax" sheet with the fountain pen and colored pencil. This method is particularly well

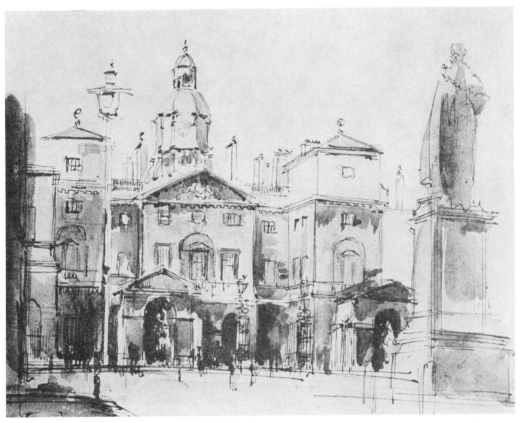

"WHITEHALL, LONDON,"—A WATER-COLOR SKETCH PAINTED BY JOVAN DE ROCCO

A crisp, fresh handling: Note the addition of line for sharper definition of form

[101]

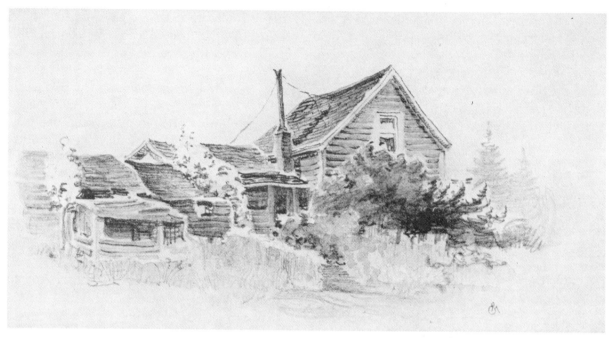

RAY O. MARKS DID THIS INTERESTING PENCIL AND WATER-COLOR SKETCH
The technique is well suited to the quaint subject. The whole is simple but most expressive

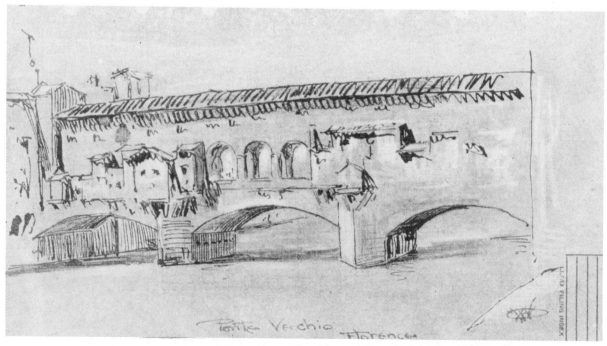

A QUICK SKETCH OF THE PONTE VECCHIO, BY OLIVER WHITWELL WILSON
This was done on a colored "Lefax" pocket notebook sheet with fountain pen and colored pencil

adapted to the making of just such "shorthand" notes as we have here. We have already mentioned that such sketches can easily prove more vital than drawings finished with greater care. One can learn much concerning his subjects, while making them, for technique, composition, and the like require little attention; they also help to recall the subjects later.

Now we turn to some extremely interesting methods of working, not as well known, perhaps, as the previous ones. First we have Sewall Smith's sketch "Venice." To describe his method

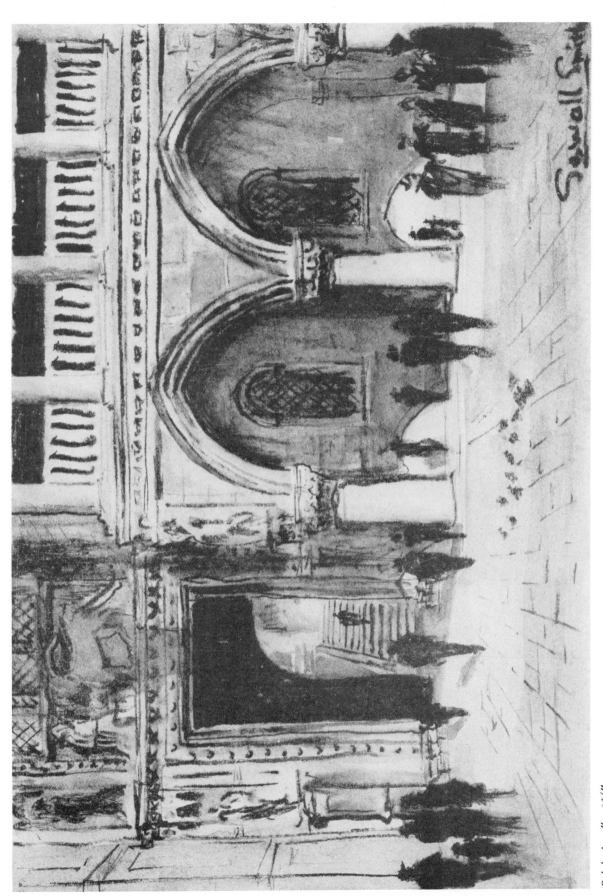

Original, 13″ x 8¾″

"VENICE," FROM A SEPIA SKETCH BY SEWALL SMITH, DONE BY AN UNUSUAL METHOD

Drawn with a sepia conté crayon on wet paper, a wet brush being used to produce the wash effect

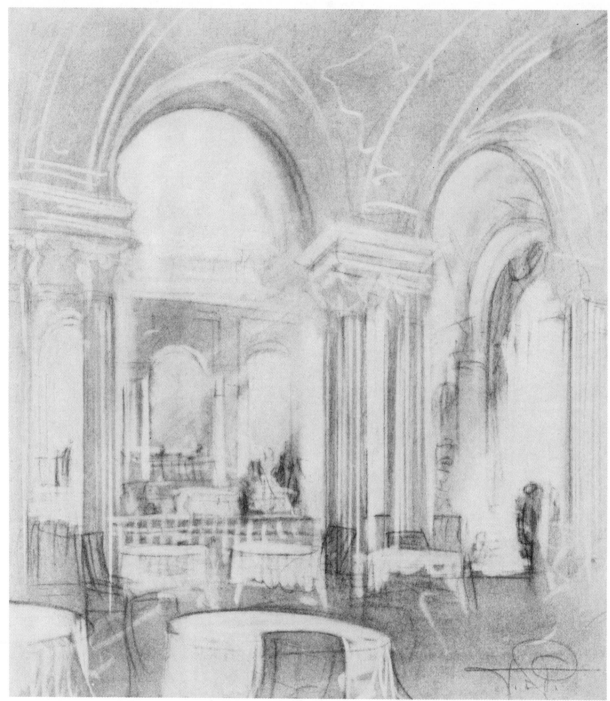

Original, 12″ x 13″ *Hotel Pierre, N. Y., Schultze & Weaver, Architects*

PASTEL STUDY ON TRACING PAPER (OVER PERSPECTIVE LAYOUT) BY THEODORE DE POSTELS

The pastel was rubbed in and the whites then removed with an eraser. Unusual effects are obtainable

prosaically, this was drawn directly with a sepia conté crayon on wet paper, using a fairly wide line. A wet brush was employed to produce the wash effect, water being added as needed. Mr. Smith discovered the method quite by chance while making this very drawing. To quote from a letter to the author, "There was a drizzling rain as I made the sketch, so I grabbed a brush and played with the brownish wash that came from the pencil, thus accidentally discovering a new medium." This method Mr. Smith quite fully described in the March, 1932, issue of *The American Architect*.

The author also discovered some years ago

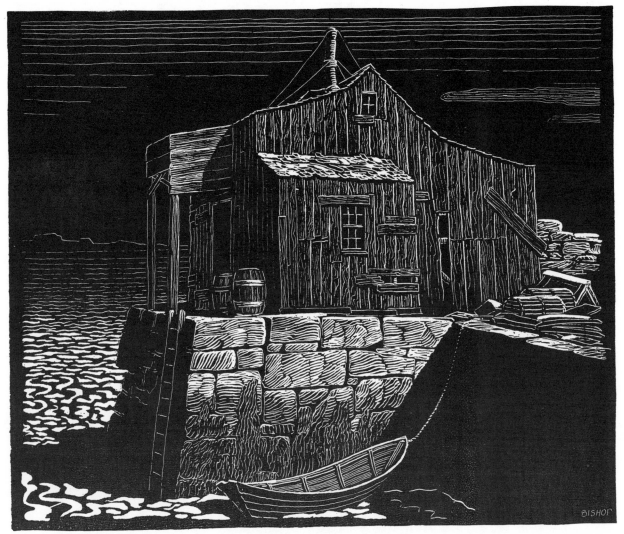

"FISHERMAN'S SHACK, PIGEON COVE, GLOUCESTER, MASS.," BY H. RAYMOND BISHOP
Scratchboard, Ross-board, white ink on black paper, etc., offer unique possibilities

by similar chance (as many others doubtless have) that certain soluble crayons have unusual possibilities. Drawing a black Reeves' crayon sidewise across a wet water-color paper of rough surface a particularly intriguing tone developed; with the crayon's solubility known, further experiments revealed numerous tricks of varied worth. He later found that many crayons, including some of the excellent ones made by Hardtmuth (Koh-i-noor), had similar characteristics. Others of the wax type can be treated effectively with some such solvent as carbon tetrachlorid. Here is a field which is all too little known. Then there are, of course, the various "water-color pencils" in different hues.

Recently more and more artists have been experimenting with "smooch" methods on the order of that so effectively displayed in Mr. de Postels' drawing. Pastel, charcoal, graphite, or something of the sort (often in powdered form) is rubbed into the paper, sometimes very briskly, highlights being later picked out with the eraser. Occasionally portions of the paper are covered with masks or stencils (of paper) beforehand, and thus kept clean. A pad of cloth or wad of cotton can be used for applying the medium.

In Chapters XIII and XIV, Part I, we described some of these media and methods, touching also on the use of scratch board. Scratch board, Ross-board, white lines on black paper, and the like, should by no means be overlooked. Raymond Bishop's valuable contribution above, quaint in subject and unique in handling, gives a hint as to what can be done in this direction.

[105]

IN OUTDOOR sketching one needs to learn to work very quickly, for the light shifts and varies in strength, models alter their positions, and numerous other handicaps arise to prove troublesome.

Mr. Imrey's capable sketch below offers a logical treatment of a typical outdoor problem. With a figure in motion, or with a subject like a boat which changes in effect as it moves (and may disappear entirely), there is no time to dilly-dally—the proportions of the leading features must be recorded with speed and precision. This was done in this instance, some of the first faint touches drawn being still visible. With the leading masses thus located, the whole was soon completed naturally and without pretense.

The two fine sketches opposite were handled with this same naturalness and freedom from restraint. There was no striving for effect, no employment of silly mannerisms or forced tricks. Both are of unusually pleasing subjects; both (particularly the latter) have the interest strengthened about the central areas; both have

a real feeling of the out-of-doors. Both, by simple indications, convey a sense of complete delineation. Observe, for instance, how Mr. La Zinsk has given a perfectly adequate impression of lobster pots with a few lines. Readers familiar with the complexity of these traps will appreciate this clever suggestion. Mr. Wright, similarly, has ably indicated the complicated crane and like details.

While these two drawings lean quite heavily on rather gray tones, punctuated with comparatively small but sharp blacks, Richard E. Harrison, in his strikingly luminous sketch of Dean's Ravine, has placed greater reliance on darks. By their use he has developed sufficient contrast to interpret most successfully the penetrating glow of light from beyond. This effect of light is, however, but one of many fine attributes which this example possesses.

Oliver Whitwell Wilson, in his example from Rome, depends somewhat more on outline. He uses values, however; the simple suggestion of texture, as on the pier at the extreme left, being

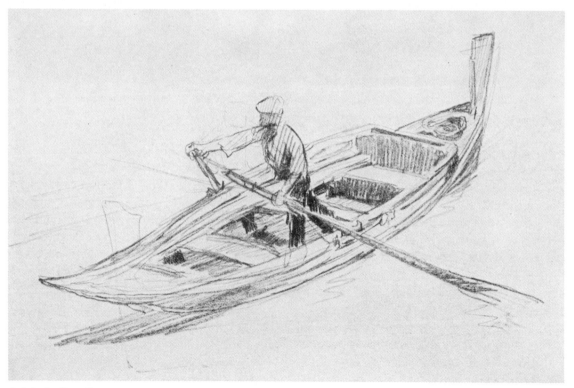

Original, 6" x 4"

"A BOATMAN OF MALTA,"—FROM THE SKETCHBOOK OF FERENC IMREY

Here there is no striving for effect: the essentials are merely recorded honestly

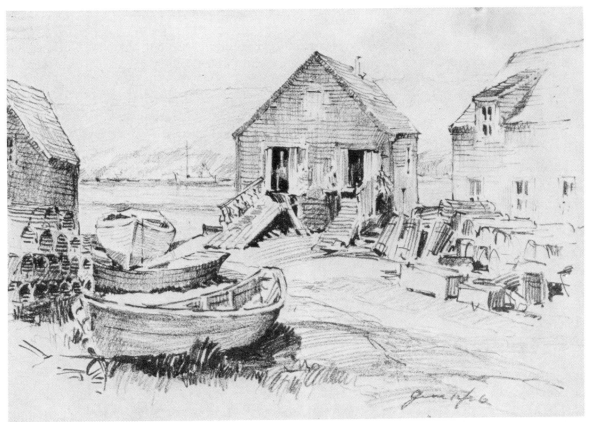

"LOBSTERMEN'S SHANTIES, MONHEGAN, MAINE," SKETCHED BY WILLIAM LA ZINSK

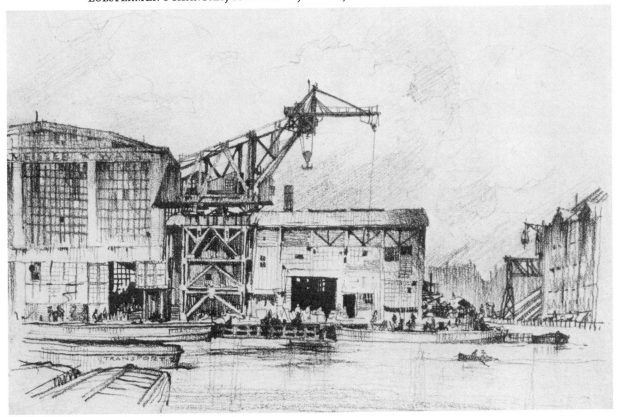

A PENCIL TREATMENT OF THE WATERFRONT, COPENHAGEN, BY LAWRENCE WRIGHT

These are both exceptionally fine examples of unaffected portrayal of appealing subjects

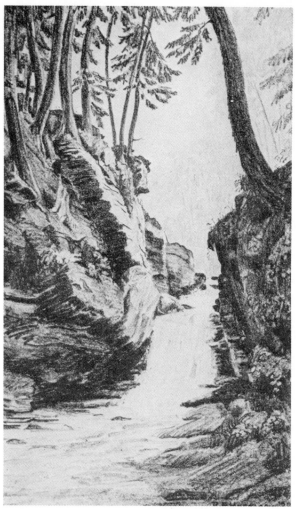

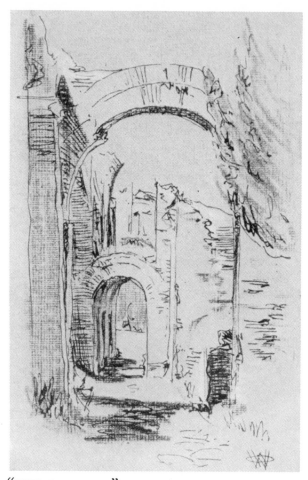

LITHOGRAPHIC PENCIL SKETCH BY R. E. HARRISON
The Upper Falls—Dean's Ravine near Cornwall, Conn.

"NOVA VIA, ROME," BY OLIVER WHITWELL WILSON
*A companion sketch to that by the
same artist in Group X and done
in the same manner*

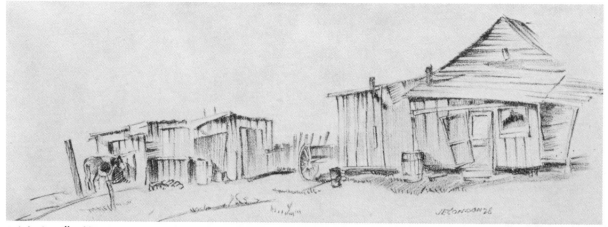

Original, 10" wide

"NEGRO DWELLINGS NEAR MEMPHIS," DRAWN IN PENCIL BY J. EMMETT CONDON
*Each of these sketches above, while differing from the others in subject and medium, shows a
straightforward approach to the problem*

SOME TYPICAL OUTDOOR SKETCHES

particularly satisfying. When rough paper is not available one can gain effects on this order by the simple expedient of using a rough book cover as the support for any obtainable paper. By varying the covers no end of textures may be created, even on a single drawing.

J. Emmett Condon's shanty sketch brings us dramatic evidence that tumble-down shacks which in themselves would attract hardly a second glance, and might even be repulsive in their evidences of squalor, can be the inspiration of praiseworthy illustrations. This example was done on 9″ x 12″ American White drawing paper with a series of pencils ranging from HB to 4B.

M. C. Nead has given us an exceptionally fine sketch of a subject which, while appealing to some more than others, works up pleasingly. The treatment is absolutely honest and straightforward, with no tricks and no trying to show off. If only beginners would also do the seemingly obvious thing instead of inventing so many

stunts! The perspective here is well managed; it is not easy to give the proper convergence to railway tracks, especially when curved.

The charcoal study by E. P. Chrystie is quite different from these recent sketches, for it attempts—and very convincingly, too—to register the mistiness of a gray day. It seems to interpret for us a particular moment—one can fairly hear the querulous tooting of the fog-enshrouded harbor craft and the muffled rumblings of the multifarious waterfront activities. Turning to details, the water itself is nicely handled. This sketch should be compared with Viele's, Group VI.

We come into bright sunshine again, and turn from city to country, in Percy Owen Danforth's extremely well managed "Mister Johnson's House." Though the building is ably treated, it is perhaps the trees and their shadows on walls and roofs which attract us most. Note that the viewpoint has been so chosen that these trees count to fullest advantage in relation to

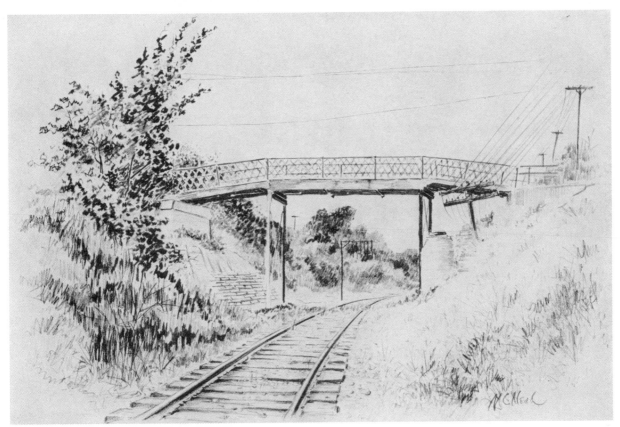

Original, 20″ x 14″

PENCIL SKETCH BY M. C. NEAD—"ROAD BRIDGE OVER RAILWAY AT DAYTON, OHIO"
Success in this attempt to render an actual place outdoors was gained by honest means

[109]

the house, the house, trees, shadows and all forming an exceptionally pleasing composition.

J. Scott Williams, in his exquisite "Hay-time" (made while the scene was in action, just as it shows), hints at the skill at illustration which has brought him such wide recognition. The introduction of the pair of horses and the man pitching the forkful of hay into the loft gives the whole an added appeal. This is indeed a superb bit of drawing; note in particular the light, free touch used in the hay indication. The original was done on cameo plate stock with a No. 2 Korn crayon for transference to a lithographic stone.

Quite different are the scenes which Edward M. Schiwetz and H. C. Douden have given us, yet they demonstrate further the interest which figures add, even when sketchily presented.

The first of these has in full measure that dash or spontaneity which is so often a pleasing characteristic of this artist's work. In spite of the speedy method, however, the whole presents a unity and consistency often lacking in more laborious treatments. Truly this is a splendid sketch and should prove an inspiration to the student who should study it with great care.

Although the subject is different and the line less dashing, Mr. Douden's sketch has many of the qualities of the previous one. It preserves large areas of white paper; it is vignetted; it gives emphasis only to essentials. It places somewhat more reliance on outline, this being handled expressively. The indication of brickwork is simple and telling. The interest is well centered. Above all, it has a certain subtle appeal not easy to define.

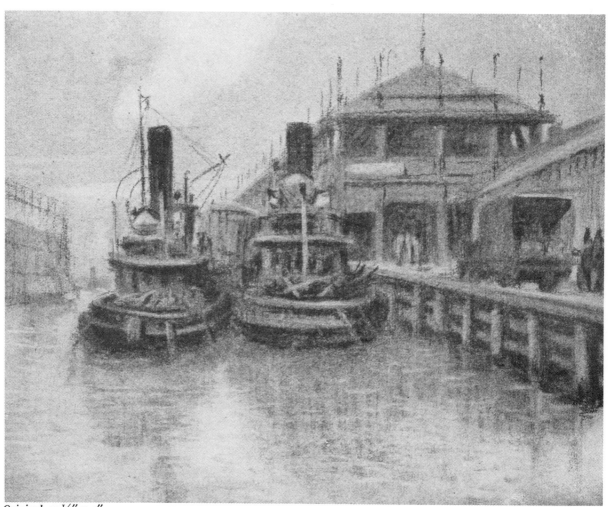

Original, 11½" x 9"

"A GRAY DAY ON THE WATERFRONT," AS DRAWN IN CHARCOAL BY EDWARD P. CHRYSTIE

What other medium could so admirably have caught the spirit of this particular moment?

[110]

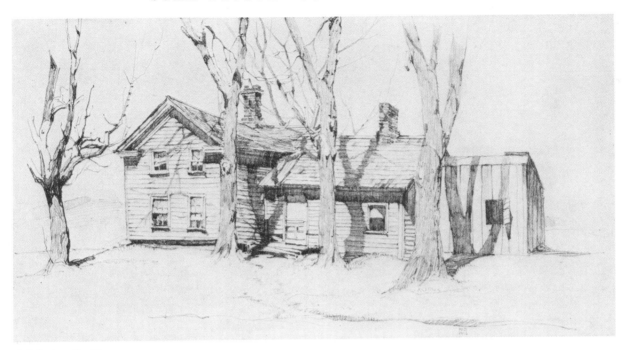

Original, 14″ wide

A PORTRAIT IN PENCIL BY PERCY DANFORTH—"MISTER JOHNSON'S HOUSE, ANN ARBOR"

A splendid sketch: attention is especially called to the handling of the trees and tree shadows

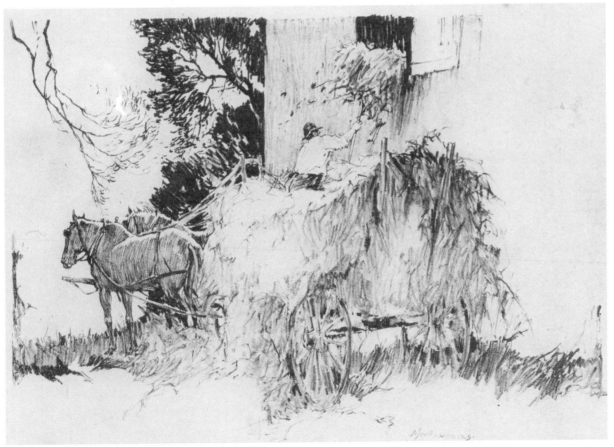

Original, 17″ x 12″

"HAY-TIME,"—A SKETCH FOR A LITHOGRAPH BY J. SCOTT WILLIAMS

The human element vitalizes this delightful and extremely well-handled subject

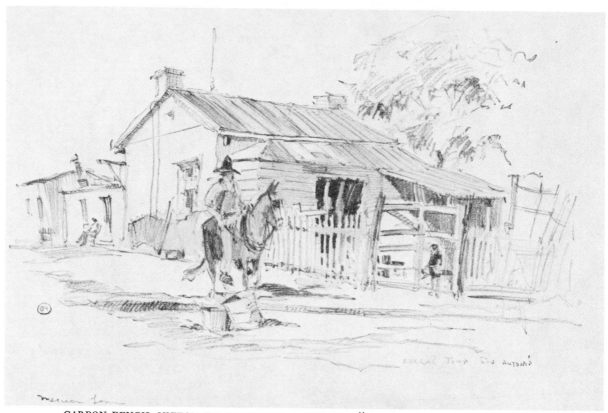

CARBON PENCIL SKETCH BY EDWARD M. SCHIWETZ, "MEXICAN TOWN, SAN ANTONIO"

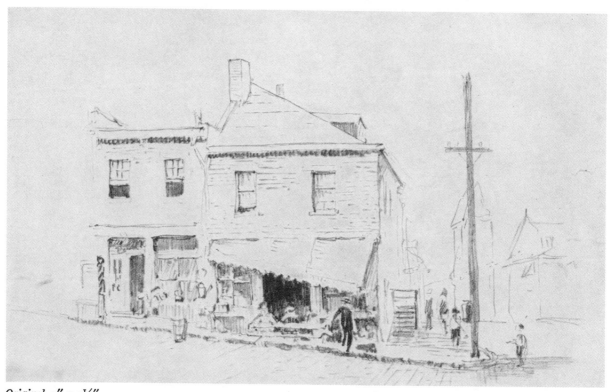

Original, 9" x 5½"

A PICTURESQUE SUBJECT CAPABLY REPRESENTED IN PENCIL BY HERBERT C. DOUDEN

Figures, as in these two pleasing examples, add scale and interest

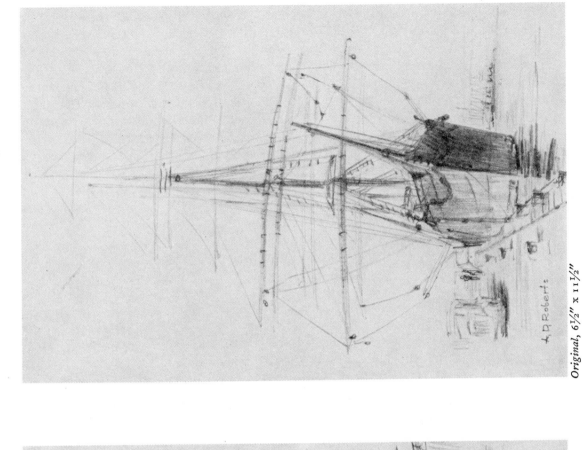

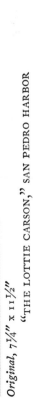

Original, 6½" x 11½"

"STAR OF INDIA," SAN DIEGO HARBOR

SHIPS ARE EVER INTERESTING: THESE WERE SKETCHED ON CAMEO PAPER BY ARTHUR D. ROBERTS

Original, 7¼" x 11½"

"THE LOTTIE CARSON," SAN PEDRO HARBOR

Ships are always interesting, and these by Arthur D. Roberts are especially so. He has caught their mass and weight and feeling of potential mobility. There is a note of sadness, too, about the comparatively rare survivors of the glorious age of sailing-ships, which these particular sketches successfully interpret.

Ernest Watson's sketch, which shows this noted artist's amazing facility with the broad lead, speaks for itself. It seems remarkable that so fine a sketch is merely one of sixty-five of like character done on a single sketching trip abroad, each taking approximately an hour's time! The student should scrutinize it inch by inch.

We close this group with Ferenc Imrey's characteristically honest drawing, which exhibits, among other commendable qualities, interesting composition, well-managed values, and satisfying indication of textures. The subject, too, is an appealing one. Truly it is a splendid example.

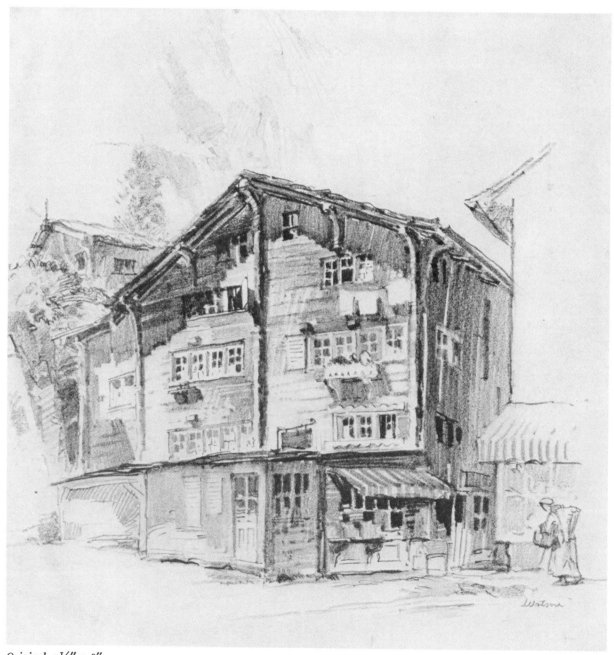

Original, 7½" x 8"

ERNEST W. WATSON DID THIS CLEVER PENCIL DRAWING AT ZERMATT, SWITZERLAND
Kid-finished Bristol board was used: Note the direct handling; there is no "niggling" here

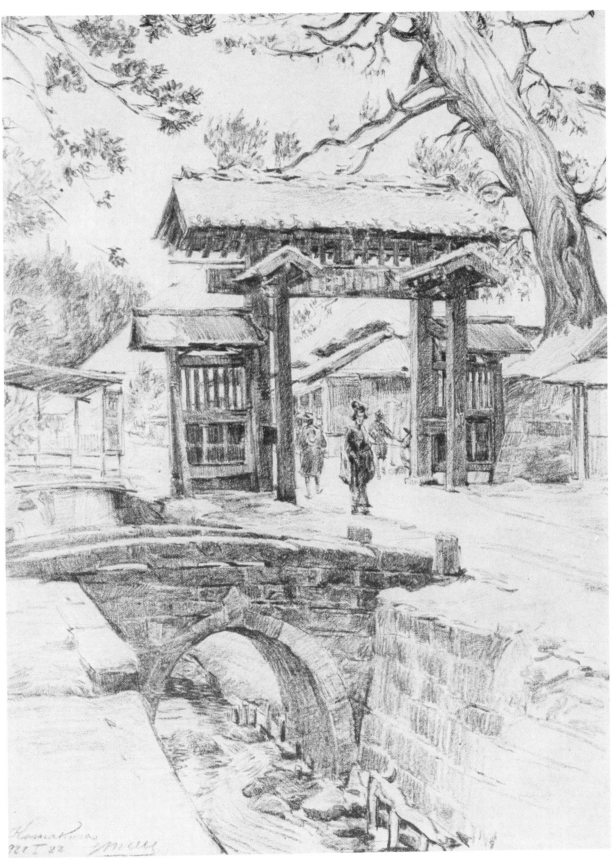

Original, 9½″ x 18″

A PENCIL STUDY BY FERENC IMREY OF THE ENKAKUJI TEMPLE GATE, KAMAKURA, JAPAN

It has many commendable points: unusually sympathetic is the indication of textures throughout

[115]

F. W. GARBER'S delightful landscape below reminds us of paintings in its general effect. The subject is attractive and well composed, its tonal qualities being unusually satisfying. The simplicity of the foliage treatment should be noted, as should the intelligent employment of the clouds, which introduce lines complementing those of the water and trees. The distance is nicely suppressed, holding its place well. Note that horizontal strokes impart a feeling of flatness to the water.

In Alfred Rudolph's laudable drawing—a study for an etching—a thing which is outstanding is the evidence of painstaking handling. Every detail included was investigated in the subject itself with an analytical eye, and depicted in the drawing with sound discernment. The result gives us a dependable statement of the facts of the site, coupled with an impression of the vastness of the spaces and the vibrant quality of the atmosphere.

In studying David Davis's stimulating example, note in particular the able rendering of the light and shade on the tree skeleton. In drawing a skeleton as complex as this, the beginner is advised to take plenty of time in order to depict successfully its individual character. Not only should he make a careful drawing, but he should endeavor to memorize the facts of form. Read Chapter XVIII, Part I, in this connection.

C. Westdahl Heilborn, who gave us the two stanch sketches in Group I, was the artist of the accompanying "Driftwood." This, both because of the subject itself and its handling, is quite decorative, even as to detail; observe in particular the lines employed in the foreground logs. Another point of interest is the treatment of the water, which, for the most part, has been left

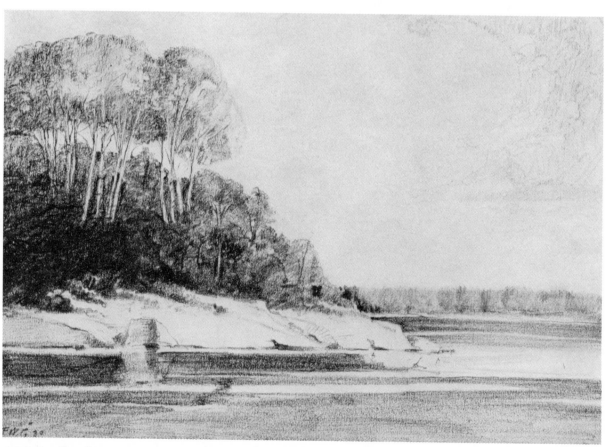

Original, 12" x 8"

CONVINCINGLY REAL IS THIS SKETCH, "GEORGIAN BAY," BY FREDERICK W. GARBER

Here the pencil was used less for line than for tone; the composition is well managed

[116]

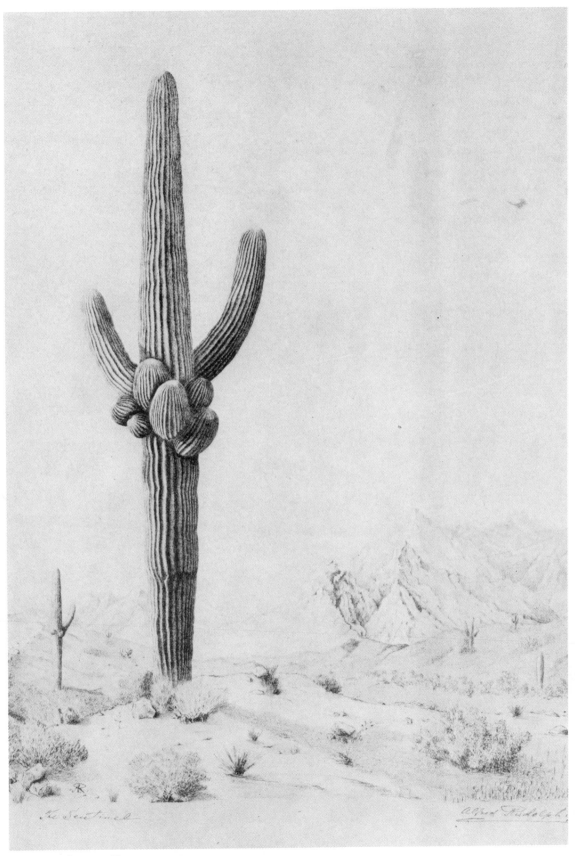

Original, 8½" x 11¾"

"THE SENTINEL,"—A PAINSTAKING PENCIL STUDY BY ALFRED RUDOLPH

Note the care given to every detail: the result speaks for itself

white, showing the reflection of the bright sky above and so forming a contrasting pathway which leads the eye nicely through the composition. Note, too, the simplicity of the indication of the distant wooded bank. As we have pointed out, the beginner is inclined to over-emphasize the details and contrasts in such areas.

Percy Danforth's jolly and convincing drawing shows a subject of ideal type for the beginner, for all that is included is sufficiently compact to fall wholly within the range of direct vision. It is usually well, in a case like this, to work around the center of interest first, developing this as fully as seems advisable, gradually extending the work towards the edges of the paper until the whole seems nicely rounded out. Mr. Danforth's dexterous management of detail, as in the brickwork and roofing materials, is especially commendable and should be carefully analyzed—the bricks in sunshine have been quite fully portrayed, yet so delicately as not to interfere with the brilliancy of the sunshine. The crisp, transparent shadows further brighten the whole through contrast. Observe the branch

A FAITHFUL TREE STUDY BY DAVID DAVIS
This was drawn on cameo paper

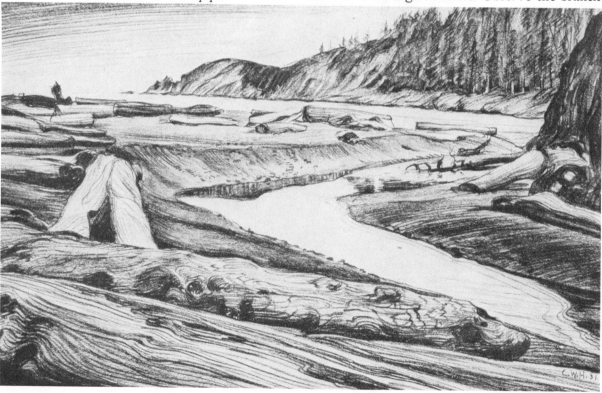

Original, 17″ x 10½″

A CONTÉ CRAYON DRAWING, "DRIFTWOOD," BY C. WESTDAHL HEILBORN
It is helpful to compare this with the examples by the same artist, Group I

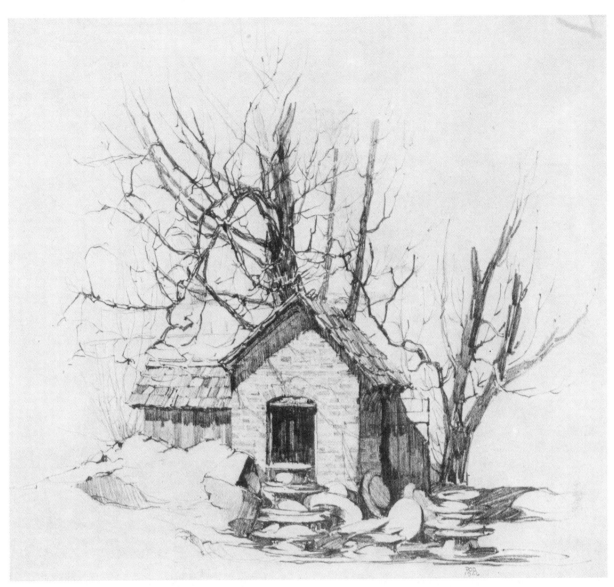

Original, 10" x 10"

"A BIT OF OLD ANN ARBOR," SKETCHED IN PENCIL BY PERCY DANFORTH

"Crisp" and "peppy" are among the adjectives needed to describe this notable example

shadows across the brickwork. The trees are indicated with unusual skill; they not only seem right in themselves, but they form a sort of decorative foil behind the picturesque structure. In drawing exposed tree skeletons one usually discovers that each species has certain consistencies of growth which recur throughout. The way the branches join and like peculiarities should be noted. All the values in this example are well arranged, the whole presenting a harmonious yet striking pattern.

The "drawn on the spot" look of all our sketches in this group is plainly manifested in Edgar Williams' competent study of a white pine tree. Here is a drawing which is truthful without being painfully exact. There is little that we need say about it beyond repeating comments made on some of our earlier sketches—the subject is interesting; it has been drawn from a satisfactory point of view; the direction of light and the laws of growth have been properly observed and recorded; the lines used are naturally suited to the purpose. A point of particular interest is the contrast of light and dark on trunk and limbs; note that some areas are practically pure white, others black, and still others gray or changing in tone from point to point. Observe the shadows which some of the branches cast on

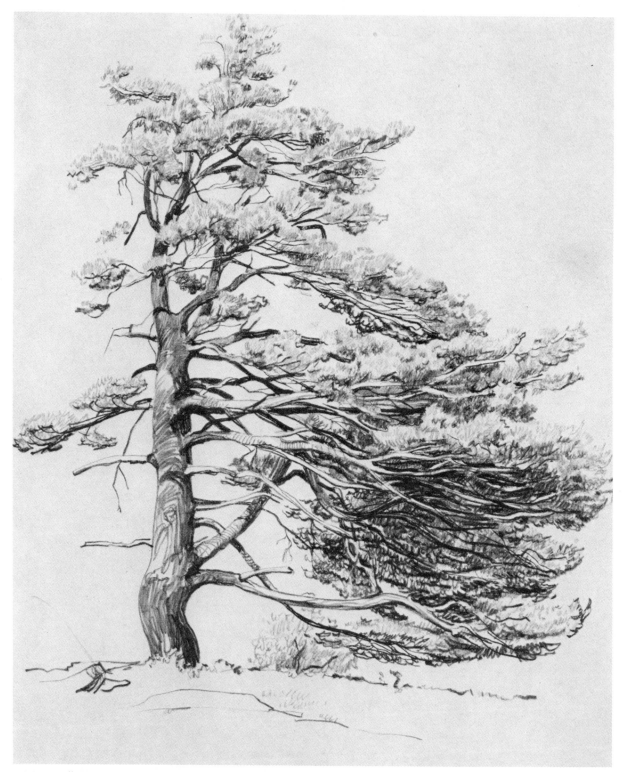

Original, 10″ wide

AGAIN THE PENCIL WAS SELECTED FOR THIS TREE STUDY BY EDGAR I. WILLIAMS

the trunk or other branches. Study the stroke which has been utilized for the suggestion of the bristling needles.

Many of the features of these last examples are also evident in M. O. Hodges' graphic delineation from Marblehead. Especially does it recall Percy Danforth's recent subject. Here the tree trunk and branches show a striking variety

of shade and shadow; the anatomical construction has been rendered with fidelity; the shadows on ground and building are well handled. This, like many of our other outdoor subjects, could be copied to advantage, after which the student would do well to seek similar subjects in Nature. We have already pointed out that before one goes far with foliage representation he would be wise to learn something of the construction of various types of tree skeletons, as drawings of trees in full foliage, done without a reasonably good understanding of the underlying "bones," seldom look just right. With

this understanding, the foliage itself can usually be mastered with ease.

Needless to say, there are many other landscape features which merit as much attention as do trees. Water offers numerous problems and so requires a good bit of serious study, especially if one includes water in motion. Skies with their clouds demand their share of attention, too, far more skill being needed for their satisfactory delineation than is sometimes realized. The best way to master all such things is by first-hand study from Nature, plus analysis of drawings by others.

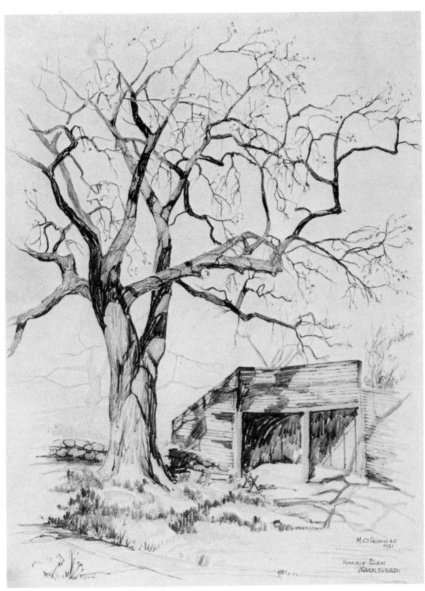

Original, 11″ x 14″

"HARRIS FARM, MARBLEHEAD," DRAWN BY M. O. HODGES

The tree skeleton is well handled: Note the shadows

OUR PRINCIPAL aim in showing the accompanying sketches is to make clear that there is no one correct way of representing interiors. Treatments vary according to subjects, media, and purpose.

Our examples, though both in pencil, are quite different in subject and handling. The first, by Cornelia Cunningham, was done rather sketchily, as is fitting in view of the informality of the subject. The values for the most part are relatively light, though with occasional dark touches. These darks are so placed as to prove helpful in developing a center of interest, for they show plainly in contrast with the light tones elsewhere. Note that this drawing is vignetted.

Elliott Chisling's study is of a subject much larger in size and of far greater architectural pretense. The rendering is studied and formal, in keeping with the architecture. The values on the whole are rather dark. The light pouring in from the left, with the dark figures silhouetted against it, help to focalize the attention. The entire drawing, instead of being vignetted, completes a rectangle. In such a treatment as this, especially when of a proposed structure (as the typical architectural rendering is), the great danger is failure to suppress the individual details sufficiently. Our present example is excellent in this respect; note, for instance, the restraint used in treating the floor and ceiling.

It is interesting to compare this drawing by Mr. Chisling with his sketch of a wholly different subject in the following group. The student would do well to experiment with subjects as divergent as these.

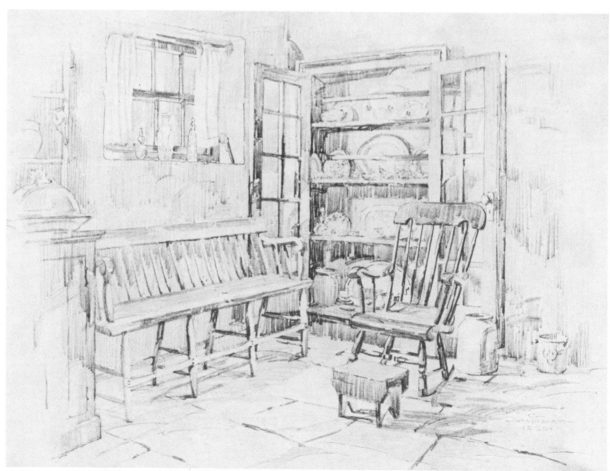

Original, 11¾" x 8¾"

A PENCIL DRAWING BY CORNELIA CUNNINGHAM, "AN OLD SAVANNAH KITCHEN"

Compare this free, quick sketch with the careful study opposite. Each serves its purpose

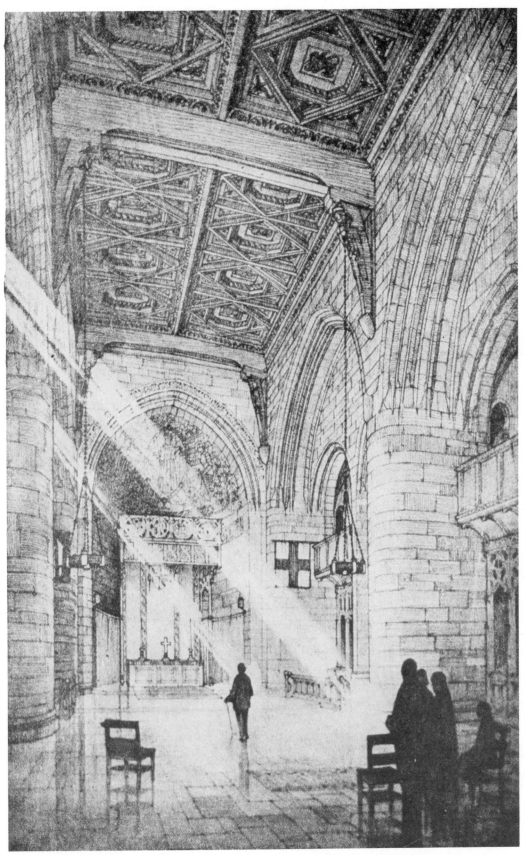

Original, 11″ x 17½″

AN ARCHITECTURAL INTERIOR DRAWN IN PENCIL BY ELLIOTT L. CHISLING

Chapel of St. George and St. Bartholomew, Baltimore Cathedral; B. G. Goodhue, Architect

ANIMALS, if drawn from life, quite obviously offer considerably greater difficulties than do most inanimate objects. Not only do they fail to stand still, which means that one must learn to draw rapidly and try to develop a retentive memory, but it is not easy to catch such things as the sparkle of the eye, the proportions beneath the hair or fur, or the elusive softness of the fur itself. This difficulty of obtaining correct and complete delineation may prove either to the advantage or disadvantage of the student. To consider the first, if one draws a tree and gets it out of proportion the effect may still be good, so he may never be conscious of his error. A like mistake in an animal drawing, however, would be almost certain to prove provokingly evident. As it is by learning to see one's mistakes and profit by them that he learns to draw, animal sketching therefore often results in sound progress. Such difficulties as we have mentioned may prove most discouraging for a while, however, so one might be wise to postpone any great

amount of this practice until he has fair mastery over things which stand still and have no life—such subjects, for instance, as objects, casts, and the photograph afford.

When one does venture into this province, outline, such as Mr. Imrey has used so effectively in his sketch below, provides a good starting-point. Note that in the beginning he sketched lightly, gradually strengthening the salient points as one would do with any other type of subject. It is well to establish the main masses and lines of action first, later adding details.

Charles Hallo, in his refined yet animated fawn studies, has used some outline and some quick shading in crayon, both augmented by wash. He has succeeded extremely well in catching the vitality of his subjects. One should study these with care.

Domestic animals make the best subjects for the beginner, for they are available, familiar, and little inclined to be timid. In Mr. Chisling's

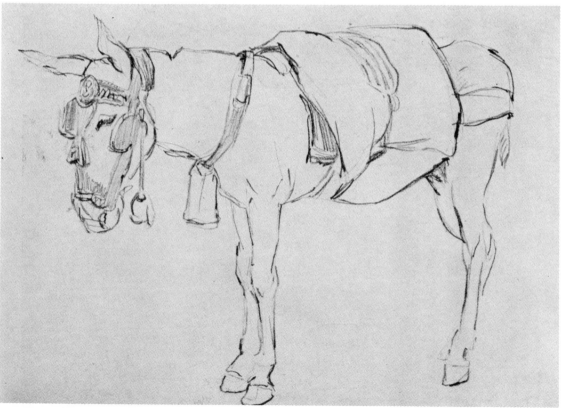

Original, 6″ x 4″

A PENCIL SKETCH, MAINLY IN OUTLINE, FROM THE NOTEBOOK OF FERENC IMREY

Animals, though difficult, offer excellent drawing practice: Try them!

delightful cat study the effect is natural indeed: one should squint at it through partially closed lids. Observe, also, the dark background and lack of outline. This drawing, like the recent interior by the same artist, fills a solid rectangle.

It is well for the student to start his practice with animals at rest—sleeping cats, dogs, etc. Animals in slow motion, such as cows or sheep feeding, afford the next natural step. It is animals in rapid motion—dogs running or horses trotting—that present real trouble. Here one must adopt a different method, watching these animals as they run, analyzing every motion, perhaps doing no drawing beyond quick impressions to help him to memorize their various actions. In later more serious drawings he will depend only to a limited extent on what he sees at any one instant, relying considerably on memory, analyzing his drawings as they develop to see if they *look* right. To draw animals really well one must master their anatomy, too, as in the case of the human figure. Modeling them in wax or plaster is also of great help. Books such as *Animal Sketching*, by Alexander Calder (Bridgman), are likewise invaluable.

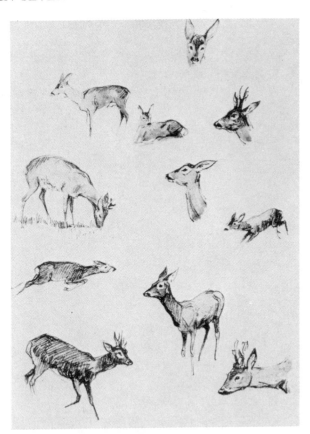

STUDIES OF FAWNS, BY CHARLES HALLO
These were done in crayon and wash

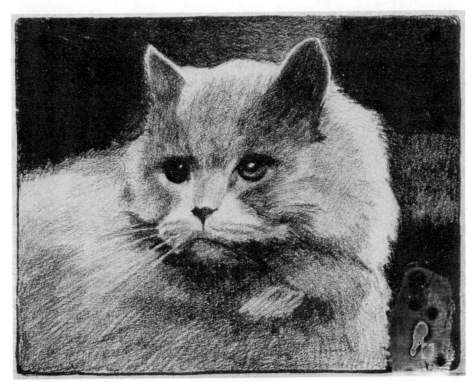

Original, 10″ x 8″
"MISS PEARSALL'S CAT,"—CARBON PENCIL SKETCH BY ELLIOTT L. CHISLING
Compare this with the drawing by the same artist, Group XIII

HUMAN beings, like animals, are very difficult to draw, whether draped or in the nude, and the beginner should not be discouraged at any slowness in his progress. There is little that we can say in this restricted space to help him, beyond pointing out that though one with reasonable diligence and application can usually make quite satisfactory advancement in most kinds of drawing without the aid of a teacher, when it comes to the living model he is wise, indeed, to place himself under competent instruction. Lacking such opportunity, he should study some of the excellent books on the subject (see Chapter XVI, Part 1). In view of these fully illustrated volumes we limit ourselves here to a few typical examples.

The portrait study below, by Elias Grossman, is a convincing one; the man looks real and alive and we feel that the sketch reveals something of his personality. Further, we can sense the solidity beneath the softness of his hair and beard,—the artist must never lose the impression of

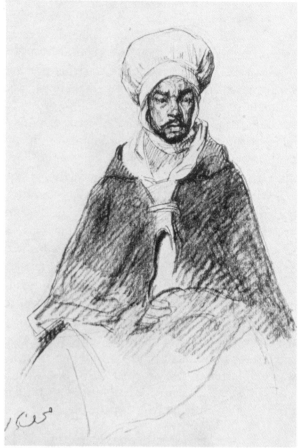

"A SPAHI SOLDIER,"—SKETCH BY CHARLES HALLO

Note the Arabic signature of the subject

sound underlying construction. This drawing was done on tinted paper with the highlights picked out in chalk, a method as effective for this type of subject as for our previous ones.

Charles Hallo's sketch also presents a telling treatment of an unusual human character. Types of marked individuality, like these two, result as a rule in far more interesting sketches than do more commonplace ones. Observe in this excellent example that the interest is concentrated on the face. Note the free, unstilted handling.

Turning to the complete figure, Sargent's characteristically vigorous, dashing action study aims only to catch the more vital elements of his subject. These have been recorded with a sureness which bespeaks this famous artist's mastery. Only long practice develops such skill.

In the drawing by Legros it is the torso, left arm, and left thigh which receive most of the

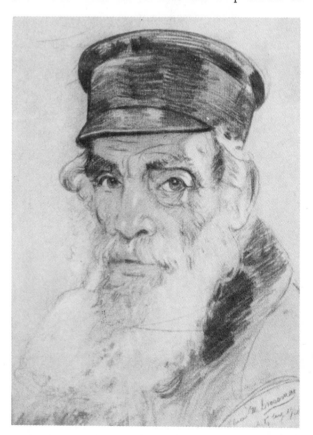

PENCIL AND CHALK DRAWING BY E. M. GROSSMAN

Portrait studies tax the student's skill

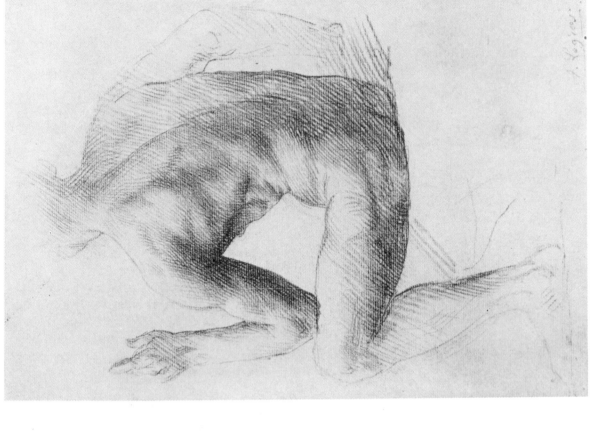

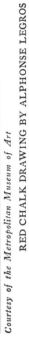

One needs instruction in such exacting and difficult work: It is folly to proceed without it

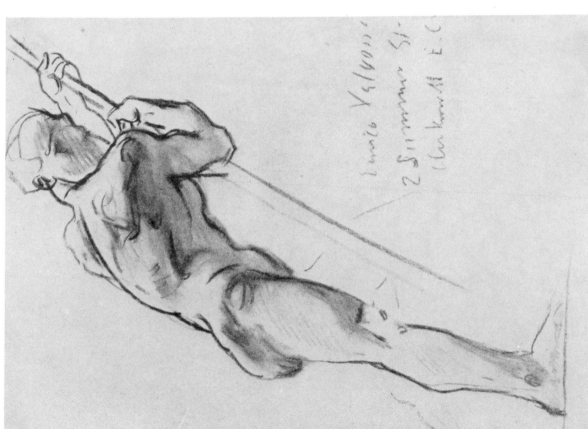

attention. Note the careful modeling of the muscles. An interesting technical point is the use of crosshatch, the close-knit lines, plus the roughness of the paper, developing a vibrant texture of great richness.

Particularly vigorous is the study by Alfred Stevens. Here again the artist has concentrated his attention on limited portions of the body. Studies such as these last three are often done as preliminaries to serious paintings, several being made from the same subject, in practically the same pose, for comparison. Note here that the head, neck, and shoulder have been sketched twice. Observe, too, that the angularity of the male figure has been emphasized.

Delightfully refreshing is Ralph Calder's dexterous charcoal study opposite. In a limited time he was able to interpret not only the form but the modeling of his subject with laudable fidelity. This drawing was done some years ago, before the artist had won his present recognition, and so can be viewed as a student's exercise,

yet there is nothing amateurish about it. In fact it compares favorably with our previous full-figure examples which were done by masters of established reputation, in the course of their regular work.

Drawings of the figure are naturally of many kinds. In conclusion we point to our frontispiece, which reproduces the cartoon for one of a series of eight mural panels by Griffith Bailey Coale in the building of the New York Athletic Club. It shows Peter Stuyvesant strolling past a game of bowls in old New Amsterdam at the site now called Bowling Green. The game was played late summer evenings far into the twilight or even by the full moon. A sloop, the ancestor of our American fore-and-aft brig, lies in the river near an early Dutch house, and the little girl encourages her father's bowling, while the young mother pays her respects to the governor. Such drawings as this are usually quite conventional, particularly as to composition, mainly because of their decorative function.

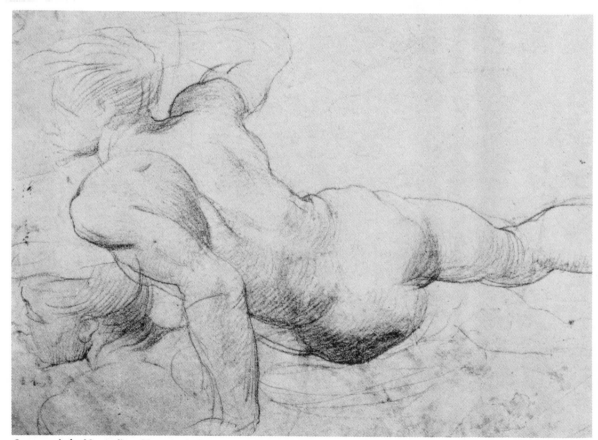

Courtesy of the Metropolitan Museum of Art

FROM A RED CHALK DRAWING BY ALFRED STEVENS

A practical working knowledge of anatomy lies behind all successful figure drawing

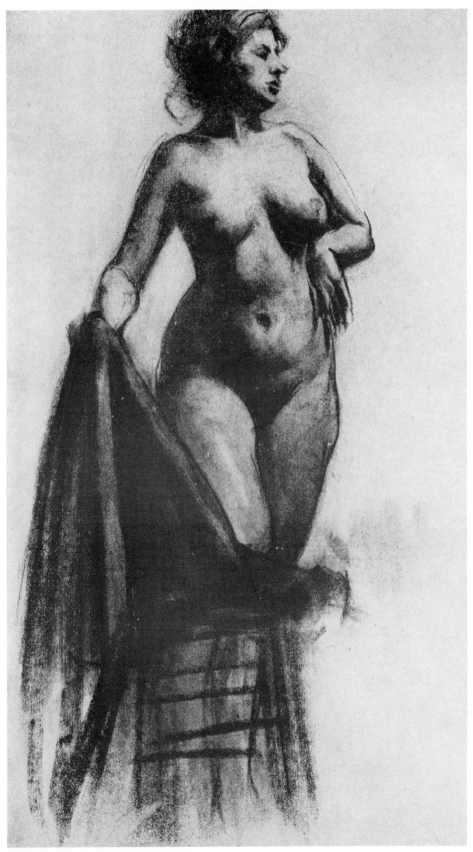

A SPLENDID CHARCOAL STUDY FROM LIFE, BY RALPH CALDER

A four-hour sketch made as a pupil of Robert Henri

[129]

INDEX

INDEX

INDEX